Art, Society, and Performance

ART, SOCIETY, AND PERFORMANCE

Igede Praise Poetry

Ode Ogede

University Press of Florida
Gainesville · Tallahassee · Tampa · Boca Raton
Pensacola · Orlando · Miami · Jacksonville

Copyright 1997 by the Board of Regents of the State of Florida
Printed in the United States of America on acid-free paper
All rights reserved

01 02 00 99 98 97 6 5 4 3 2 1

Library of Congress Cataloging-in-Publication Data

Ogede, Ode.
Art, society, and performance: Igede praise poetry / Ode Ogede.
p. cm.
Includes bibliographical references and index.
ISBN 0-8130-1541-3 (alk. paper)
1. Laudatory poetry, Igede—History and criticism. 2. Igede (African people)—
Social life and customs. I. Title.
PL8274.5.O35 1997
896'.337—dc21 97-37516

The University Press of Florida is the scholarly publishing agency for the State
University System of Florida, comprised of Florida A & M University, Florida
Atlantic University, Florida International University, Florida State University,
University of Central Florida, University of Florida, University of North Florida,
University of South Florida, and University of West Florida.

University Press of Florida
15 Northwest 15th Street
Gainesville, FL 32611-2079
http://nersp.nerdc.ufl.edu/~upf

This book is for my father and my mother

CONTENTS

Preface *ix*

Acknowledgments *xvii*

Introduction: The Context of Igede Songs 1

1. The Dialectics of Satire: Form and Content
 Interaction in Vilification Songs 24

2. Death and the Communal Consciousness: Listening to
 Mourners Celebrating Life and Castigating Death 50

3. Politics and Creativity:
 Using Praises for Conscientization 67

4. The Image Burden:
 Form and Function in Praise Songs 102

5. Proverb Usage in Praise Songs:
 The Dynamics of Performance 138

Conclusion 154

Notes 157

Bibliography 163

Index 169

PREFACE

This book makes a joint study of praise songs and vilification songs. Songs of eulogy exist side by side with the opposite, songs of reproach or vilification; and so, I argue that their combined analysis constitutes the best approach to studying praise songs. Scholars have tended to treat praise and rebuke as if the two were separate entities and, in particular, have given attention to praise song, while too often ignoring its twin component of reproof. In his recent study *African Oral Literature*, Isidore Okpewho singularly accords recognition to the coexistence of praise and vilification, when he observes that "[a] great deal of critical spirit is embodied in African oral literature. Some of it is to be found even within what generally passes as praise poetry" (147). But a detailed exploration of the practical and theoretical ramifications of this phenomenon is yet to be accomplished.

The impression that the practice of praising stands apart from the desire to defame is erroneous, for while praise satisfies a universal and fundamental human need—the need to give or receive adoration, recognition, or exaltation—the reverse, tongue-lashing, also satisfies the human need to withdraw compliment or commendation. Both appeal directly to the intellectual and emotional faculties of people, and the two almost always go hand in hand. They touch the very nerve of being and reveal the contradictory nature of life. The song mode provides a particularly effective means for the articulation of accolade and castigation. Among the Igede people the urge to admonish or vilify, like the desire to praise, is accepted as a process by which one gives honest appraisal of the behavior of others or of any context in which one finds oneself. Those who live in cultures where people are more discrete or less forthright in expressing opinion may need to be reminded of this: one of the most cherished values of traditional societies is the courage to uphold and express a view-

point; praise and censure are the strongest—and the most constructive or the most harmless—culturally sanctioned expressive forms open to human beings for conveying courage.

In this study of the oral performances of the Igede of Benue State, Nigeria, the first full-length study of its kind to be devoted exclusively to this minority African group, I present a detailed illustration, description, and interpretation of the context, form, and character of the Igede praise and reproof songs. I urge a consideration of praise song alongside an analysis of its reverse, songs of disparagement, because extolment would be meaningless if there were no alternative disapproving temper. This study demonstrates clearly that the analysis of vilification greatly helps our understanding of praise songs. Although they are often the inventions of known individuals, Igede praise songs and vilification songs are powerful art forms with the objective of negotiating the patterns of individual and group interests in the community. I make an attempt to shed light on questions of authorship, of goals and aesthetic effects, of literary backgrounds, and of social relevance, and I also attempt to shed light on the values, culture, and creativity of the Igede through the ages. The study definitely makes available to the reading public both in translation and in original transcripts an important corpus of Igede-language poetry that otherwise would have remained inaccessible.

As an African group for whom praise and criticism are favored forms of discourse, the Igede use praise and criticism especially for dealing with those in positions of power, for they perceive power as existing in material, political, social, and spiritual realms, and they believe power can be deployed either to positive or negative ends. Whether it is in festive or solemn moments, the Igede habitually employ praises and songs of admonishment with astonishing effects—to entertain, please, or humor those who are powerful; to laud or criticize those who excel or fail to excel in exemplary modes of behavior; to instruct others to emulate acceptable modes of behavior; and, yet, to obtain spiritual favors or cleansing from the ancestors. Praise and disparagement songs are highly valued forms of artistic expression among the Igede, for the people exceptionally cherish honor, integrity, achievement, justice, and generosity. Always manifest in the scale of values of the Igede is a willingness to reward those who embody these cherished attributes as well as the determination to punish those who fail in the public display of integrity, honor, and courage.

There have been many studies of the vast body of the oral literature of Africa published dealing with the majority ethnic groups, but very little published work exists on such minority people as the Igede. Even a cur-

sory glance at the bibliographies of such specialized books as Adeboye Babalola's *The Content and Form of Yoruba Ijala*, Dan Kunene's *Heroic Poetry of the Basotho*, Kwabena Nketia's *Funeral Dirges of the Akan People*, Leroy Vail and Landeg White's *Power and the Praise Poem*, and Karin Barber's *I Could Speak Until Tomorrow* (to mention only a few of the leading works) would show immediately that a disproportionately quantum amount of work has been done on the oral literature of Africa's predominant language groups. There is no doubt that the oral traditions of such ethnic groups as the Acholi, Akan, Hausa, Yoruba, Igbo, Ijo, Mende, Wolof, Ewe, Urhobo, Swahili, and so on have already received tremendous attention (to the neglect of the minority ethnic groups) because of the wrong impression created by researchers—that the size of a community is always an indicator of the quality of the creative endeavor among its population. But the Igede praises and satires are living proof of the falsehood of this claim. They provide an excellent index to the charm and complexity of the oral performance arts obtained among the minority peoples of our continent that have been largely undocumented. One of the strongest areas of cultural interest about Africa, which the songs illustrate, is the variety of artistic creativity arising from the ethnic diversity of its communities. The Igede have a self-enclosed cultural heritage of which their praise-and-critical song performances are a vigorous expression, and discussions of Igede praises and songs of disapproval inevitably must reckon with this one phenomenal aspect of Igede oral culture: the common and widespread propensity for new genres to be created by individuals.

This leads me to an overall statement on the vexing issue of methodology in oral literary research. My interest that determines the framework employed in this work lies primarily in the form of the Igede praises and satiric songs, and my bias is not fortuitous but has been taken in thoughtful recognition of the significance attached to form in determining the overall value of oral literature. The eminent folklorist Alan Dundes stressed this importance of form in folklore studies a long time ago when, in his book *The Study of Folklore* (1965), he makes the following pertinent observations:

> In a way, one would surmise that the study of form is the logical beginning for the study of folklore. After one has delineated the structure of riddles, the pattern of myth, and formal intricacies of folk dance, one should be in a much better position to define these folklore genres, to hypothesize about their origins, and to investigate their function.

Formal criteria might also be used to illuminate the complex interrelationship between folklore and literature: To what extent are the formal features of folklore found in sophisticated literature? Can such features be used effectively to differentiate folk and written literature? (127)

As Dundes notes further in the same context, attention to the formal properties of folklore is additionally useful because it can empower us to gain knowledge about the personality of the people who produce them. It is my firm belief that, in order to come to grips with the essential character of the Igede oral arts in general, and ribald and praise songs, in particular, as well as the people who produce them, we must employ a literary approach that not only places emphasis upon form but also relates each of the performance genres to its context. Only by restoring a large corpus of praise and satiric performances by various groups of Igede people to the central position they deserve in the procedure of literary analysis, I believe, can we tease out the needed body of knowledge. Thus, by subjecting to provocative interrogation this large corpus of performances seen within their socio-political, cultural, historical, and literary contexts, I aim to place in perspective the intensity of their composers' concern to deal with issues of a kaleidoscopic nature: injustice and oppression, justice and fairness, immorality and indiscipline, as well as integrity, joy, anger, and hopefulness. What emerges clearly as the most crucial aspect of the Igede culture reflected in the songs is the primacy of the communal consciousness, the necessity to preserve the life of the people as a corporate entity. As I hope to show, the Igede regard the welfare of individuals as something that is meaningful only when the group as a whole is in good health because they view the group as more important than any single individual, no matter how rich or powerful, brilliant or strong, he or she is.

Performance is meant in this study as an act of visual display/verbal expression that may be accompanied by body movement; a sense of reenactment/stage presentation/display, or a put-on by human beings. One of the questions that I address is this: as Igede people compose new songs of their own as well as sing those composed by others, do, or can, they remember the original composers? What is the essential character of the Igede praise-and-satiric song? And what are the effects, the powers of such performances?

As a child, I participated in the creation of such materials, but it was during fieldwork as a student of oral literature among my people that I began to apply the tools of social science research to my observations.

Carrying out my research with my parents, brothers and sisters, uncles and aunts, as well as the children and wives of my relatives has been an intellectual homecoming. As a native speaker of the Igede language with an academic training in literature, I have been in a good position to study the materials.

The results of my findings, I hope, should also have serious theoretical implications for a number of debates: for instance, about the collective or communal character of oral cultures; about tradition and the individual talent; and about the invention of tradition. It is my final hope that other scholars can use this detailed study of the form and content of Igede oral praise and vilification song performances in the on-going debates in Africanist discourse on gender, language, class, ethnicity, and cultural nationalism, as well as comparative analysis. In short, it is my overall hope that the dynamism of the Igede oral arts examined in this study will further the goals of African studies as a whole. The breadth and range of the issues and subjects covered in this study give me no doubt whatsoever that it should be of interest to scholars in a diverse range of disciplines, including those in literary studies, anthropology, political science, sociology, psychology, and even philosophy.

For convenience, the study is divided into five separate chapters, all of which could be taken together by the reader desiring to get a holistic sense of the awesome creativity of Igede singers. Other readers seeking understanding of only specific aspects of the materials could, however, consult just the chapters dealing with those issues. To further my aim of challenging readers to take a fresh look at issues that have been all too often either ignored or oversimplified in the study of African performing arts, the introduction presents the specific context in which Igede songs are composed and performed. In my effort to establish the complex nature of Igede identity, I have found it useful to discuss as well how singers establish intercourse with tradition and by so doing put the stamp of their individual voices on the conventional forms with which they work. By paying attention to details about some of the key figures in the field, it is my aim to demonstrate the sense of the enormous individual talent that is involved in oral literary creativity in Igede. In order to make clear my point that, even though the notion of total translation of meaning from one language to another may be an illusion, translation can be a fruitful undertaking if handled with the kind of integrity, sensitivity, and care that I strive for, I have made an attempt also to offer an explanation of the method of classification and translation this study has adopted. I stress the importance of performance in the culture because it is in performance

that the oral artist connects with the community. The chapter concludes with a detailed analysis of the nature of the Igede oral song transmission and the vital role children play in it, both as a community of performers and as individuals.

Although, conceptually, praise and vilification may exist as independent categories, in practice, Igede singers do not observe such generic distinctions. Experience shows that a singer may sooner shift to vilification as to praise within the context of a performance, depending on his or her desires at a particular moment, whether it is to treat a subject, idea, attitude, value, or thing to comic ridicule, or to exaggerated boast. This is the reason I urge that we must never entertain the idea of clear-cut generic boundaries because they never exist in the rhetoric of the performers. The first chapter explores this matter further by making an elaborate illustration with vilification—which I view as a technique by which Igede singers concerned with the quality of the moral life of their community accentuate their denunciation of those practices that threaten the qualities they desire to see in abundance. Simultaneously, within the same space, vilification songs carry undeveloped praise forms that embody hidden notions of the beauty that is threatened by the ascendancy of the perversities decried. Thus, whenever either praise or vilification dominates in the songs of Igede singers, I indicate, it is a matter of critical emphasis; for, almost always, the two forms are ever present in an interlocking relationship. Underlying my analysis, then, is the importance of community, for the unrelenting attack that a singer makes on habits that negate the singer's proffered communal values may be balanced only by his or her commitment to the moral health of the society expressed by his or her uninhibited promotion of those qualities to which he or she is more favorably disposed. Igede vilification performances thus attest strongly to the reformative power of songs on the folk imagination because of the vision of the alternative values they suggest with praises.

When, however, a singer achieves a fairly handsome balance of praise and vilification forms in his or her compositions, the practice challenges us to make an integrated examination of those devices in order for us to understand fully how the twin elements of praise and vilification work, and why praise cannot be appreciated fully without an understanding of vilification. I demonstrate in the second chapter that the dirge provides the best mixture of praise and vilification. Dirge expresses elemental anguish, and its mood is almost always pervaded by hopelessness and despair. The primary goal of the dirger is to preserve and celebrate life; when death occurs, it is a blatant denial of all these values sought by the praise

singer, who mourns the loss and in grieving condemns those held responsible for the breach of the human peace occasioned by the death. Dirges—though a storehouse of Igede beliefs, practices, and wisdom—thus, ironically, lead us into a world of spirits, a dreadful world of ancestors fearfully conjured up as a universe of monstrous, malignant forces before whom humans are vulnerable beings. As humans find themselves constantly constrained to plead for protection, praise and vilification constitute the primary armory with which they seek the mercy of those forces that are larger than themselves through an expression of the pain they feel as a result of the loss. While praise helps the singer to expand the listeners' understanding of the good things people can do when they have life, vilification enlarges their idea of the absurdity that the destruction of those qualities by death represents. The contrasted pairing of praise and vilification is therefore very effective in dirges, for just as the technique brings together good and bad as opposites, so it places life and death in antithetical relationship.

In chapter 3 I discuss the use of praises in a predominant manner to elicit good political behavior. The singers who are engaged in this sort of exercise are very courageous people. They gain respect in their communities mostly because of their single-minded devotion to truth as they see it. Political songs spring from the desire to change immoral political attitudes. At such local government levels as those in Igede, as in the larger national polities of Africa, political management has presented an array of problems. Because of limited resources, human greed, dishonesty, aggrandizement, competition, and a plethora of other factors, large-scale abuse of power has been rampant the world over, and Igede's situation is not an exception. Embedded in the values pushed by the singers in the praise songs of political tenor is the optimism that songs can help in cultivating a healthy political culture through the dissemination of ideas that stress communal values, the sense of brotherliness and love, justice, honesty, the integrity of courage, and sympathy toward the weak. Accountability is considered of utmost importance by the singers, who use praises to goad their audiences toward the pursuit of collective goals, while deprecating destructive individualism and greed, injustice, corruption, and decadence—in short, every form of irresponsible and disorderly behavior. Once again, I show that, as with other areas, so also with political songs: though distinctly different categories appear in different levels of dominance, praise and vilification are yet overlapping; for they exist in the form of an interlocking relationship, one helping to push the meaning and significance of the other forward.

Prominent among the devices employed by Igede praise and satiric singers to create enlarged mental pictures of their objects of adulation or ridicule are imagery and proverbial usage. Chapters 4 and 5 are devoted to an analysis of the nature and function of imagery and proverbial usage seen as salient aesthetic ruses used in the project of forming enlarged ideas for purposes of gaining audience attention. The focus on narrower discussions of these artistic conventions helps us obtain a clearer conception of the skills with which the oral performers approach their work. And the study concludes with remarks that emphasize the underlying idea of the project, namely: the unprecedented need to view the praise songs and vilification songs examined as the creation of identifiable Igede citizens deeply rooted in the mores and values of their society. Although Igede praise and vilification songs are created by individual men and women—and even children—these singers could speak to their communities with vision and authority for the essential reason that they derive their voices from the pool of communal wisdom.

ACKNOWLEDGMENTS

During the course of working on this book many people lent a helping hand, and I would like to thank all those who shared their expertise, resources, and valuable time with me. I am especially grateful for the generosity of Misters Okwute Oibe, Agi Ajochi, Egboja Agi, Groovy Idikwu, Jairus Edeh, Edugbeke Ogede, John Idikwu, Joel Ogede, Iduh Onah, Micah Idah, and Rev. Ogbale Ikoni, who helped me to understand key issues during the fieldwork. My special words of gratitude to the artist Micah Ichegbeh for our friendship and collaboration over the years; I sincerely hope that this study does credit to his phenomenal talents.

I have benefited a great deal from the work of many scholars in the general field of oral literature, and I wish to express my deep gratitude to all the writers whose works I consulted. For professional and personal support, I must specifically mention the debts that I owe a number of individuals. Foremost among those individuals are Funso and Iyabo Oluyitan of Bennett College, F. Odun Balogun of Delaware State University, Isidore Okpewho of the State University of New York at Binghamton, F. Abiola Irele and Ruthmarie Mitsch of Ohio State University, as well as Marilyn Button and Ropo Sekoni of Lincoln University of Pennsylvania.

My thanks also to my friend Damian Opata of the University of Nigeria, Nsukka, for the encouragement he has given me over the years; needless to say, his own work on the Igbo of Nigeria has been a great source of inspiration for me. At the University Press of Florida, Walda Metcalf, the former editor-in-chief, gave this project immense encouragement and I am grateful to her for her enthusiastic support; I'd also like to thank Ms. Metcalf's assistant, Chris Hofgren, and the two anonymous readers who were responsible for helpful recommendations. I am most grateful to Meredith Morris-Babb for seeing the work into print with skill, extraordinary efficiency, and genial humor. I am most appreciative of the

efforts of Abraham Joseph and Jonah Ajogi, who typed earlier drafts of the manuscript. I deeply regret that I cannot now share the joy of this moment with the late Richard Bjornson who took a personal interest in my writing and helped me to improve it.

I have drawn heavily upon my articles published in a variety of journals. I wish to thank the editors of *Africa, Research in African Literatures,* and *Children's Literature Association Quarterly* for their kind permission to reproduce material that appeared in a different form in their pages.

This is a good occasion for me to publicly thank John Sekora, Arlene Clift-Pellow, Patsy Perry, and my other colleagues at North Carolina Central University, for creating the environment that enabled me to complete this study. For their friendship, collegiality, and support during our time together, my thanks also to my former colleagues in the English department at Ahmadu Bello University, Zaria, Nigeria, and especially to Philemon Gomwalk, Chidi Okonkwo, Mbulelo Vizikhungo Mzamane, Tanimu Abubakar, Sanni Abbah, Rex Moser, and Ken Evans. Ode Ojowu, Abdullahi Mahdi, Otegwu Ewule, Andrew Ohwona, and Ebow Mensah also did much to further my understanding of society and art, and I wish to thank them for their contributions. The authorities of Ahmadu Bello University made available a small research grant that enabled me to begin this work, and I would like to thank all those who were instrumental in my securing the grant.

I must acknowledge my loving wife, Shianyisimi, who has supported my research over the years. Through her characteristic display of intelligence, endurance, and unique ability to accomplish difficult tasks under conditions of extreme stress, Shianyisimi not only allowed a relentless husband to sacrifice the family's lean resources in order to pursue his intellectual adventures, she also transformed herself overnight into a superb typist and produced the early draft of the work at a very short notice; her labor of love is greatly appreciated. My thanks also to our children Ochuole, Ogede Jr., and Michael, without whose willingness to forego the company of a father who buried himself endlessly in his studies, this work would not have seen the light of day. The arrival of Michael at about the time I was putting finishing touches to the study brought much optimism for the future, and I am most thankful for the unending patience and forbearance of these family members.

Most of all, I would like to thank my father, Ogede Ode, an extraordinary man—master farmer, poet and storyteller, hunter and orator as well as impartial judge—who continues to teach me the ways of our ancestors.

Father, you are the ideal father any son could ever wish to have! My profound gratitude also to my mother, Ochuole Ode, for her contributions to the success of my work: as an active participant in some of the cultural practices examined in the book, the philosophical impact of Igede women's songs bears testimony to the numerous gifts of which she is heir. For my parents' many sacrifices on my behalf, I dedicate this work to them.

Introduction
The Context of Igede Songs

The contemporary homeland of the Igede—called variously the "Igedde," "Egede" (Armstrong), or "Egedde" (Frampton)—is found in Benue State, Nigeria, where they are bordered by the Tiv to the northeast, the Idoma to the northwest, and by the Izzi of Anambra State and the Ukelle and the Yachi of Cross River State to the southwest and southeast. Pockets of Igede-speaking peoples are also found among the Igabu and Yala groups of Cross River State. Traditional farmers engaged in subsistence agriculture, the Igede predominantly grow such crops as yams and cassava as staples; they also produce sweet potatoes, water yams, rice, millet, and sorghum for cash and engage in other occupations, such as hunting and fishing, as well.

Throughout the colonial era and up to 1976, the Igede were administered to under a single political unit with the Idoma with whom they suffered much neglect by the federal government. In recognition of their distinct history, language, and culture, the Igede were accorded a separate divisional status in February 1976 following a countrywide state and local government creation exercise. While Igede can boast of a few amenities for those who live in the seat of the local government today—a modern housing unit for local government officials, a postal agency, a commercial bank, a modern hospital (with hardly any drugs and with an irregular supply of pipe-borne water)—most of the hinterland remains brutally neglected. This is the area that constantly witnesses much suffering as well as death from causes ranging from malnutrition to such other preventable diseases as cholera, dysentery, and measles—diseases that continue to ravage the community. These conditions give oral performers material for their compositions, which take the form of the satires as well as the praise dirges to be described later in this study.

A Brief Political History of Igede: The Context and Material of Oral Artistic Composition

When the Igede were first brought to the attention of the Western world in 1922, it was as a warlike people.[1] Igede was the main theater of the Ikerri-Igede British colonial military operations in 1922, which delimited the boundary of the northern and southern provinces. Captain Money, who commanded this and other operations, recounted, "Egede was the only place in Idoma where [he] was opposed by an organized military force. The last and most serious resistance was shown by the Egede rising in 1928 which lasted for several months" (Armstrong, "The Idoma-speaking Peoples," 140–41). It is not surprising that the image fed to the British home audience was that Igede people were "a head hunting people . . . very primitive having had few contacts with the outside world and having been entirely surrounded until recent years by other tribes with most of whom they were in a state of war" (Frampton, "Intelligence Report," 16). What the British invaders and their public at home could not know, however, is the past history of war and persecution that had lodged itself deeply in the imagination of the Igede race, giving rise to the resilience, intransigence, and defensiveness the people demonstrated not only in their opposition to the colonial occupation of their territory but also in their dealings with neighbors who might have had less sinister designs on them.

The first written evidence of Igede history and culture came predictably from the British colonial officers, but today numerous and varied local oral accounts of Igede's origin circulate widely within the community. What is interesting about these different accounts is the thematic focus on war and violence as inescapable aspects of the history of this minority group. Legend relates that the Igede had their original home around the River Niger, where they made war with their "fair-skinned" neighbors, known as the Ora, who subsequently overpowered the Igede, forcing them to move to their present home in Benue State. Today this legend is widely recounted by many Igede people who believe it to be a factual story, but only one attempt has been made to render it into song. Interestingly in the only noteworthy reconstruction of the legend in song by the singer Micah Ichegbeh, we find not only extreme faithfulness to history but also adept use of both praise forms and vilification forms to tease out issues of perennial significance: while blaming his people for bringing about their own suffering through intransigence, his song *Egoh Ny' Igede* (The History of Igede) celebrates the communal atavistic instincts that have ensured the survival of the group. As I show in the chap-

ter 3 analysis that follows my presentation of the full transcript and translation of that song, in composing the piece, Ichegbeh has created a work of utmost importance to Igede oral narrative genre and to Igede social history as a whole.

All over the world, legend has always provided fertile material for oral creativity. Thus in employing the most significant legendary tale about his ancestors, Ichegbeh is seizing on this age-old tradition. However, what makes Ichegbeh's performance outstanding is his peculiar power of eloquence and aesthetic sense of discipline—rare qualities that enable him to not only adhere to the most outstanding moral ethics but also to render his song intelligible to even the most uninformed listeners. In a number of the stories told today, many elders still recall vividly the sense of terror, social turmoil, human suffering, and pain inflicted by the British colonial war, but few have any memory of the war their ancestors fought with the Ora, the legendary race who drove out the ancestral fathers of Igede from their original homeland around the River Niger. And yet, likening the British invaders to this "fair-skinned" old enemy was what fomented the Igede people's hostility toward the British. In the words of one writer, "The coming of Europeans recalled the bitter memory of the people's traditional enemy and the Europeans were seen as the Ora carrying out yet another invasion into Igede" (Ominyi, "The Igede Rebellion of 1928–1929," 21). This is where a special significance attaches itself to the role of Micah Ichegbeh's *Adiyah* praise song, *Egoh Ny' Igede*, which attempts to relive that painful but instructive aspect of Igede's history with the greatest sense of accuracy for the benefit of contemporary society.

Despite the stiff resistance put up by the Igede, British colonial occupation was a success. With the Igede eventually subdued on February 2, 1922, British colonial administration was established with its headquarters at Barracks (Anyuwogbu). Nevertheless the Igede people continued to resist colonization and to demand their freedom. This resistance was created by the oppression and suffering of the regularized forced labor through which the native populations were conscripted to build roads, to maintain courthouses and government rest houses, and through the agony of taxation and other services the Igede rendered to their white overlords. The 1928 Igede resistance war marked the climax of the people's outraged reaction against enslavement.

Led by their hero, Ogbilokoh Onawoh, the people waged a bitter war against the British occupation forces. Ogbilokoh eventually was assassinated by one of his own tribesmen who wanted to bring an end to the widespread hardship caused to the general public by the war (Ominyi,

"The Igede Rebellion," 41). Following the death of Ogbilokoh, the Igede were defeated in February 1929. As Ominyi emphasizes, Ogbilokoh was not killed to put an end to the resistance war because Igede people preferred servitude under the British to freedom, but instead he was killed out of frustration: "The hunt for Ogbiloko was joined by those who could not bear the situation any longer. They had discovered the futility of further resistance. They had been forced to abandon their homes for months, their farms were in ruins, many of their kinsmen had been killed and there was no possibility of defeating the British troops" (Ominyi, "The Igede Rebellion," 41).

One of the distressing paradoxes of modern African history has been the failure of political independence to right many of the injustices of colonization. Thus in literary documents from all over the continent—essays, fiction, lectures, and symposia—we still hear about African peoples fighting to regain the freedom, equality, and economic prosperity they felt they were denied by colonization. Igede's situation is no exception. In fact, Igede's socio-political conflicts predated colonialism, for despite the united front which they formed in their resistance to the British colonial occupation of their territory, Igede was a divided society. As elsewhere, the colonial venture in Igede was a quest for men, their land, and the acquisition of economic power and the political prestige that accompanied wealth. Ironically, similar interests already existed in the Igede community among its various groups even before the coming of the colonialists.

That socio-political turmoil had run parallel with the Igede race's recorded history is not an overstatement. For example, A. Frampton, the British colonial administrative officer, reports that even though the Igede "territorial association [was] assisted by vague traditions of common descent," which made the group's different clans come together in the "interests of security," these various Igede clans had at one time or another gone to war with each other (Frampton, "Intelligence Report," 3–4). At the time of his report in 1935, "the Worku group," for instance, had been for "the past 70 years . . . at a feud with Aliechc in particular and with Egedde proper in general . . . and Ainu . . . was on bad terms with Ito."

While the research for the current work was in progress in 1981, the same history was repeating itself. It had been five years since the greatest part of the Igede people had had their "independence" proclaimed. Though the euphoria of freedom had not yet been overtaken by the waves of disillusionment so widespread elsewhere on the continent, there were already signs that the peace that the young division needed to establish itself firmly was proving elusive. As one writer remarked: "Things have

however not changed nowadays. For example, in December 1974, elders from each of the thirteen clans of Igedeland met at Ada's square at Ujegbe to discuss and resolve disputes on Ito vs. Ainu war over murder of an Ainu man by Ito . . . Ibilla vs. Ukpa dispute over Onyike market; and Ibilla vs. Oju dispute over the name of Oju Local Government Area. The war between Uwoku and Ainu clans over the ownership of Obusa . . . is another. . . ." (Abi, "Administration of Justice in Igede," 72).

With one correction (the claim of Ibilla's dispute over the name of the local government area is not entirely correct, because the dispute is over the name given to the piece of land that houses the local government headquarters and not over that of the local government area as a whole), Abi's commentary is very informative. It was unhealthy political situations of this nature that gave birth to such Igede song genres as Odeh Igbang's *Etuh* ensemble; and others, such as Micah Ichegbeh's Adiyah group, have also utilized it in their compositions.[2] Nearly every one of these composers utilizes the people's "independence" mood in an effort to urge them to patch up their differences and work together for the common good. Firmly convinced that the Igede people have bright prospects to develop their land, the singers present the attainment of their divisional status as a sign of the Igede people's potential for modernization. While some employ material from history, others create their own original compositions.

The Social and Cultural Contexts

Among the Igede, songs find popular and widespread expression in festivals, at village social meetings, and in the context of solitary farm work. Also, when death occurs it is mourned with song. Of these contexts, the most misunderstood is that of death. There have been some important contributions to the scholarship on Igede funeral ritual that show the inextricable links that exist between burial occasions and other social functions. The most detailed of these is Eriba Idikwu's *Burial in Igede*. The only detailed study so far available that provides reliable information about the context of Igede dirges, *Burial in Igede* is best read along with Robert Nicholls's essay on Igede funeral masks. But while such background research is essential, by failing to include the actual texts of the dirges, these works make a serious omission because dirges constitute the primary means through which the Igede mourners express their grief.

One of the interesting features about the Igede that both Idikwu and Nicholls recognize is, however, that when death occurs in their community, the immediate response of everyone nearby is to break into spontaneous outbursts of dirging. However, the Igede categorize deaths as those that are "good" and those that are "bad" and have severe penalties for

anyone who mourns "bad" deaths with elaborate dirges; as soon as the cause of a death is ascertained and if it is declared "bad," people must stop all dirge singing and hasten to make minimal arrangements for the interment.[3]

Thus, among the Igede, the performance of dirges is not a specialist occupation of separate communities or cult groups, such as hunters with their ritual observances as reported by Babalola (in *The Content and Form of Yoruba Ijala*) and Ajuwon (in *Funeral Dirges of Yoruba Hunters*) for Yoruba communities. Nor do we find among the Igede such professional mourners as the Idoma *Alekwu* troupe, which moves from one funeral to another and receives a fee for its performances. Viewing dirges as an expression of genuine grief felt by relatives, friends, and acquaintances for a dead person, the Igede perform dirges copiously and by that means call all their neighbors to attend the scene where a death has occurred. They believe that this is necessary in order to involve everyone in the community in sharing the sorrow occasioned by the loss of a life.

The practice whereby the Igede draw a distinction between dirge (*Idah ny' ogwuh*) or funeral essay and a lament or personal elegy (*eru*), shows the degree of veneration they accord death: they not only regard it a taboo to compose a dirge in any other context except where a death has occurred, they prohibit the use of dirges for the attainment of any form of material reward whatsoever. The Igede perform dirges from the moment when a death is announced to the lying in state to burial and for the following two-week period of mourning. (Memorial ceremonies to mark the first calendar year of a death are not acknowledged with dirges.)

At every Igede funeral the practice is for each mourner to sing or chant his or her compositions regardless of the fact that other composers are also performing at the same time. Nketia reports of the Akan that, while "a good singer wins in emotional appeal . . . a funeral is not the occasion for mere display," and "one of the requirements of a performer is that she should really feel the pathos of the occasion and the sentiments embodied in the dirge" (Nketia, *Funeral Dirges of the Akan*, 9). The situation of the Igede dirger is the same, and the mourning occasion is therefore always noisy and chaotic, which makes it nearly impossible for the student of Igede dirges to record one free of background noise on a tape recorder. Despite the apparently chaotic nature of the Igede funeral, however, the dirgers achieve an absolute sense of order in their compositions. This organizational acumen reflects what Bjorn Ranung describes in *Music of Day and Dawn* as the sense of "formal convention" (5) that dominates every aspect of Igede social life.

A typical Igede funeral begins with the arrival of the elders of the community at a scene where a death has been reported. These are the political, religious, and moral power holders in the community, who will immediately call for the cessation of all dirge performances before commencing a preliminary inquest with the question: *Ewu ole ti bwuhih anyi wee?* (How has this war invaded us in this way?) The reference to death as a war (*ewu*) in the quotation above illustrates that the Igede view death as a calamity, an unfortunate invasion that they intensely hate. As noted by Idikwu, while a full inquest follows the death of an infant immediately after it is reported, inquests have to be delayed where a death involves a married woman who is survived by children,[4] or when involving an elderly man of eighty years and above. Where an infant's death has been certified as "good," it will be mourned with profuse dirges before burial on the same day; thereafter, no dirges must be performed.

As soon as an old man's death is confirmed, the family's spokesman will declare that a headache (*egbejuh-obeneh*) has afflicted him. Though all dirge compositions are officially to be suspended forthwith and should remain so for the next three days (the fine by default being an adult he-goat), this is the time when such aged women as Ebeleh Ondah, whose composition is discussed in this study, perform highly complex dirges in low tones. As we shall see in chapter 3, the message of such pieces is entirely the pain inflicted on the composer by the loss of her relative and the need for greater ancestral protection. What lends the composition special interest is the performer's use of poetic language in an original manner.

Songs in Performance: The Testing Ground for Popularity

The centrality of performance in the Igede song genre should never be in doubt. Songs are realized in performance and it is performance that gives each one of them its distinctive character. The good singer seeks the involvement of his or her audience through an appeal to both its emotional and intellectual faculties, thus the singer needs to be very knowledgeable in the culture of the community. Because the effect that the singer has on the audience is invariably dependent on the dexterity with which he or she manipulates the values and resources embodied in the Igede language, it is very advantageous for a singer to show unwavering allegiance to this crucial aspect of Igede culture. The Igede language has an exceptionally rich supply of proverbs and proverbial expressions, maxims, vowel harmony or assonance, puns, repetition, alliteration, rhyme, tonal variation, and other sound patterns, and the gifted singer learns to use these materials to good effect. In the Igede worldview also are embedded numerous

folktales, legends, anecdotes, myths, and beliefs that aid creativity. While all these things are readily available for the use of every member of the community, what sets the gifted artist apart is the distinctive use he or she can make of the common heritage. In other words, audiences look out for the stamp of individuality that individual artists can put on their product. The Igede define a good singer as one who possesses sweet voice, wisdom, and gait. For them it is not only important for a singer to move with agility on stage, it is even more useful if his or her songs contain words of instruction and have an appealing melody. Thus, voice modulation, theatrics, and linguistic dexterity, as well as structural coherence and logic are very basic to Igede notions of beauty in performance. In Igedeland, whether a singer is engaged in solo or in group performance, he or she must constantly keep in mind the idea that he or she is involved in anything but a haphazard and undefined activity. How each singer responds to tradition without sacrificing the spontaneity of individual creativity is the true measure of talent. As one informant put it, the earlier in childhood a budding singer's interest began to take shape, the better the chance in having a successful career later in life.

The Transmission of Songs: The Role of Children

Indeed nearly every one of the Igede oral artists whose works are discussed in this book confirmed that their learning began during their childhood, and so their experiences tell us much about the role children play in the process of oral transmission. So important are children as an agent by which oral literature is passed on from one generation to another that, continuity in oral literary creativity may not conceivably happen without them. In the particular case of Igede children, what immediately strikes the person observing and listening to their performances is the close relationship that exists between praise forms and vilification forms. When we examine one of their popular artistic forms, verse, we discern that the corpus is of interest not only because of the link it establishes between the world of childhood and that of adults, but also because of its distinctive creative form, its adept pairing of praise and criticism. Igede children's songs both reflect and resist adult practices in that they endorse community values but criticize all those who fail to live up to them. The imaginative effort that many Igede children demonstrate while they prepare themselves for the challenges of adulthood recommends their verse as worthy of consideration in any serious attempt to understand the Igede song tradition.

Igede children contribute to the perpetuation of the song tradition in their community, and songs are created and popularized by them in very interesting ways and for aesthetic and instructional purposes. This verse constitutes a valuable oral literature both because of its vigorous expression and because it confirms the life of the Igede people and their response to certain fundamental human values. The children do not merely play on the common elements of vowel harmony, assonance, rhyme, alliteration, and other patterns of sound; they compose lullabies as well as other songs of a more serious disposition, which convey messages about such topics as motherly, sisterly, brotherly, and fatherly love; hunger; misery; co-wife rivalry; marital boredom; and community is nearly always their focus of interest.

In traditional Igede society, a mother, or anyone else entrusted with the responsibility of caring for an infant, sings or recites songs. The lullaby, containing brief statements geared toward entertainment and education, is therefore the first cultural vocal expression with which the Igede child comes into contact. Afam Ebeogu confirms that lullabies also serve as "a medium for filtering into the baby's consciousness patterns of language and [the] implied world view" among the Igbo people (99). But I have no evidence to back up Ebeogu's claim that the lullaby "courts the rhetorical resources of a language more than its semantic resources" (Ebeogu, "The World of the Lullaby," 99).

Among the Igede such verses can move from one situation to another so that a considerable overlap exists in the categories of the composers and the contexts of the compositions. What ultimately matters is the end goal of the performer in each context; the songs are elastic and have the potential to achieve any desired effect in direct proportion to the emotional intensity with which each performer manipulates the song to suit his or her particular purposes. Thus a song performed with a mellow sound by adults for the purpose of lulling a baby to sleep can become transformed when used by older children for their recreational purposes in a different context. The textual content may remain the same, and the language may continue to be direct and easily accessible; but the parameters of the performance have changed dramatically as there is now a release of new energy, making for a vigorous, even electrifying, moment approximating participation theater.

An example of the transformation of lullaby into children's play song is afforded by a performance that I witnessed involving a group of children about six years old. During moonlight play, they exhibited an early mastery of *Ayilo* (play accompanied by singing) by including in their de-

livery tonal changes, facial expressions, and dance movements appropriate to the Olympian stance they adopted toward their object of attack:[5]

Onyi kewe k'ahi k' ogoh
Eheh, Mka k' ogoh mi ka, E-e-e
Onyi kewe k'ahi k'ogoh
Eheh, Mka k'iwu mi ka, E-e-e
Onyi kewe k' ahi k'eru
Eheh, Mka k'eru mi ka, E-e-e,
Kewe k'ahi ri-ang
I ma nyam awe le
Onu pye ma yeh rih
Koh koh koh

Come, child, let's go to the stream
No, I can't go to the stream
Come, child, let's go get firewood
No, I can't go get firewood
Come, child, let's work in the garden
No, I can't go work in the garden
Come, let's eat some food
That's what I like
To open my mouth and eat
And to chew fast

Here the connections between praise forms and vilification forms assert themselves strongly. The quality and texture of the children's singing demonstrated an acute consciousness of the linguistic possibilities of the Igede language. In their exploration of word and sound play, they also emphasized the communicative value of bodily expression. They sang to rhythmic hand clapping, foot stamping, dance, and mimicry; the dance steps accompanied the singing, the hand clapping occurred at the end of each line, and the mimicry took over after the whole verse had been performed. The children grouped themselves into two parts—one group stating the lead or request lines while the second group provided the replies. The performance was a communal affair, and the action was repeated as many times as the children desired to do so. As in another song that employed similar performance procedures, *M Haaka* (I am a hated one), the children parodied the sternness with which they are disciplined at home.

On the other hand, the children were also using the song to critique behavior some adults associate with children, such as laziness and irre-

sponsibility. Ironically then, their singing is a form of self-mockery. They deplore the view that they are unable to look after themselves; being forced to travel long distances to fetch water and firewood with which to cook; and being made to do agricultural work. Implicitly the mother is the other person in the song making the requests in the lead lines. Because the children owe their lives to the care of their mothers, the song frowns at laziness. Moreover, the song depicts children whose insatiable appetites have earned them the ideophonic derision of *koh koh koh*, a nonsense phrase that forcibly expresses the greediness with which children eat, even before they are invited to do so. Their song is a praise for industry, discipline, and self-control.

Nevertheless the children miss the degree of sarcasm and insult such an interchange could convey on the adult level. Many mothers confirmed in later interviews that they included these songs in their repertoire of lullabies, but their performances are naturally marked by a greater restraint. Not only do the mothers claim that they sing alone and in a solemn mood, but they also reduce their body movements to a minimum. For these women, however, the song may also be used as a vehicle to censure their husbands when they refuse to offer their support on the farms or to check the indolence of their co-wives. Both the children and their mothers are aware that it is the blend of rhyme words, praise, and satire that lends the song its symbiotic unity, emphasizing the qualities of hard work and considerate behavior cherished by the plurality of the Igede people—virtues the song indirectly urges children to espouse as they grow up.

In all the Igede children's songs that I taped, there is a similar effortless fusion of play and instruction. Community is the focus of the songs, and poetic expression involving praise and vilification forms is integral to the realization of both objectives. Igede children learn quickly from adults the techniques of verse composition and delivery, and studies must reckon with the sociological impulses that make them derive pleasure from using songs for praising as well as for exchanging banter and gossip within their play groups.[6]

As the performers lavish praise or criticism (depending on the situation at hand) on one another's behavior, their use of imagery is pervasive. There is an obvious relish to their actions, as demonstrated in the following song:

O Rim Ela Ka
O d' onu chim ka

M w' eje ka
O d' onu chim ka
M w' eje la
Alikpa nyam a d' onu chim ka
M w' eje ka

Chorus: Inyi I ki r' ichicheh
I pyeh-pych-pyeh, i pyeh-pyeh
Inyi 'ki r' ituka
I nmo-nmo-nmo
I nmo-nmo-nmo
I h' inu gbogbilo-gbogbilo!
I h' inu gbogbilo-gbogbilo
Aricha h' inu gbogbilo-gbogbilo!

I don't care
She doesn't say hello
I don't mind a bit
She doesn't say hello
I don't mind a bit
My friends don't say hello
I don't mind a bit

Chorus: The skinny ones
Sneak quietly away
The big, fat ones
Rudely bulldoze by
Rudely bulldoze by
They perpetually twist their faces
They perpetually twist their faces
Azicha perpetually twists her face

The speaking voice belongs to a group of children addressing a particular girl, Aricha, whose individualism they evidently view as a source of danger to one of their society's most cherished values—group solidarity. They make a running commentary on Aricha's misbehavior in order to discourage any other person who might be inclined to behave like her from doing so. Because all the singers know Aricha and see her daily in their midst, they may feel that their singing can directly influence her to change her bad habits. The rude comments that underlie their singing, then, are meant to serve an instructional purpose.

Equally noteworthy is the aesthetic effect that the singers seek through their virtuoso delivery. The juxtaposition of the children's gaiety and boisterousness with the sullenness and pugnacity that they denounce in their colleague helps not only to emphasize their criticism but also to underline the regularity of the song's rhythm. They heighten the drama of the event by manipulating such simple phonological words as *eje, ka,* and *onu* (song, do not, and mouth), as well as such complex ones as *gbogbilo-gbogbilo* (twist their faces). The appropriateness of these devices lies in their ability to diffuse a confrontation with an individual. When a group of children gives collective expression to a point of view using the song mode, it manages to convey the authority of the community but rules out the quarrels that could occur when personal opinions are expressed through nonartistic channels. This instance demonstrates how Igede children, like their adult counterparts elsewhere on the continent, utilize the license embodied in the poetic mode to endorse group ideals.[7]

Another example of the concern of children to regulate each other's conduct is provided by the traditional *Ejeh ny' Ewa Ol' Oboche* (The Song of the Proud Spur-Fowl). The adult versions of this song employ allegory to warn girls to curb their fantasies about ideal lovers and to accept gladly as their husbands any suitors that might come their way. Such versions stress the punishment a girl must suffer when she rejects all the suitors from the neighborhood and foolishly accepts as her husband a spirit who comes dressed in immaculate clothes. The children's version, however, concentrates only on the girl's moral failing—her pride.[8]

In all such songs there is ample support for Ruth Finnegan's 1970 claim that "African poems about nature are few and far between" (Finnegan, *Oral Literature in Africa,* 247). Even when Igede children bring nature into their songs, they use it symbolically to foreground their social goals. Thus nature as an object of human admiration, as in English Romantic poetry, is totally absent in Igede children's songs. This piece by a group aged between eight and ten provides evidence that indeed there are no songs contemplating the beauty of roses in the repertoire of Igede children. Instead of mirroring the mood of an isolated, solitary individual, the song merely utilizes nature to reflect communal concerns, life, and society in a rural environment.[9]

Leader: Ahu nyi k' ipinuh ka
Chorus: Ahu nyi k' ipinuh ka
Leader: Ahu nyi k' ipinuh ka
Chorus: Ahu nyi k' ipinuh ka
 Ukojih ole k' rw' ipinuh

Ugbakah too memeh
O ti ching yari
Ahu nyi k' olugonoh
Ugonoh y' ela onyobi
Ahu nyi d' ojeh gwo
Ahu nyi d' ojeh gwo
Ahu nyi d' ojeh gwo

Leader: They say, don't go into the forest
Chorus: They say, don't go into the forest
Leader: They say, don't go into the forest
Chorus: They say, don't go into the forest
[Because] a tree in the forest
Hides a green mamba as big as it is
The snake will bite you right away
They say, "go to the fortune teller."
The fortune teller foretells evil
You must placate the gods
You must placate the gods
You must placate the gods

In the first stanza the lead singer and her accompanists (i.e., the chorus) sang alternately: the lead singer sang the first line, and the chorus repeated the line. All the participants formed a semicircle, and as they sang they stamped their feet heavily. The rest of the verse was then sung by the lead singer and the other participants, who swayed their heads sideways in rhythmic tune with their singing. The laughter, gleeful cheers, and occasional ululation of some of the children as they interrupted their singing added gaiety and sparkle to the whole event, imprinting the message deeply in the minds of the participants.

The opening lines indicate the didactic intent—warning children against walking into forests lest they receive snake bites. The forest harboring dangerous snakes stands for whatever actions adults consider to be harmful to children and against which children are warned. At this level the song, apparently about a natural danger, turns out to be about obedience. The song's message is interesting because it is conveyed through an alliance of vowel harmony, consonance, assonance, rhyme, and tone variation.

Typical of the concerns of Igede children's songs is the teaching of morals needed to prepare children to be useful members of their society. A har-

monious meeting of African and Western ethical codes permeates Igede children's play songs. An example is provided by the following piece:

Onyi-ogwuh gbil' ochiri ga rih
A nwo ka ka
O ti roo kp' ineh le
A nwo ka ka
Ogbene g' ichiri y' oyih rih
Ogbene g' ichiri y' oyih rih
Ogbene kp' abwo k' onu ka
Ichiri y' abi-abi m' ogoh
Ichiri y' abi-abi m' ogoh

An orphan has eaten a cowpea
Please don't kill her
She has already eaten it
Please don't kill her
[But when] Ogbene stole cowpeas to eat
[But when] Ogbene stole cowpeas to eat
Her hand hadn't reached her mouth
[Before] the cowpeas became a bowl of dust
[Before] the cowpeas became a bowl of dust

The central issue here is the difference between the genuine need of the orphan who takes a morsel to survive and the greed of Ogbene. The song urges sympathy and kindness toward the orphan but denies spiritual support to the gluttonous. Igede culture is unequivocal in frowning on theft, and the disappointment that Ogbene suffers when the stolen cowpeas turn to dust provides the lesson that divine vengeance awaits those who steal.

In this performance the children again relied on the power of sound for the song's effects. The gestures of the performers also contributed to the overall impact, and the entire performance was truly dramatic. To make known their approval of the orphan's determination to survive, the children chanted the part of the song dealing with her plight in a solemn, imploring tone. Their leg movements were slow and their faces sober, in order to make their sympathy clear. On the other hand, they took a sarcastic tone toward Ogbene. They stamped their feet vigorously, as if to tell everyone that they were literally trampling to death the object of their attack. This song is a clear example of children's ability to utilize subtle forms of praise and vilification techniques of poetic composition.

Informants, who include housewives with much experience in composing and listening to songs, note that moonlight play situations are occasions when older Igede children invent songs. Because such verse is very popular in the villages, it is in plentiful supply. Here is a typical example:

Leader A: Ugben-ke-jwo
Leader B: Obiri-teh-teh
Leader A: Ugben-ke-jwo
Leader B: Obiri-teh-teh

Chorus A: O-y-ego-kp-ejih
Oy-ete-kp-ejih
O kwur-oko-choh!

Leader A: Ugben-kejwo
Leader B: Obiri-teh-teh
Leader A: Ugben-ke-jwo
Leader B: Obiri-teh-teh

Chorus A: O-y-ego-kp-ejih
Oy-ete-kp-ejih
O kwur-okochoh!

Chorus B: Ongo h' ubwo
Oluhwah a gboo!
Ongo h' ubwo
Oluhwah a gboo!

Leader A: Sandstone
Leader B: Butterfly
Leader A: Sandstone
Leader B: Butterfly

Chorus A: Hit your knees
Hit your head
Fall down

Leader A: Sandstone
Leader B: Butterfly
Leader A: Sandstone

Leader B: Butterfly

Chorus A: Hit your knees
　　　　　 Hit your head
　　　　　 Fall down

Chorus B: Whoever lets go
　　　　　 Will be cursed
　　　　　 Whoever lets go
　　　　　 Will be cursed

The performers of this song were four boys and seven girls, but I was informed that any number of children, from three up, will do; sex is not a consideration. The rules of the game require the players to form a circle. A self-appointed leader commences by singing the first line, and a second leader takes a cue from the first and sings the second line. As all the participants sing the first chorus, they mimic its message; when they move to the second chorus, all the players hold one another's hands firmly in a tug-of-war. They pull so hard that a break occurs in the line. At this point the game is interrupted. If there is more than one break in the line, the participants must help identify the two persons who first broke it, and these squat at the center of the ring. They are joined by the next pair of players, who break the line when the actions are repeated. The game comes to an end as soon as those within the circle outnumber those outside it.

As far as I can tell, this is the Igede children's game that bears the closest resemblance to the *Nao Ayele Awi* (Who Gets Hurt) game that Abarry describes among the Ga. But many mothers claim that they have sung this song in a different context, for example to lull a baby to sleep.[10] During the performance in question, the children's responses show that they, as with their Ga counterparts, stress that "failure in play as in life may not only be disgraceful but also precarious and expensive" (Abarry, "The Role of Play Songs," 212). But, more important, Igede children's performance of this song emphasizes the team-building effort and thus asserts the value of community.

Careful attention to the histrionics of the song's performance style shows how the children conjoin body action and narration to achieve their effect. Drawing deftly on the abundance of alternate tone levels in the Igede language, the voice of leader A mimics the downward falling action of a stone that has been thrown in the air, and leader B captures the pretty, fluttering movements of a butterfly. While the singers of the first line of

chorus A utilize a rising cadence, those of the second line employ a falling cadence. This sets the stage for the ideophone, *O-kwurokochoh*, a descriptive sound that registers the concrete idea of falling down with a heavy impact. The word lends the event a more powerful auditory and visual resonance when the warning of chorus B is sounded. The first "casualties" who begin to squat within the circle are solemn and shame-faced, suggesting they have really been bewitched. The complex interaction between text and gesture makes the game truly entertaining as a communal act.

Igede children help to keep alive the oral culture of their society. They sing about issues that are crucial to their existence, and they thus revitalize the values of the community. Although they learn songs from their parents, they also compose their own fragments of song. Some of their songs are reflective, but they are all performed with a gaiety and exuberance that asserts a love of life and of community. Igede children's play songs are interesting not only because of their entertainment value and the messages they contain, but also for the quality of art they show. Though it may appear on the surface that some songs are popularized by the children merely for linguistic pleasure, they are equally rich in meaning. Watching and listening to Igede children compose and perform leaves no doubt whatsoever that they are a valuable means by which Igede praise and vilification techniques of poetic composition are passed from one generation to another. However, we cannot begin to have anything like a faint idea of the enormous resources involved in the mastery of Igede performing arts until we have looked closely at the careers of individual performers from a personalized perspective.

The Birth of the Singer: Two Notable Examples

Two careers that readily suggest themselves for such close consideration are those of the Adiyah superstar Micah Ichegbeh and the Etuh composer Odeh Igbang, on whose works a substantial portion of this study will be based. We must understand how they became artists in the first place. Both are avid inventors, who command enormous respect both among their peers and among their audiences; their experiences tell us a lot about how the Igede artist finds his or her voice, and in finding it, connects harmoniously with the community.

Although Micah Ichegbeh regards himself as the inheritor of a tradition that had become dormant, he is actually the only Adiyah poet in Igedeland today. His use of the tradition amounts to an invention in the sense that he has given it a unique rhythmic form, a melodic pattern, and

a vocal element that any local audience can promptly recognize. Similarly, he retains the costumes and masks that he inherited from tradition, but the primary stylistic and thematic elements of the Adiyah art form are his own creation.

Ichegbeh's poetic career began during his childhood. His parents were artists; his father was the leader of the Adiyah association in his village, and his mother was its dance queen. Ichegbeh himself learned Adiyah performance by imitating his parents: like his father, he learned to play *Ojeh* (a brass bell that gives a raucous sound when struck), *Icheche* (a calabash covered with a net of beads that make an abrasive noise when beaten), *Ajii* (brass horns), *Okpirih* (small slit-drum), *Ubah* (medium slit-drum), and *Egbong* (large slit-drum). From his mother, he learned to accompany his singing with these instruments, and he learned to dance. He himself explained: "When my parents were performing, everywhere they went, I always went with them, right from my childhood, up to the time when I grew up to be a man and could play some of the instruments, starting with the simple ones. I learnt to play *Ojeh, Icheche, Ajii, Okpirih, Egbong,* and *Ubah*. I can play the instruments as accompaniment to my singing" (interview with Micah Ichegbeh, July 28, 1981).

Ichegbeh's parents were subsistence farmers who performed Adiyah as a pastime, but they did it frequently, often as much as twice a week. His grandfather had been an *Ayid' Ayilo* (a head of Adiyah music); therefore, when Ichegbeh's parents initiated him into the Adiyah tradition, he was merely following what had become a family heritage.

Although his instruction was largely informal, Ichegbeh's interest grew, and he quickly showed that he had a unique, creative talent. In fact, his later performances clearly demonstrate how successfully he combined tradition and individual talent in a single symbiotic whole. He explained: "It [i.e, his place within tradition] is like the making of the Bible . . . when Jesus Christ said in the Book of Matthew chapter 5, verse 17 that he did not come to the world to destroy the rules but that he helps his father. I learned from my father. If I have any vision I only add to further my father's work" (interview with Ichegbeh, July 28, 1981).

The comparison with Christ is instructive; Ichegbeh takes his role as the most important custodian of Igede culture seriously. As far back as 1974, he carried the banner of Igede art to a performance competition in Kaduna, where traditional artists from all over Nigeria had come together. Still relishing his performance in that competition, where he was judged the second-best performer, he declared that "since then, we have been in the business—I and my group. We still have our costumes, what we in-

herited from our ancestors" (interview with Ichegbeh, July 28, 1981). For him, his creative urge is akin to revelation: "I myself, I enjoy what I do. But if any good comes someone's way—say one has a gift of a child, I do celebrate with the parents, or a good house being commissioned. And as no one can hide his or her head from God, if a death occurs I do console the bereaved. It is when my brain opens for me that it [i.e, ideas] flows" (interview with Ichegbeh, July 28, 1981). Under the circumstances, it is perhaps more accurate to speak of improvisation than of strict memorization as a primary method of poetic composition by such oral poets as Micah Ichegbeh. While he usually seems to have a ready song for any event, occasion, or context, Micah Ichegbeh is actually a poet who creates on the spot and only fits his extemporized material into the pattern that is woven by the musical accompaniment to his singing. In this regard, Charles Bird's observation about Mande hunters' method of poetry performance might also be applied to Ichegbeh's work, especially in the light of Bird's remarks that "the essential metrical requirement is that the singer keep in rhythm with his instrumental accompaniment" (Bird, "Heroic Songs," 283). There was no evidence from my observation of Ichegbeh's performance to support Ruth Finnegan's claim that we should also consider "the possibility of prior composition followed by memorization" (Finnegan, *Oral Poetry*, 79)—a claim that has also been called into question by Chukwuma Azuonye.

Perhaps closer to the method of "prior composition followed by memorization" observed by Finnegan is the method employed by the Etuh singer Odeh Igbang. Igbang has composed a lengthy narrative relating the actual circumstances that led him to invent the Etuh song tradition, and this will be given a more detailed treatment in chapter 4; suffice it here that his method of composition and performance is indeed unique. The poet himself puts it as follows: "My vision of the world that inspires my songs is the cry over suffering. I sing one song I use a proverb; I sing another I use a proverb because suffering teaches one a lot. When you go to bed, you know thoughts precede dreams. Your thoughts are your dreams. . . . When I was suffering I would go to bed but peace would elude me. . . . If I dream, I sing from there" (interview with Odeh Igbang, July 9, 1981). Igbang claims that he invented the entire genre in a dream and says dreams have remained his main source of poetic inspiration. When he wakes up from his sleep, he then teaches the other members of the group the choral responses to his songs. The Etuh performance has an electrifying intensity; it is pure spectacle. Etuh appears to be performed in three ways, to each of which rehearsals are basic. The first method is when Igbang en-

gages in a dialogue with his assistant, also a poet in his own right. The master sings a verse and provides material for his companion, who takes off from the last statement of the master. They utilize the initiating drum rhythms. The deep, moody ostinato voice comes to a slur; it is then replaced by another voice: light, low, and piercing, both of which are played by Igbang. The battle of words comes to an abrupt end when the performers' repertoire is depleted. They shift to a combined chorus and are joined by the other members of the group. In the second type, Igbang sings alone in accompaniment of drumming. He uses an ostinato drum note to convey an anguished, chilling message. He suddenly stops the drum entirely and relapses to vocalizations. The supporting instrumentalists and singers, who had hitherto remained still, are called into play. These include players of *Icheche* (basketwork maracas), *Ubah* (membranophone drum), *Ekwure* (horn), *Egbong* (large slit-drum), and *Okpirih* (small slit-drum). The third method is when the group leads with a chorus, which offers the poet the material for his compositions. The Etuh ensemble moves rapidly from one method to the other, and the ease with which its members cross the methodological boundaries outlined above contributes greatly to the overall dramatic effect of their performances.

Odeh Igbang's use of the proverb amounts to an invention in that he was the first—and has so far remained the only—Igede poet who has developed the proverb into fully developed rhetoric. Though the proverb is a conventional idiom of expression in his community, he is the only one who has built whole songs entirely on proverbs; in fact, all his songs consist mainly of an extended web of proverbs. However Igbang's mode of proverbialization constitutes a pattern into which he introduces new elements that he presents in an entirely original manner. In other words, what matters is not the existence of the proverb as a style of communication per se, but the unique use to which Igbang (a talented individual artist) puts selected strings of proverbs. As a rule, he avoids trite, familiar proverbs and creates new, startling ones that he develops in equally unfamiliar contexts. He then fits the strings of proverbs into a musical format with a melodic range that is distinct and recognizably his own. Thus, although proverbial usage is an established form of communication in his community, Etuh represents something entirely new in Igede oral culture. All that came to an abrupt end in 1988, when Igbang was elevated to the status of a chief among his mother's Anyogbeh people and a new chapter was opened in his career; but the significance of Igbang to the Igede performance culture will remain everlasting, for recordings of his performances are now a major part of traditional Igede cultural history.

Translating and Transcribing Praise Songs from an Oral Medium to a Written One

A student of Igede oral literature encounters a daunting task in attempting to recreate a live sense of Igede song performances in print. The composers are volatile performers, whose voices, body movements, gestures, and rapport with the audience are better heard and seen. What is therefore offered here is only as close an approximation of the original as one could manage under the circumstances. During my fieldwork I had a number of recording sessions with the singers, and I periodically discussed their work with many knowledgeable people in Igedeland (including elders and other performing artists). Igede belongs to what has been described as the "Kwa language family" (see R. G. Armstrong, "The Idoma-speaking Peoples"). As such, it is a highly rhythmic language. In each translation, I have relied on the orthography of the working dialect of each of the composers, and I have taken the verse line to represent the breath pauses that I hear when the singer breaks to take in audible air. Often, these breaks are indicated by the "ooh!/eeh!" exclamation signs. The elliptical markers in my transcriptions also reflect an orthography that strives to capture the many contractions of vowel sounds as they are heard from the singers trying to make their way through the rhythms of the Igede language. Where the circumstance has made it necessary for the composer to supply the title of a composition, I have reflected this in my transcription and translation as well; in all other situations, the first verse line can be taken as the title of the piece.

While the search for direct English equivalents of the Igede vocabulary was a tiring one, I have adopted a word-by-word, nearly literal translation. Although I am convinced that intercultural translation from Igede into English is possible, my transcriptions and translations are tentative, and I look forward to a more meaningful work in this direction in the future.

Classifying the Song Tradition: Issues and Procedures

The usual division of African performers into praise singers, epic poets, social critics, and dirge singers does not always do justice to such performers as Ichegbeh, Igbang, and the other Igede oral artists discussed in this book because their method of composition and performance cuts across generic boundaries. Nevertheless, several distinct genres are evident in their work. In fact, the issue of categorizing the Igede song genre must be seen in the context of the problem of classification in the study of African oral literature. With regard to this question two broad lines of argument are nor-

mally followed: (a) the argument of those who accept Dan Ben-Amos's insistence that typologization must respect the perceptions of the communities in which the oral literature is performed, because "genres are distinct modes of communication in the lore of a people" (Ben-Amos, *American Folklore Society,* xxxi; see also Babalola, *The Content and Form*); or (b) the argument of such scholars as Isidore Okpewho who warns that we "must be careful of what use we make of the claims of our informants [as] their generic values are not exactly interchangeable with the kind of analytical systems we are trying to build" (Okpewho, "Rethinking Myth," 11).

Broaching the subject in an essay on Akan *Apae* praise poetry, Kwesi Yankah has argued that the interchangeable use of such labels as praise poetry, panegyric, heroic poetry, and eulogy is itself a commentary on the difficulty faced by researchers in their attempts to find an "appropriate label, as an analytical megagenre that embraces all forms of poetry in which praise names constitute a key structural feature" (Yankah, "To Praise or Not to Praise," 381). Nevertheless, Yankah continues to use the tag "praise poetry." Despite acknowledged "instances of deviance," he believes that praise remains the dominant issue in the poetry that places "primary emphasis [on] the use of appellation" (Yankah, "To Praise or Not to Praise," 382). I have adopted a similar view of the matter in my description of Igede songs. My fieldwork as a student of folklore from 1981 to 1991 has covered many aspects of Igede oral art, including proverbs, oral narratives, oral epics, dirges, and incantations, but I focus attention in this study on praise songs and vilification songs because I believe they are the most vibrant and the most misunderstood of the Igede oral artistic inventions.

ONE

The Dialectics of Satire
Form and Content Interaction in Vilification Songs

In this chapter, I will demonstrate that an understanding of the concept of vilification is indispensable to any effort to grasp the full meaning of praise. Praise will be meaningless if its opposite—abusive expression—did not exist because the dignity of praise gains stature primarily in relation to the existence of a contrasting state of inelegance or degradation. Put differently, a good understanding of the concept of vilification will enhance greatly the full significance of praise, for the heart of the matter is that it is only by comparison with that which is the direct reversal of praise that the eminence of praise can be enlarged. Even more than the other methods of social control—such as banishment or social ostracism, fines or levies, and even execution—lampoons are very effective in checking conduct in traditional societies; among the various attempts to explain why the use of vilification is commonly effective among unlettered peoples, perhaps Donatus Nwoga's is the most satisfactory.

Emphasizing the edifying function of satire, Nwoga argues that rural communities employ satire in particularly effective ways to check the conduct of their members because of the face-to-face nature of social interactions that are typically conducted in such places. People here live in close-knit environments, he observes, and everyone knows everyone else; no one wants to be the object of gossip or ridicule among his or her neighbors. He explains: "Homogeneous, kindred societies depended on the sense of full human dignity being shared by all members. To find oneself regarded as in any way below the standard, to become the object of ridicule, or of children pointing fingers at one and sniggering, was punishment of a great dimension. Satire was the verbal equivalent of actions like tying a stolen object around the neck of the thief and parading him through the village" (Nwoga, "The Igbo Poet and Satire," 162). As Nwoga notes in the

same essay, because of the stability of norms or standards of behavior in the traditional settings, satire works through the "spirit," forcing the culprit to "fight an internal battle with him[self]" and forcing him to "spend sleepless nights worrying about himself. Shame and scorn and amusement for others would prevent his free movement in the town for some time" (Nwoga, "The Igbo Poet and Satire," 162).

Vilification songs find their most frequent occurrence among the Igede for just the reason outlined by Nwoga: Igede is a close-knit society that places primacy on high ethical conduct. The Igede were described by A. Frampton in 1935 as being both morally and intellectually superior to any of their neighbors in the Benue trough. Frampton specifically praises the Igede's strict attitude toward sex; indeed on the basis primarily of more relaxed sexual behavior among the Ito (the Igede group who are Idoma's closest Igede neighbors) he had concluded that the Ito are of Idoma origin and not originally of Igede stock (Frampton, "Intelligence Report").

The Igede employ satire in songs for very fundamental instructional purposes: to teach the virtues of sexual purity, to frown upon incest, adultery, fornication, and early or premature sexual knowledge, even to discourage excesses in political action, or any form of irresponsibility in general. The restrained sexual behavior observed by Frampton in central Igedeland more than five decades ago has not changed drastically. While it would seem ironic that many oral artists in Igedeland attempt to safeguard sexual innocence through lighthearted erotic songs with language that often borders on pure pornography—a device that appears on the surface to contravene those values—actual efficacy of this method of moral education has been confirmed. This success might not be unconnected with the way satire works in concert with praise.

Among the performances that I attended, vilification elicited direct communication among Igede people not only because the language was shared widely, but also because the melody was appealing; incipient praise established an enviable standard toward the attainment of which everyone was urged to aspire. All the stirring songs that I discuss in this chapter had great impact on their audiences. They were performed by poets who had won well-deserved recognition for their sharp wit, image-laden language, captivating singing voices, and agile dance steps in their respective communities. The Adiyah group performed on July 25, 1981 at a drinking pub in Onyike Market, and then at my cousin's house at my invitation on July 27 at Barracks (Anyuwogbu); the Etuh performance took place at Odeh Igbang's village of Adum-Owo three days later. The *Ihih* songs were obtained from their composers Mrs. Ogwugwu and Mrs. Ode, each of whom sang alone. While each of the performances by the Adiyah and

Etuh ensembles typically attracted audiences of nearly a hundred people, fewer people were brought together to watch the Ihih performances.

The enchantment created by one of Ichegbeh's songs, entitled *Ojeh nyam j' Atang Ka* (My Bicycle Has No Bells) derives largely from the poet's deft use of the defective object of the song's title as a symbol of an undisciplined male genital organ. The song shows clearly how criticism gains effect even by the presence of latent elements of praise. Let us look at the full text of the song.

Ojeh nyam j' Atang Ka

Ichegbeh: Ojeh j' atang ka, anu pee
 Ojeh nyam am Ochonye j' ibireki ka
 Anu pee h' ugbeyi ooh!
Chorus: Ojeh j' ibireki ka, anu pee
 Ojeh ny' Okwute Oibe j' ibireki k' anu pee! 5
 Chorus: [repeat refrain]
Ichegbeh: Ongo r' iyoh enenu le, iwoh hoo
 Enu m' enu k' onginy' a r' iyoh enenu l'
 Iwoh hoo piko-piko
Chorus: [repeat refrain] 10
Ichegbeh: Onyang a mow' ogb' enenu le, iwoh hoo
 Enu m' enu k' onyang a mow' ogbe enenu le
 Iwoh ny' ogbe hoo piko-piko le!
Chorus: [repeat refrain]
Ichegbeh: Ongo mw' imwoh enenu le, iwoh hoo 15
 Enu mi-enu k' ony' oleng mw' imwoh enenu le
 Iwoh ny' imwoh ho piko-piko le
Chorus: [repeat refrain]
Ichegbeh: Ongo r' iyoh enenu l' iwoh hoo
 Itilo-oligw' am r' iyoh enenu le, iwoh hoo lume. 20
 Ojeh j' ibireki ka, anu pee
 Oje ny Okwute Oibe j' ibireki ka, anu pee h' ugbeyi
 Iyeh eeh, Ongo r' iyoh enenu le, iwoh hoo!
 Iyeh eeh, Ongo mw' imwoh enenu le, iwoh hoo!
 Iyeh eeh, Ongo r' iyoh enenu le, iwoh hoo! 25

My Bicycle Has No Bells

Ichegbeh: The cycle has no bell, you better give way
 My poor self's cycle has no brakes
 You people give way, please!

Chorus: The cycle has no brakes, you people give way
Mr. Oibe's cycle has no brakes, you people give way!
Chorus: [repeat refrain]
Ichegbeh: A person who eats meat daily, hungers for more
and more of it
Whenever a person eats meat daily,
The hunger for meat disturbs him ruthlessly
Chorus: [repeat refrain]
Ichegbeh: If a woman fucks the penis daily, she hungers more
and more for it
Whenever a woman fucks penis daily,
The hunger for penis disturbs her ruthlessly!
Chorus: [repeat refrain]
Ichegbeh: A person who fucks the vagina daily will perpetually
hunger for more of it
Whenever son of man fucks the vagina daily,
The hunger for vagina will disturb him ruthlessly!
Chorus: [repeat refrain]
Ichegbeh: A person who eats meat daily hungers for more
and more of it
My friend the tailor eats meat daily, the hunger
for meat disturbs him ruthlessly
My cycle has no brakes, people give way,
Mr. Oibe's cycle has no brakes, people give way,
Yes, surely a person who eats meat daily, hungers
for more and more of it
Yes, surely a person who fucks vagina daily, hungers
for more and more of it
Alas, a person who eats meat daily hungers for more
and more of it

This song makes an effective attempt to offer praise for such virtues as decency, moderation, and self-control through an attack on those patterns of conduct that deny self-control: sexual promiscuity and greed. Though the language has a lighthearted touch, the criticism is biting.

Reviewing many similar instances of "sexuality" as a device by which various oral artists from Yugoslavia, the Gambia, and Nigeria create "saucy humor"—and with which they keep their audiences exploding with "constant laughter" while they digest topics of serious import—Isidore Okpewho has said that the bards have popularized such a device for reasons that lie deep in the personality of the artists: "The sexual touch may be

due in part to the character of the bard himself; many studies of bards have revealed that they are frequently known to be fun-loving men" (Okpewho, *The Epic in Africa*, 203–4). The comment also holds true for Micah Ichegbeh who, as I was informed, is a hard drinker, a smoker, and an incurable chaser of women. So, in a sense, the performance can be seen legitimately as an expression of Ichegbeh's deep-seated subconscious indulgences from which he might be seeking escape.[1]

In this context, the experience of Ichegbeh is instructive, for it does say something about the tensions that attend human society—the conflict between the human desire for decency and purity and the propensity for indecency and crime. Ichegbeh demonstrates clearly that an artist, who exhibits in his own life the worst of indiscipline might, paradoxically, yet be able to use his art to champion decency. Interestingly, while Ichegbeh himself may be guilty of the weaknesses that he exposes, he used his public's common negative assumptions about these indulgences to campaign against the vices in his song. The significance of the image of the bicycle used in the song derives from the fact that up to the time of this research in the 1980s bicycles were still the most common form of transportation in the community. Because bicycles were needed to move people and their farm products from one market or location to another through the numerous narrow footpaths that link up Igede's villages, there was hardly a home where a bicycle could not be found. It was common knowledge that each new bicycle came from the manufacturer equipped with a bell and a braking system in good working order.

In the everyday usage of Igede, the idea of *Ojeh oj' atang ka*, or *Ojeh oj' ibireki ka*—that is a bicycle that does not have a bell or a good braking system—will be automatically understood as being a figurative speech alluding to major personality defects. It is in this sense that *Ojeh oj' atang ka* and *Ojeh oj'ibireki ka* equate nicely with the concept of a man with a restless genital organ. The expressions connote sexual promiscuity. Because Igede people practice high moral principles regarding sexual behavior, such a character would be regarded as the most loathsome creature, a beast that is not fit for life in human society. The song ridicules and parodies this monstrous creature while indirectly holding to high praise the alternative mode of behavior.

Among the taboos of the Igede people that a sexually undisciplined figure might represent, the most serious are incest, adultery, and prostitution. The song attacks these taboos indirectly through its negative depiction of sexual laxity because of the violence, anarchy, insecurity, and general unrest that the taboos usually generate. Still, another indulgence discouraged for the same reasons is that of the excessive consumption of

meat. Meat is very expensive; this explains why the Igede social group by consent view it with suspicion, as it can easily lead to such crimes as theft and prostitution. In the background is an endorsement of peace, order, security, and stability—states that are best obtained through self-discipline, abstinence, moral restraint, and decency. The delivery of this song shows how oral performers exploit latent praise and vilification as effective methods of composition. By fusing satire and praise with resonant force, the singers heighten their audience's repugnance for those appetites that negate the objectives they are promoting, and the singers make the audience aware that the goals they are promoting are attainable.

Praise is also hidden, though it is no less effective, in another song, *Akpara ny' Anyang* (Women's Prostitution), in which the Adiyah ensemble not only traces the origin of prostitution in society to women but also holds the same group responsible for the persistence of that indecent profession. The following motifs are involved: the action of the woman whose approval is needed to grant a man entrance is an analog for the cock's undoing of himself, and both show the inability to resist an enemy's ploy. In the background is the singer's homage to respectability and vision. The image of grinding stone suggests how difficult it is for the enemy to get at a target without assistance from the target itself. The practice of grinding is so noisy that it cannot be done in secret or without the approval of the owner of the stone. So is sex an intimate relationship that cannot be stolen, ordinarily. By this image the singer makes the members of the audience see the mental picture of the first act when a man mounts a woman as vividly as the picture of a woman that they see and hear daily grinding food. But because the singer underplays the crimes of passion, such as rape, committed by men against women, it is evident that what he has in mind is an ideal situation. Indeed, the reference to the weak man moving about peacefully with his treasures in a bag dangling from his shoulders underscores the idealistic perspective from which the poet diagnoses society's problems. Though the spirit of the song is oblivious of such crimes as theft, armed robbery, thuggery, and so on, which daily threaten the peace of contemporary society, it is an engaging performance.[2] The text is presented thus:

Akpara ny' Anyang

Ama l' ito m ka t' onu woh
Ama l' ito m ka t' onu woh:
O' ti j' omwu ny' uya h' anyang?
M l' ito m ka t' onu woh,

Anu k' uru me k' anu woh 5
O' ti j' omwu ny' uya h' anyang?
Ilah! enwa, eyeh!
Anyang a j' omwu ny' uya h' ilawa le
Anyang a j' omwu ny' uya h' ilawa le
Oduduh r' ye kee, kuru k' anu ka woh 10
Uka ny' ogbanye-ogbanye, uka ny' ogbanye-ogbanye
Eka ch' ehi ka y' ube ny' unu
Eka r' unye k' o da bih
Uka ny' ogbanye-ogbanye
Eka ch' ehi ka y' ube ny' unu 15
Eka r' unye k' o da biih
Unu-unu ma ti duh!
Unu l' ilomu a ti d' al' iwee!
Unu b' eka yekee:
Ube ny' owa ny' g' omila gbuuh oduh inyi 20
Nyi ka je wuh onginyi r' mi ka!
Orih k' ahu nyi d' iw' ahu nyi
Kp' ubwo ka m o o yee
Eka kp' ubwo ka m' ube ny' unu yee
Ube ye meneh-meneh, ube ye meneh-meneh! 25
Duh k' eka kp' ubwo ka m' ube ny' unu ye
Ube ye meneh-meneh
Enu-utur' oowa, enu-uturu oowa,
Eka gba pwura ka ka w' unu!
Enu-utur' oowa, enu-utur' o o wa, 30
Eka gba pwuru ka ka w' unu!
Onwu mi-onwu je yekee
Onwu mi-onwu je yekee
Ori k' oligoh mi ka
Olijah ka goh mi ka 35
Olihye pile-ibang ka
Olihy' a pile-ibang ka?
Olihy' a pile-ibang ka?
Du ka any-anyang a kp' ogene-ogene mw'ahi ny' Ogene le
I kp' ogene-ogene mw' ahi ny' ogene 40

Women's Prostitution

I have a question to ask you
I have a question to ask you:
Who initiated prostitution for women?
I have a question to ask,
Listen and hear: 5
Who started prostitution for women?
Alas! my dear,
Women initiated prostitution for themselves!
Women started prostitution for themselves
The reason is, listen and hear: 10
In the beginning, in the beginning,
When the Cat saw the Cock's comb
The Cat took to flight
In the beginning, in the beginning,
When the Cat saw the Cock's comb 15
The Cat took to flight
The Cock himself is the cause!
The Cock himself caused it all!
The Cock informed the Cat
"This comb of mine may be frightfully reddish, 20
But it cannot hurt."
That if in doubt,
"You should bring your hand and test it."
So Cat tried it out!
The comb was found to be soft and malleable! 25
Which is why Cat tries out Cock's comb
The comb proves to be soft and malleable!
On that day, on that day,
The Cat swiftly caught the Cock!
On that day, on that day, 30
The Cat swiftly caught the Cock!
As everyone knows
As everyone knows,
If the owner of grinding stone does not offer approval
The grinder cannot grind his material 35
Does not a lazy person hang his bag?
Does not a lazy person hang his bag?
Does not a lazy person hang his bag?

> Which is why women carry their pleasure in search of (another)
> pleasure
> They carry their pleasure in search of [another] pleasure 40

Akpara Ny' Anyang (Women's Prostitution) opens with a question-and-answer form of the riddle. If we see the song only as a suppression of female sexuality, we get the poet wrong entirely. Rather, the whole song, on a deeper level of meaning, is an instance of political carping, using sexual symbolism. The actions of the cock (and by extension, the virgin, or the cat) are analogies for any wrong political actions one takes that might allow the enemy to gain penetration into one's territory through a personal weakness shown to the enemy by oneself. The song's stress on the perfect model of behavior works indirectly through its denunciation of corruption. Once again, it is evident that the creation of communal harmony is the object of the song, for the denunciation of destructive personal tendencies is tied to the idea of how people can use decency to build a society where trust and intimacy prevail.

This emphasis on the ideal is evident in another song, *Anyang A likpa* (Women Age-Mates), where the poet tries to present the state of eternal innocence as the most desirable norm. This song's uniqueness lies in its attempts to prohibit early sexual knowledge among girls by raising unpleasant and terrifying pictures of the aftermath: unexpected aging and physical or bodily deterioration that come with pregnancy and childbirth. Couched in an imaginary dialogue between a virgin and a mother, the song depicts the taunts by a virgin of a bloated pregnant woman. Because the virgin's boasts eventually come to nothing when she herself becomes distorted by experience of sex, this song might appear on the surface to present a despairing vision of life. The image of the virgin ultimately violated literally conjures a creeping sense of the inescapability of decadence. Yet these images are the song's means of serving a warning that innocence must be preserved by determination, corruption should not signify the inherent debasement of the mother; it merely evidences acceptance of self-destructive habits. The poet's use of a mocking and sarcastic tone during the performance of this song was intended to put the innocent ones on guard, to make them realize that their state of innocence is a status that can be lost. The song cautions against carelessness, in the interest of self-preservation.

Note the particular effect of the imagery of the cooking pot. It derives its impact from the use of firewood as the only fuel for cooking food in a rural setting like Igede. The song evokes a highly visual scene in which a

brand new and shiny aluminum pot is suddenly covered all over with thick, black soot.

 Anyang A likpa

 Ech' onyeweh t' onyogo ela woh ye kee
 I ye ti hong
 Iye ti hong
 Ka l' ibirih iwee?
 Onyogoh w' onyeweh ela ye ye kee 5
 Onyogoh w' onyeweh ela ye ye kee
 Ela k' o lam ja ka lang
 Ela k' o lam ja ka lang
 Ela k' o lam ja ka lang ijwujwuh!
 Ela k' o lam ja ka lang ijwujwuh! 10
 En' uturu gw' en' uturu ka
 Inepwa hw' onyeweh t' ilah
 Inepwa hw' onyeweh t' ilah
 Onyweh ch' obirih l' onyogoh
 Onyogoh ch' obirih l' onyeweh 15
 Onyogoh ch' obirih l' onyeweh
 Onyeweh ch' obirih l' onyogoh
 Inyinyi am Imaika Ichegbeh aye wee,
 Anyang i kp' ame da do do do
 Iwaa r' alogwuh alogwuh eeh 20
 Iwaa r' alogwuh alogwuh
 I j' anjwoh dati h' igbahi ka
 Iwa r' alogwuh-alogwu-alogwuh eeh!
 Iwa r' alogwuh-alogwuh!
 Iwa r' alogwuh-alogwuh! 25

 Women Age-Mates

 The new pot asked the old:
 "What is the matter with you
 You are so black?
 What is the matter with you,
 You are so black?" 5
 The old answered the new saying
 Answered the new saying

> "The thing which happened to me
> Will ultimately happen to you!
> The thing which happened to me 10
> Will happen to you tomorrow!"
> It does not take too many days
> The woman of the house put the new on the fire.
> The woman of the house put the new on the fire
> The old is as black as the new! 15
> The old is as black as the new,
> The new is as black as the old,
> For this reason, I Micah Ichegbeh say,
> Similarly, all the women with sagged breasts
> Are age-mates, they are all age-mates! 20
> You do not know the young to be different from old.
> My sisters with sagged breasts
> They are all age-mates!
> They are all age-mates, alas!
> They are all age-mates, alas! 25

In this song can be discerned an effective use of vilification techniques in alliance with the extended metaphor to depict a graphic picture of the horror of sexual corruption. The song's impact was so immediate that it elicited much laughter and ululation from a good number of the female members of the audience. From this segment occasionally came such comments as *Ilah inyi* (It's fire!). When asked to explain why they referred to the sexual act as a "fire," a number of these women responded sarcastically that it was not the nature of things that men, such as the researcher, could ever know the pain of labor or childbirth! In a society like Igede, where the practice of contraception is almost unknown, it was entirely appropriate that the sexual act should be inevitably linked with pregnancy and the resultant pain of labor. It is in this context that "the woman of the house" who "put the new pot on the fire" becomes an apt metaphor to describe the act of seduction of women by men. Inherent in the idea of "the sagged breasts" of course is the equally tiresome practice of breastfeeding a baby. The effect of this song is to highlight a wider dimension of all the consequences of illicit (or premature) sexual knowledge than that handled in the two previous songs. It attempts to neutralize men's seductive tactics by deprecating them, empowering young women to put moral strength into their lives in order not to be taken in by the deception. And it reinforces the viewpoint, expressed powerfully in the preceding song,

Akpara Ny' Anyang (Women's Prostitution), that women have their destiny in their own hands—to make or break; consequently, women should accept the blame should they choose to bring about their own doom.

Examples such as this abound in the songs of a satirical temper. Many of these songs utilize moral exhortations within the framework of gender differentiation. Although the values articulated are ultimately communal, transcending gender, the distinction along gender lines reflects the peculiarity of the problems men and women face in real life. One common problem faced by both sexes—marital harmony—may take different forms for men and women. *Onyang Onyobi* (Evil Woman) is a recipe for a harmonious relationship between women and men, a husband and a wife. But it approaches the issue from the male perspective, depicting women as their own worst enemies, as objects men too often find impossible to deal with. As the song's message conveys, the earlier women become aware of their situation, the better for everyone. The song was performed to great audience applause by Odeh Igbang's Etuh at a social gathering in Adum-Owo. It derives its impact from the shifting array of vilification images with which it presents a wife whose bad attitude ostensibly becomes cause for great concern to her husband.

Onyang Onyobih

O tumuh ny' ela ti kpa la l' onyogoh!
O tumuh ny' ela kpa la l' onyogoh!
O tumuh ny' ela ti kpa la l' onyogoh!
M j' odeheh ka la ile
M ka j' epwu ka 5
M j' odeheh ka l' ile
M ka j' epwu ka
Olujoh tom
Ahu nyam onyila onyila,
M be m ka h' una ny' ela 10
A y' am i nyi b' uwe
M g' ijuh ka ka gw' ejih!
A y' am nyi b' oho me, ooh!
A y' am nyi b' oho me, ooh!
M y' ohiri-iwoh hang ooh! 15
A y' am i nyi b' enyi-ohyohyoh
M y' uchah-onyoru hang!
Iwaa wuuh nwang ka

A r' unye ka ka da bih!
Ar' unye ka ka da bih! 20
A r' unye ka ka da bih!
Hah, hah!
Oho-onene ha gw' ono-limi
Oho-onene ha gw' ono-limi
Ahu nyam, m' oho-onene ha gw' ono-limi 25
Ma ti je ne ka
Oka ching kilomih!
Oka ching kilomih!

Evil Woman

The matter is indeed following the way of the past!
The matter is following the way of the past!
The matter is indeed following the way of the past!
If I knew the world would be as it is
I would not have reincarnated 5
If l knew the world would be as it is
I would not have reincarnated.
I am grieved!
My pretty, pretty wife,
Can I cope with intricate ways! 10
You asked me to provide foofoo
I brought yams down!
You asked me to provide the soup,
That I should provide the soup
I gave you a naira! 15
You asked me to provide a bath
I gave you a scented toilet soap!
All these do not satisfy you
You ran to an unknown destination
You ran to an unknown destination 20
You ran to an unknown destination
Hah hah!
Having some soup to drink is better than starving
Having some soup to drink is better than starving
My wife, licking the soup is better than starving 25
If you do not drink with care
It will irritate your throat!
It will irritate your throat!

The song powerfully conveys the controlled anger of a certain man in the face of severe provocation. It illustrates the effects that can be gained through a satiric mode of composition that employs a language saturated with homely imagery. Despite the fact that his wife's irresponsibility is the source of discord in their matrimonial life, rather than delivering to hellfire and brimstone in punishment for her obnoxious actions, the man is ready to approach her with forgiveness. The expression *Otumuh ny' ela ti kpa la l' onyogoh* (The matter is indeed following the ways of the past) registers the man's sense of despair as he helplessly watches the breakup of his home. Repeated with variation (lines 1–3), the terminology underscores the depth of the frustration of the singer, whose intention is to force a change of heart in a woman he loves dearly. Disappointed by what he believes to be the repeated unsuccessful attempts that he has made to cool the tempers of the woman so that she could be tied down within their matrimonial fold, the protagonist of the song enumerates all the items that he has endeavored to procure for her satisfaction, including the yam (a king of crops among the Igede), cash, and scented soap. In this context, it is helpful to know that the true value of these objects transcends their literal meaning and resides in their symbolic representations.

For example, every Igede person knows that even though the yam is the staple food crop in the society, only the very rich can eat yams all year round because the yam is highly perishable and difficult to preserve. Similarly Igede people know that cash is scarce in their community, for the people are farmers predominantly engaged in subsistence agriculture. And finally in the society in which prostitutes are well known for the easy access they have to cash, "prostitute" is synonymous with scented soap, which they not only can buy freely but must use to enhance their continued attractiveness to the men.

Thus, within the symbolic system recognized by the Igede people, yams, money, and scented soap are associated—in different lights—with status. The singer means, therefore, that within his means he provided no less than the best material comfort for his wife; but she found the glamorous life outside wedlock more attractive. When he ends the song with the proverb *Oho-onene ha gw' ono-limi* (Having some soup to drink is better than starving), he is serving a warning to the woman that marriage might provide meager material comforts, but it offers greater security than prostitution. The use of unflattering images in reference to the wife was therefore part of the husband's conscious effort to reform his beloved one. This compact song is an example of how a good use of satire can assist in achieving moral reform. What gives the terse song its impact is the latent presence of a notion of beauty that is suggested by the idea of the happiness

that restraint in personal life can create. Impact is found also in the notion of stability, which the institution of marriage can provide, opposed to the self-destruction, unhappiness, and uncertainty that inevitably result when women allow greed and prostitution to take over their lives.

If the foregoing discussion leaves the impression that there are no vilification songs addressed to men in Igede, that is not an accurate impression. The process of reformation through vilification targeted at men abounds in plenty, and it is observable in the song *Am' ar' Egena-Ony-Ode ka* (I Am Not Egena, Child of Ode). The rendition of this piece was performed by the Adiyah ensemble first at my cousin's home at Barracks on July 25, 1981, and also at the village of Igori on November 26, 1991. On both occasions the singers enact a pathetic story. In the song, Egena Ode finds that he has fallen into a life of alcoholic addiction. The main incident relates the events that led him to literally smoke a naira bill (naira is the Nigerian currency). The song is presented from a communal perspective, and the anonymous speaking voice uses Egena's story of avoidable waste to effectively warn others against the danger and waste that inevitably follow when individuals fall into a life devoid of self-discipline.[3]

> Am' a r' Egena-ony-Ode k' oh!
> Am' a r' Egena-ony-Ode k' oh!
> Egena-ony-Ode k' h' inaira nw' echu l' oduh!
> Am' a r' Egenaa-ony-Ode k' oh!
> Am' a r' Egena-ony-Ode k' oh!
> Egena ony-Ode hw' inaira nw' echu l' oduh le oh!

> I am not Egena, the child of Ode
> I am not Egena, the child of Ode
> Egena, the child of Ode who smoked up a naira bill in the darkness of night
> I am not Egena, the child of Ode
> Egena, the child of Ode has smoked up a naira in the darkness of night

In this evocative story, the performer gets his point across to the audience with the greatest economy because all the details of the incident were already well known to the members of the audience. Perhaps the most remarkable feature of the song is the fact that the issue of alcohol is not mentioned directly. The idea of alcohol addiction—though implicit—nevertheless, successfully connotes a larger notion of irresponsibility and waste because the members of the audience live in a close-knit rural commu-

nity where gossip and rumor-mongering are the order of the day, and where everyone knows the facts of his or her neighbors' public and private lives.

As this popular story goes, Egena is a man with an insatiable thirst for alcohol. One of the eternal frequenters to the Onyike Market (known for its rich supply of strong alcoholic beverages), Egena has the ugly habit of always returning late from the market after spending too much time at *Udaah*, the store where the *oburukwutu* (locally brewed liquor) is sold; he stays until the last drop has been bought and consumed. Whenever it is the Onyike market day, Egena will always be late for dinner. One fateful night, Egena returns so typically late that he finds no one at home to serve his dinner, his family having retired early to bed.

Though Egena decides to go to bed on an empty stomach, he is unable to find sleep. Ravaged by hunger throughout night, he attempts unsuccessfully to suppress the hunger by endlessly smoking one wrap of *otabah* after another (otabah is the fresh leaves of tobacco that smokers in the community wrap up in pieces of plain sheets of paper). It is not until day breaks that Egena finally finds out to his great distress that one of the ordinary pieces of paper he used for wrapping his tobacco during the night was, in fact, a naira bill. Consumed by anger at his own unprecedented act of folly, Egena becomes literally insane. He runs into his compound and lets out a loud cry that alerts numerous neighbors to the scene. All efforts, however, fail to console him because it is too late to save his money.

Running through the song is a strong moral undercurrent, which is pushed by apt uses of vilification techniques. The song's hidden message is that individual indulgences such as alcoholism and smoking are harmful enough—when combined they are fatal. This song is a success in an important aesthetic sense, for it shows how vilification, applied through the anecdotal form, can help singers convey the dangers of two vices (drinking and smoking) simultaneously. The song gathers public opinion in favor of responsible living among the menfolk in general by warning the community against the pattern of living such people as Egena fashion for themselves—a pattern that unavoidably led to his senseless act of waste and self-inflicted suffering.

For their part, Igede women who compose and sing vilification songs from the woman's point of view tell a story different from that of the men about many of the issues that are central to women's lives. They are asking and seeking answers to such questions as: What does being a woman entail in such a poverty-stricken society as their own? (Igede women not

only must till the land and weed the crops alongside the men, they must return home daily to fetch the firewood and the water with which they alone cook for the family, and for one half of the year, they must provide all the food needed to feed the entire family; these duties are in addition to their roles as mothers). Their answers are deep, searching, and profound, bringing out pictures of the pain that typifies their lives.

One such singer is a housewife named Christiana Edugbeke Ode from the Uchenyim village of the Ibilla clan, who sang numerous songs for me during my research. Sitting on a hard bench in her hut after dinner, Christiana, who was surrounded by her five children—a boy and five girls—burst into a solo performance. Her audience comprised myself, her own children, her two co-wives' children, and the crowd of other children from the neighborhood who were attracted by her captivating melodies. Her husband was relaxing on an *ugadah*—a very comfortable traditional Igede sofa made of a long woven cloth tied at both ends to wooden legs—in the otherwise sparsely furnished family main hut located within hearing distance of each of his three wives' huts. The children provided the chorus, but there was no instrumental support for her singing. I present the full transcript and my translation of one of her songs.

A Pwam Ka

Anu ba l' omony' ino, oh!
Ino m' am hwang ka ka rw' oru wee
M j' abwo je k' am ho ho ka ka, oh
M' am kp' udu ka ka le
M'am r' oloru ri ka ka, oh! 5
Am ochonye!
Am onyodoh Omujah,
Am onyodoh Omagijah, o kiliyah ogboh j' abwo:
Odoh o nw' anyang i l' enyi
Duh k' anyigbang legbeh-ame mi 10
H' ejih Owo
Oru nyam a pwam t' akamah ka ka

Chorus: Oru nyam a pwam t' akamah ka
A y' ubwo d' akamah tam mee
A y' ubwo d' akamah tam 15
Oloh ny' ubwo d' akama tam mee
Iloh ny' akamah lume
A y' ubwo d' akamah tam mee

Don't Divorce Me!

People, your attention, everyone!
Indeed, I elected to marry!
I don't know what wrong I have done
But I am not rich
So I'm not one of the married; 5
Poor me!
Daughter of Odoh Omijah,
Daughter of Odoh the great,
Who channeled all feat into his hands;
Odoh that killed the pregnant women
And caused the firm-breasted ones 10
To be scarce in Owoland!
My husband, do not divorce me because of hardship

Chorus: My husband, do not divorce me because of hardship
You lend a hand and lift the hardship with me
You lend a hand and carry the burden with me 15
Help me carry the ponderous burden
The weight of the burden is enormous
You lend a hand and carry the hardship with me.

The song is a saga, tracing the fortunes of one individual woman whose plight may also be archetypal, representing that of all women who view themselves as victims of male harassment. The song shows the great effects that come with the twining of praise and vilification. The song's opening, in which the singer presents herself as a self-respecting young woman is obviously a good instance of self-praise. But the tone is devoid of celebration, for, though she had obediently followed the injunction to seek life's ultimate fulfillment in marriage (according to the Igede tradition), she eventually was disappointed. Implicit in her statement *Ino, m' am a hwang ka ka rw' oru wee* (Indeed, I elected to marry) is the woman's exasperated regret over the great hope she had nursed as a young girl that marriage will not only be peaceful, it will be eventful. To make life prosperous, she gave her husband all she had, but poverty came between them and caused the original passion that united them to evaporate.

Christiana's struggle with her fate takes on a renewed recourse to the use of memory, and she relies on traditional praise epithets. With these, she traces her noble ancestry through a line of warriors, using her nostalgic, celebratory language to capture her longing for the way of life in which

she was nurtured during her childhood. Memory empowers her appropriately to deal with the harsh present; thus, rather than seek an escape from an improvident marriage, she makes an attempt to persuade the man to change his irresponsible manners. And although the singer's effort to redefine power and to abrogate the structures that ensure men's domination of women yields no obvious result in the song, her act of singing in itself signals the recovery of the female voice—a challenge to patriarchal authority whose project assumes fuller stridency in the songs of another housewife, O'loju Ogwugwu.

O'loju, whose husband, Ogwugwu, (the target of attack in her song) died exactly three years later, had mothered eight children, only three of whom were among the living at the time this recording was made (July 4, 1981). All the children, I was informed, had died before any one of them was five. O'loju herself, then probably in her early sixties, was not only very bitter but in poor health. Her misery and infirmity were aggravated by the fact that her husband was a very lazy person who shunned farming and thus pushed on to his wife the responsibility of feeding the family. Her song, which attacks this arrangement whereby the woman is made to slave for her husband, holds up men's laziness, irresponsibility, and callousness as the main causes of marital crises. On the other hand, she generously pays tribute to her daughter Ongaji for the help she renders in supporting the family. Sure enough the rare instance of praise is particularly effective: is it not indeed a wonder that Ongaji, a mere child, has voluntarily and gallantly accepted to take up the responsibilities of others, while Ogwugwu, an adult, who calls himself a husband and father, runs away from his duties? What is worse, O'loju explains, is that when women undertake to resist playing the slave role that men force upon them, men resort to further acts of aggression directed against women and driving them away. Her song's delivery is in the terms of embittered messages from one woman victim of this obnoxious relationship, reporting the sorrow this situation causes women from her father's home, to which her husband had driven her. The overall effect is that the combined role of praise and vilification allows for a heightened awareness of the cowardice of the husband and the heroism of the women in his life.

Ejeh Ny' Imahi

Anu Anyogwaje,
M j' in' obeh ny' obih le
I woh ny' anu mila wum kw' ehi ka oh!

Am a duh ka!
Am a duh ka! 5
Ino, uka kam hwang ny' Oju we le, oh!
Am a duh ka
Ole k' am hwaam d' ale
Iwoh ny' anu mila wum lume!
Obeh Obeh 1' Obeh, am okpehika! 10
M mila y' inu d' ejih k' oh!
Anu ji Ongaj'obeh-ohoho h'am;
Ongaji-o-ny'-Ogwugwu
Ino or' oowa k' oh
Ino 'm mila ka kp' oheh ny' ihu l' ogogoh epu-inyiyo 15
Ino, ogbale-gbale w' oh!
Ahi bal' oru nyam a' mila r' i-yeka, oh!
Ahi mila r' uhih le ka
Uka ole k' omiletu wari,
Oru nyam mila j' ahi dam 20
L' igwuh j' ahi d' Al'l-Owo
M j'ela 'm mila do ka, oh!
M mila mila j' el m d' oru ka ka oh
El' owe l' am oyoyih lume
Chorus: Oru nyam eeh 25
 Opw' am rwaru eeh!
Leader: Ayibam eeh
Chorus: Opw' am rwaru eeh
Leader: M j' ela 'm ti do ka
Chorus: Opw' am rwaru 30
Leader: 'M j' abwo 'm ti ho ka
Chorus: Opwam rwaru eeh
Leader: M' ayibam awe le eh
Chorus: O pw' am rwaru e eh
Leader: Oru nyam onyilah ole 35
Chorus: O pw' am rwaru
Leader: O pw'am rwar' ale le
Chorus: O pw' am rwaru eeh!
Leader: M j' abwo 'm ka ya ka
Chorus: O pw' am rwaru eeh 40
Leader: M'j 'abwo mti ho ka
Chorus: Opw' am rwaru eeh
Leader: M maga kwehi ka

Chorus: O pw' am rwaru eeh
Leader: Op' am rwaru ododuh
Chorus: Opw' am rwaru eeh
Leader: Oru nyam awe le le
Chorus: Opw' am rwaru eeh!
Leader: M hel' onyobih nyamu ka!
Chorus: Opw' am rwaru eeh!
Leader: Oru nyam eh, ilah!
Chorus: O pw' am rwaru eeh!
Leader: M chaji ny' anyi nya le
Chorus: O pw' am rwaru eeh!
Leader: O yah yah am nyi ru me
Chorus: O pw' am rwaru eeh!
Leader: M pwa pwa m ka ru ka
Chorus: O pw' am rwaru eeh!
Leader: O ch' anyah o ka nwum le
Chorus: O pw' am rwaru eeh!

Song of Frustration

You children of Ogwaje
I say good evening to you
I truly long for you severely
It's not my fault,
It's not my fault,
Really, when I left for Oju, oh!
It wasn't my fault
That I have remained there till today
I do long for you in earnest!
I'm thankful, poor me!
I didn't cast a curse!
You thank Ongaji for me;
Ongaji-the-daughter-of-Ogwugwu
If it were not for her
I would have crossed the river with old age in my blood
You see, in the past,
I and my husband were if you don't see . . .
We had not known famine then
But when the hard times came,

My husband faced me
Like death faced Owoh people
I did not know what wrong I had done him!
I really don't know what wrong I have done the husband
This matter shames me greatly.
My husband
He has denied me.
My master,
Chorus: He has denied me
Leader: I don't know what wrong I've done him
Chorus: He has denied me
Leader: I did him no wrong
Chorus: He has denied me
Leader: But that is my husband
Chorus: He has denied me
Leader: This my fine husband!
Chorus: He has denied me
Leader: He has denied me today
Chorus: He has denied me
Leader: I don't know what to say
Chorus: He has denied me
Leader: I don't know what I have done
Chorus: He has denied me
Leader: I tried in no small way
Chorus: He has denied me
Leader: He has denied me for no good reason
Chorus: He has denied me
Leader: And that is my husband
Chorus: He has denied me
Leader: I have done him no evil!
Chorus: He has denied me
Leader: My husband, fire!
Chorus: He has denied me!
Leader: I returned because of the kids
Chorus: He has denied me!
Leader: He has ordered me to leave
Chorus: He has denied me!
Leader: I declined to leave
Chorus: He has denied me!
Leader: He has threatened to kill me
Chorus: He has denied me!

The facility with which O'loju handled both the lead and the choral responses to her singing was astonishing. The performance was a success both as an artistic and as a political act. In it, the composer uses a judicious combination of vilification elements and praise elements to make a statement on the predicament of all Igede women who find themselves victims of a combination of all sorts of social abuses, and her style reflects her high level of political consciousness. In this song, history and art also find a superb integration. One piece of historical information that is needed for an outsider to have a full understanding of the force of the song is the heightened animosity that existed (and still exits) between the clans of the wife (Oju) and the husband (Ibilla). This dispute dates back to the time when the British colonialists who conquered Igedeland during the early 1920s situated their headquarters in Ibilla land but arbitrarily named the place after Oju. Over the years the struggle over the name of the land became so fierce that the hostilities spilled over into all other areas of social intercourse between the Ibilla and Oju peoples. In her song, O'loju (whose name simply means "Indigene of Oju") alludes to these hostilities; in fact, she believes that the misunderstanding in their family is being intensified by that wider communal crisis.

Thus, she opens by addressing her husband by his clan name: *Onyogwaje* (meaning "Child of Ogwaje"). The name is the ancestral praise appellation by which the Ibilla clan is known and addressed appropriately during important meetings, especially whenever all the thirteen clans of the Igede people meet to discuss vital issues affecting them. During such meetings, the socio-political interactions between the groups are conducted in terms of absolute and democratic equality. But, in employing this formal mode of address, the composer is not exactly singing praise to the man, but instead making it clear that her message is being conveyed in a collegial spirit, as one from one clan representative to another in a relationship of equality rather than one of subordination. Because Igede is a male-dominated society, where equality of the sexes is nonexistent, her performance is parodic in intent, a reversed form of praise. She keeps in view throughout her singing the immediate experiences that precipitated the unrest in their home: the hunger ravaging her husband and his violent reaction to it. Implicit in her message is the rejection of the traditional expectation that women should protect their men from hunger, disease, and all other forms of hardship; the message comes through in her raillery and in her sarcastic and mocking tone. O'loju achieved her desired effect: although her husband (then lying on a bed in the same hut in which the performance took place) showed no apparent reaction, the composer told me in secret that he was boiling inside with bitterness, frustra-

tion, and rage, and that only my presence had prevented his fury from erupting visibly. Despite the absence of any form of musical accompaniment to her performance whatsoever, O'loju's singing had extraordinary beauty. It was a musical triumph in which art and politics were dramatically integrated, with satire and praise serving as fresh combinations as the main vehicles through which the exploration of these relationships is conducted. The silence of Ogwugwu in the midst of obvious provocation is perhaps not a conscious effort to propitiate his aggrieved family but the result of shame. Whereas praise acts figure O'loju and her daughter in heroic terms, vilification devices present Ogwugwu as a man who fails to measure up to the standards the Igede community sets for its menfolk.

If we revisit an aspect of methodology in oral literary research that has caught serious academic attention lately in relation to the vilification song samples we have been examining (that is, the question regarding what is the best circumstance in which recordings are to be made), we find many interesting results. Many scholars have asked and attempted to answer this question: Can a solicited oral literary material be as authentic as the one that is recorded in its "natural" performance context? Afam Ebeogu claims (about the Igbo lullaby), for example, that "a contextualized performance" makes an impact far superior to the one produced by "a stage-managed performance" (Ebeogu, "The World of the Lullaby," 100). That notwithstanding, for him, "even the staged performance is usually rich enough for the scholar's study and analysis, and can provide valuable insights into the histrionic scope of the performance" (Ebeogu, "The World of the Lullaby," 100).

The data drawn from my fieldwork suggest that we are asking the wrong question. There should be no doubt about it: each and every composition—irrespective of motivation, occasion, or circumstance—is valid in its own right, and the variations in textual content, function, and circumstances of performance are all integral aspects of oral literature. Thus, what Karin Barber observes about the texts of Yoruba *Oriki* is no different from what exists in Igede vilification songs: "'The text' is continually remade, not only by the reader . . . but also by the composer/performer. Poststructuralist criticism enjoins us not to privilege one version of a text over the others as if there were such a thing as a single authentic text which could be established for all time. With *Oriki*, the existence of multiple variant texts is a fundamental and inescapable feature of the mode of transmission. (Barber, "Yoruba Oriki and Deconstructive Criticism," 508). If we recall that the songs of the Igede men performed within the genres of Etuh and Adiyah, which we sampled in context, made vigorous and re-

lentless efforts to popularize and perpetuate stereotypical images that devalue women, but the responses by the women, though "induced," have been no less effective in countering those abuses, then we begin to sense the complexity of the issue of textual variability in oral literature.

Indeed, Igede women who demonstrate resilience, inventiveness, and the creative angst needed to free themselves from male domination are using art effectively to serve a political function. They are conquering and occupying new artistic spaces and territories, and they are helping to reproduce and to undercut the social ideologies that seek to dehumanize them through inventive uses even of such conventional techniques of poetic composition as praise and vilification. The songs of Christiana and O'loju were sung within the framework of an old Igede women's tradition called Ihih (meaning "honor" and "respect"). Ihih is the farthest back they can go in Igede oral song tradition, and there was no doubt whatsoever in the minds of the audience members I interviewed that their goal was to use one of the most respected traditional expressive cultural forms to lend authority to their grave matrimonial grievances. It was not accidental that neither of these women chose to employ *Ibomah*, a new offshoot of this old Igede tradition. According to Bjorn Ranung, who describes *Ibomah* as "an entirely Igede type of music," the origin of the genre can be traced to "a woman of Ojenya who had been compelled to take care of the baby child of her sister who had died. The child was crying for its mother and the step-mother had to soothe it with it and lull it to sleep by frequent singing" (Ranung, liner notes to *Music of Dawn*). O'loju's decision not to sing within the format of Ibomah was of particular significance as she originated from Ojenya, where Ibomah was invented and and where she might have learned it during her childhood. Interestingly, during the time this study was conducted, Ibomah was very fashionable with many other women in the village. That rather than follow this fashion, Christiana and O'loju decided to reach back to the very roots of Igede women's expressive culture tells a lot about their artistic goals. Expressed in their performances is the sense of urgency with which these singers desire to use the most powerful verbal means as vehicles of redress for their domestic griefs. Because their suffering appears to be enduring, any setting is an appropriate context in which to express it. The singers are undoubtedly engaged in a punchy battle to win themselves recognition as a socially respected group. But, ironically, the competition inherent in the African polygamous institution within which they must carry out this struggle prevents the formation of a strong united women's front. Forced by exigencies to undertake actions which could win them

favors from their husbands at one another's expense, the women find themselves introducing further elements of division among their ranks.

In their drive for gender solidarity, Igede women also find themselves up against another masculine odd: men's preference for sons over daughters. Privileges go to those women who produce male children for their husbands over their less fortunate sisters who produce only daughters. This preference also confers a subhuman status on those women who cannot bear children at all. Igede women must overcome the petty rivalry, jealousy, and rancor engendered by male chauvinistic attitudes if they hope to not only overcome male domination but also to escape being the targets of male sarcasm and verbal slurs.

The tremendous active participation that came from the audiences during the performance of the vilification songs performed by the Etuh and Adiyah ensembles—either in the form of their laughter, sneers, or their choral responses—suggest that oral artists have a greater chance of producing a widespread impact when they address an entire community. Because in every situation the audience's active participation is a precondition for any lasting effect to be produced, a singer who desires to get his or her community emotionally and intellectually involved with the core ideas he or she explores through the medium of songs, must seek out as many people possible and bring them together. For vilification songs, in particular to find pungent expression, the melody must be appealing. While I would suggest that in performing these songs the Adiyah and the Etuh ensembles have been engaged in pressing a claim for a place for the oral artists in modern Igede's search for enduring values, I would not underrate the value of the solo performances being put forth in the format of Ihih by the likes of Christiana and O'loju. The impact of the attempt by all these singers to hold the Igede society together is owed to their adept uses of varying combinations of praise and vilification mechanisms through which they expose the danger of deviation from traditionally sanctioned sexual and other moral norms. Though these singers have had different levels of success, they have all produced messages that have continued to receive considerable attention. For obvious reasons having to do with the size of their audiences, a greater number of those I interviewed said they regarded the ensembles as their most valued cultural heritage, pointing out that the groups represent the voice of the past's wisdom. But the performances of the soloists that we have examined can be no less regarded as acts of hope and demonstrations of the singers' conviction of the time-honored duty of oral artists as guardians of cherished indigenous customs.

TWO

Death and the Communal Consciousness
*Listening to Mourners Celebrating Life
and Castigating Death*

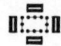

Because of the important place that death occupies in human existence, most unlettered peoples have a rich supply of dirges or funeral essays. The dirge provides a profound and reliable index to the expressive capacity of many peoples worldwide, for the sense of sorrow and hopelessness that emanates from bereavement or from the death of a relative or friend (even more than the other human emotions, such as fear and insecurity, joy and hopefulness, anger, and so on) has tended to force most people who still live in oral cultures to reach down in their souls for the most condensed form of verbal articulation. The dirge offers one of the richest and most balanced sources of praise and vilification as primary materials for poetic expression. Because the Igede dirger stimulates his or her audience fundamentally by means of expressive power—this chapter will argue—without paramount consideration paid to the oral literary technique employed by the dirger, we cannot form a comprehensive understanding of the Igede dirge.

Igede dirges are like cultural autobiographies in that they convey the values the community generally holds dear, and praise and vilification are the resources through which dirge composers process these qualities for our heightened understanding and reflection on them. Through praise, such attitudes as honesty, hard work, fair play, solidarity, and generosity are underlined as the people's preferred values, while vilification helps to expose such characteristics as malice, jealousy, arrogance, greed, selfishness and so on as being those the people frown upon. That the dirges reveal the kindred spirit the Igede share with other African groups (as evident, for example, in the belief in the narrow link that exists between the

world of the living and the world of the dead) may say something about the cultural unity of Africans. However, more specifically, the narrowness of the gaps is reflected in how the Igede refer to the phenomenon of death.

They merely say *Oguh gbuh* (literally, the dead died). This expression shows that the physical being is only a body, life being ohu (breath). Death is occasioned by the instant disappearance of ohu. The worlds of humans and of the dead are viewed as linked; when death occurs, humans make a transition to the world of the dead. The dirge plays the spiritual role of speeding the deceased's transition to the spirit world, to the world of the ancestors, to which the Igede believe a person retires when he or she dies. Not surprising, therefore, for the Igede, the funeral is "an occasion for making or renewing social contacts and involves lengthy and costly preparations regarding food, drink, and entertainment" (Nicholls, "Igede Funeral Dirges" 75). The Igede view dirges as vehicles through which their living members can celebrate the good deeds of a dead person; for them therefore, to mourn the dead is, indirectly, to celebrate life—death's antithesis. And so, the funeral setting not only brings the Igede together socially, as Nicholls suggests, it also provides an occasion for the people to prepare their dead for the afterlife in the dead's world. This is why praise and vilification constitute the primary modes of expression in Igede dirges—praise to assert a love of life, and vilification to castigate the forces that deny life.

The Primacy of Form: Praise and Vilification as Poetic Expression

If we view poetry as a mode of impassioned utterance that emphasizes its prosodic features dramatically, then there is good reason to believe that Igede dirges employ poetic language. According to Rene Wellek and Austen Warren, "poetic language organizes . . . the resources of everyday language and sometimes does even violence to them, in an effort to force us into awareness and attention" (Wellek and Warren, *Theory of Literature* 24). For R. N. Egudu, "poetry ⋯ is a method of literary expression which suggests by means of imagery, rhythm, and sound" (Egudu, *The Study of Poetry,* 4). In this study of Igede dirges, I will show that Igede dirges employ the resources that all great praise and vilification poetry utilizes—imagery, rhythm, and sound effects.[1]

Consider, for example, the condensed combination of the multiple paralinguistic and expressive verbal devices that a dirger used to bring her composition to life, when a boy of sixteen years died suddenly at the Ichakobe village on July 4, 1981. In this performance, a middle-aged woman received the shocking news of her nephew's unexpected death. She ar-

rived at the funeral ground, went down on her knees, and performed the following dirge.²

Adada eeh,
Aka y' ugbah h' ah' eh,
Inene m'de le m' dee le
Inene ny' ikpiko
Alihih tom k', oh!
Inene m' d' ubwom le
Ale r ' ony' ochicheh
Ale r ' ony' ochicheh
Ony' ochicheh ka pw' epwa k' oh!
Inene m' ela l' oh!

Alas, father
Come see me in my aloneness
Mother here I lie, I lie here
My mother, child of the great one
The warefarers do not cross my path
Mother I lie here all alone
[Sobs] Today it's a child
The child has not arrived home yet!
Mother I have spoken the word

Central to this brief but laconic composition is a particular woman's shocked sense of loss and deep regret over the death of a loved one. In giving expression to her feelings, she also creates a melodious chant through the repetition of simple phonological praise words, such as *Adada* (father) and *Inene* (mother). While soliciting ancestral support to overcome her grief, she also gives us an introspection into the psychology of the Igede dirger through a carefully constructed network of allusions to Igede beliefs in the power of the dead. This song shows a subtle use of praise, for *Adada* and *Inene* connote deep meanings. To the English, "father" and "mother" may be simply terms for one's biological or adoptive parents. These words represent for the Igede something deeper when mentioned in a funeral context—they are general invocations to the peculiarly warm bonds known to exist between all human beings in stressful circumstances, such as those presented by death in Igedeland. In other words, they are praise terms.

It is in this context that the expression *ony-okpiko* (child of the articulate one), derives its significance as an obvious praise epithet intended to

highlight the fallen state of human beings when death occurs. People such as the dirger regard articulacy as an expression of human dignity and nobility; when death happens, it degrades humanity as a whole by silencing it. *Alihih* refers to the warefarers. The speaking voice laments their parallel paths; this connotes her ill-luck because for the Igede, as for many other African peoples, life is like a journey to a market where one may meet good or bad luck. The speaking voice asserts that her own journey to this world has not met with much luck; in fact, it has been filled with misfortunes because of the constant deaths in her family. *Inene m' y' ela le oh*! (Alas, mother, I have spoken the word) is an expression of this composer's ultimate state of despair in life, for she has been silenced to a point where silence itself has constituted her only form of expression. By moving from song to speech and punctuating her dirge with sobs and weeping, she accentuates her depressive state through performance theatrics that truly express the depth of her grief.

Among the Igede, the dirge might be characterized by a style in which the performer uses a pure singing voice. The performer gains most of her effects by emphasizing the philosophical content of her composition. Through an amplification of the devices of praise and vilification, the singer uses imagery and sound devices with depth and feelings. This is the style favored by elderly women, such as Ebeleh Ondah, the composer of the following piece, who begins by invoking her ancestor, and then moves from the delineation of her own unhappy lot to the plight of her late brother, moving through the family history and then back to her personal grief. In her richly suggestive and poetic constructions, the use of body movement is reduced to the minimum.[3]

'M beko ny' adada
'M beh gbeh gbeh gbeh.
Enwa to k' enwa ka kaah
Anyang k' umwo,
Ah' anyang k' umw' ile: 5
Ah' anyang ya j' awule ka.
Og' onyomilah ny' adam
(Ang nyam j'epwu ny' ejih ile.)
Ijwuh l' ununah ka
O ka kpeheh 10
Ugbileh ang ony' adam Ogbohondah
L' iny' ang' ugbileh ny' iwu
'M beko nyang
'Mbeh gbeh gbeh gbeh

'Mbeh gbeh gbeh gbeh 15
Uhyawu ny'am ony' Ogbohondah
Uhyawu nya l' iru
Uhyawu ny' alir' ile
Iru kpo rwo rwo ka,
'M beko ny' enwa le, 20
Ojih kpur' ony' adam Ogbohondah
Adam ji ka
Anyi nyang d' odenu
Enw' eeh, ugbile ang adam eeh
Ugbakah adad' ony' Ogbohonda 25
Iloh m' iloh ch' igwu nyaa
Adam r' ugbakah
Ogwu ny' ugbakah a l' ununa ka,
Og' onyomil' o ny' adam Ogbohonda,
Adam ch' ekwu ny' ijwuh ile 30
Ijwuh l' ununah ka,
Enwa ka ka,
Anyang k' umwo
A yem l' ira wem weh weh, adam, onyogboh-Onda
A d' onu ch' enwa h' am 35
A tiyo bi ya adam kpira nyamu ka h' ang ikila
H' anya-adamu bejih eje
I nyawa nwu' alee, l' ichiri nw' awu-iru
O kpabwo ka r' udu ny' adada
O kpabwo ka ri ny' onyi-adamu 40
Okpabwo ka r' udu ny' onyi-inina
O wur' any' ochony' anyi nya-adamu
'M beko ny' adada ee!
Enwa ee, enwa ka ka ah!
A y' achiketeh-ony-ogbondah, 45
L' i nya wu-egbu epete
Eyeh yeh yeh
B' Ogbenyi l'okpa
Eyeh yeh yeh
'M beko ny' adada, 50
'M beh gbeh gbeh gbeh,
Abwo-iduh-anyang il-Ihy-obila,
Anyang k' epwa ka ya
Iwa nyi y' iru!

'M ya mi ka, 55
Iko talah
Iye ti h' iwunah k' iko ny' iwunah talah?
Oheh d' iwunah enyi
Iko ny' iwunah gwum talah leh, ale!
'M beko ny' adam 60
I dinu ch' enwa ham,
'M ya mi ka, iko talah,
'Mbeko ny' adada
'Mbeko gbeh-gbeh-gbeh-gbeh.
Adada kpete 65
Anginyi kej' ij' anyi;
Adam k' ej, adam j' anyi ka
Adam g' anyi b' ilomu wuh
'Mbeko ny' adad' ile,
'Mbeh gbeh gbeh gbeh, 70
'Mbeh gbeh gbeh gbeh gbeh
Ojuta-oludu, 'm beko nyang
Adam hum ujijih kpinih kpinih,
Ujijih ny' ela jum kwehi ka
Anyanu ch' ayamah 75
Anyanu ch' ayamah le
Anyanu ch' ayamah.
Udoh-Okwur-anu-onyogbondah
Adam jih ka
Anyanu ch' ayamah 80
Anyan' d' odeheh ri ny' Igbeh-bala-iko.
Iwoh kpam ahi ka
Iwoh kpam ahi ka
Iwoh ny' enwa kpam ah' ale ka
Imi kpam ahi ka, enwa 85
'M che-ekoh ile,
'M che-ekoh ile,
'M yehi r' oyi ny' adada
Ehi toyi lam eje,
'M yehi riri-oyi ny' ehi ny' inina 90
Ehi toyi le, ee!
Ehi toyi kwehi koh!
Ikangbiri-adam eeh!
L'inya r' ekwuh-itabah

Ekwu-Itabah, adam 95
(Inyam kp' igogoh
Inyam Kp' idadah ka)
Anu y' oyi ny' ela nyam
Ela nyam a Kp' egoh Ibilla,
Egoh nyam a kp' igbeh-gbeh koh 100
Inene ony-ogbondah r' egah ila-agbeyi
L' ahi anyang nwu l' atah
'M r' ugbunogoh d' ugbeyi le
Otu koka ji k' enwa,
'M beko ny' adada 105
'Mbeh gbeh-gbeh-gbeh
'M beko ny' adadah ile,
'Mbeh gbeh gbeh gbeh!
Enwa hwum ujijih kpinih-kpinih le, ooh!
Ojih-kpururu-onyaje, 110
Adam ji ka'
Anyumu d' odenu le,
Ojih-o-lugbeyi, oti h' ate, ale!
Uturu K' orih ihyejwo, ile,
Ukoh chim epwu l'am arih onyi-enu. 115
Anginyi cheheh ny' epwa ny' adawa
I hi ke-ke-ke;
Inene ony-onda ch' eheh ny' epwa ny' adamu
Uko chim ile l' am ar' onyi-emu
'Mya mi ka, mya mi koh, 120
Ilah o-leta, oduh riru, oduh biri le,
Odu kp' arigoh
Ilah ony' ukpute,
Oduh bir' ale le!

I call for father,
I call again and again
The dear one didn't ask, he didn't go
Women go in search of fortune;
We women go for fortune this way: 5
We women don't tell each other [the secret of success]
The fair-complexioned Ogo, son of my father
(my possession is underground)
Yam is unique;

It will come out 10
Majestic son of father Onda
Like a huge log of wood
I call for you dear one,
I call again and again
I call again and again 15
The rare one of father Onda
The rare one sought by suitors
If this is what constitutes beauty,
Marrying is worthless!
I call for you dear one 20
The great-shade-child of father Onda
My father is not here
And his children bake in the sun
My dear, magnificent father
Father Onda, the Green Mamba 25
Every snake has its track marks;
Father is Green Mamba
And the Mamba's marks are unique
The fair-complexioned Ogo, son of father Onda,
My father cut a piece of yam, 30
The yam is unique
The dear one didn't go
And women go for fortune . . .
You have seen me in my grief, Father Onda,
Greet the dear one for me 35
And let him know that my father has given his wisdom to others
And forgotten his offspring;
Theirs grows for them like cowpeas on yam heaps,
When they turn to one side, they enjoy their mother's wealth
When they turn to another, they enjoy their brothers's wealth 40
When they turn to the next, they enjoy their sister's wealth
When they turn to the other, they enjoy their fathers's wealth
I call for father,
The dear one, my dear one didn't go
If you see the proud one of father Onda 45
Like camwood on the feet.
Eyeh yeh yeh
Inform Ogbenyi the great
Pain, alas! what a pain!

I call for father 50
I call again and again
The issue of embracing girls at Ihyobila!
The girls smile coyishly,
They go home and boast they've got husbands
I am unable to say much 55
I have lost my voice!
What happened to Canary, Canary lost her voice?
The rain beat Canary,
The Canary lost her voice to me
I call for father, 60
Greet the dear one for me
I am unable to say much, my voice is lost
I call for father,
I call again and again
Father kpete, 65
Other people go underground, they care for their offspring;
My father went and didn't know his children,
My father collected all his children along with him
I call for father this way
I call again and again 70
I call again and again
Ojuta-the-rich, I call for you
But father gave me no answer at all
This silence grieves me greatly
The young chicks are stranded, 75
The young chicks are stranded,
The young chicks are stranded,
Father Onda, the basket that covers chicks
My father, you are not here
And the chicks are stranded 80
Alas the stranded chicks are for the Eagle and Beak!
Longing disturbs me
Longing disturbs me
Today, longing for the dear one disturbs me greatly
Hunger disturbs me greatly, dear one 85
I grieve this way
I grieve that way:
I look forward to seeing father;
My waiting is in vain

I looked for mother! 90
I have looked in vain
My waiting is entirely in vain
Ikangbiri, my father,
Like a piece of tobacco,
My father, the tobacco piece 95
Mine is good for grinding
But mine is unfit for snuffing
People, see my condition,
My condition has become a peculiar history in Ibilla,
And the history is not fit for recounting. 100
The daughter of Ondah has become a roadside ant,
Something we women kill with our legs
I have become a condemned bowl on the road,
There is no shoving it from the way, dear one
I call for father, 105
I call again and again
I call for father this way;
I call again and again
My dear one has kept a dead silence
The great shade of Ibilla 115
My father is not here, his children bake in the sun
The last road prop, he has been uprooted today
Whenever it is Ihyejwo
There is anxiety in my soul as if I am a slave
Other people plan to visit their fathers's homes 120
They are festive,
The daughter of Onda plans to visit her father's home
Anxiety gnaws inside me as if I am a slave
I am unable to say much, I can't say much
The fire on the feet, it burns the soul to ashes 125
The home has fallen apart
The heart is decayed
The fire on twigs,
The heart is decomposed

Given the background of grief as the main motivation of the dirge, the important point about it is the numerous stylistic devices used to express the dirger's feelings. This performance was recorded in the village of Uchenyim on the occasion of an early morning remembrance of the dirger's

dead brother. She was more than seventy years old. In order to convey the emphasis on the philosophical content of her composition effectively, she chose each word and image with care. The lament incorporates all the main features that my informants regarded as typifying the highest expression of the Igede dirge form.

One of the striking features of the song is that it was the utterance of an old woman who was physically very weak. She paused intermittently during the performance to cough, often relapsing into a sleepy slur before nasalizing some of her words. These elements were the most difficult to transcribe but I have attempted to capture some of them with parenthetical markers; my translation and transcription of the song are as close a reflection of the original as could be achieved under the circumstances. Another outstanding quality of the composition is that, despite the performer's obvious physical disabilities, she was mentally alert throughout. The immediacy of her culturally derived motifs, the pungency of the expressions she employed, pregnant with many layers of meaning, and the artistic coherence of the song generally all point to the control she exercised over her material.

Ebeleh Ondah placed considerable emphasis on the poetic content of her composition, and praise and vilification are the prominent strategies by which she achieved the focus of her song on the sense of loss occasioned by the death of a relative. The song opens, as I have already noted, with the speaker introducing herself as someone whose "father" (meaning ancestors) has abandoned her to fate in a competitive and hostile world—a world in which "women go in search of fortune" and hesitate to reveal the secret of success to each other: *Ah' anyang k' umw, ile/Ah' Anyang ya jawule ka* (We women go in search of fortune this way/We women do not reveal the secret of success to one another, lines 5 and 6). With these statements, she describes the business of living as a competitive one and expresses Igede belief in the protective role of the ancestors.

The next movement, the portrait of the deceased, endeavors to give expression to the totality of the Igede concept of beauty as the performer vizualizes her late brother, both in terms of the physical attributes he possessed and in terms of the inner qualities with which he was endowed. Here she calls into play many poetic devices. For example, the praise epithet *Ogo-onyomila ony' Ogbonda* (Ogo the fair-complexioned son of father Onda) is a direct eulogy of his physical attractiveness, while the reference *Ugbileh ang ony' adam Ogbondah* (Majestic son of father Onda) is a more generalized praise for his total comportment. The speaker refers to her dead brother as a distinctive yam tuber planted underground that

will sprout into a new one (line 9). This gives metaphorical expression to the Igede belief in reincarnation. The yam image is an instance of praise, for, as among their Igbo neighbors, the yam is the king of crops among the Igede. Further she pictures the deceased in terms of a huge log of wood, an apt simile to evoke his sturdy physique, which is indicative of an ideal quality that is desired in such a traditional farming community as Igede, which relies on human labor to till the land. The praise expression *Uhyawu nyam ony' ogbonda/Uhyawu nya l'iru* (The rare one of father Onda/The rare one sought by suitors, lines 16 and 17) also mirrors his composite attractiveness, and the reference *Ojih kpuru ony' adam Ogbonda* (The great shade child of father Onda, line 21) alludes to the deceased's previous role as the breadwinner for his family. Thus, she reasons that, just as his death meant a destruction of his physical beauty, which brought to nought the love of his wives ([it] Made marrying . . . worthless, line 19), so too it has brought untold havoc on dependent relatives, such as the speaker, by destroying their main source of support. The overall picture that emerges of the deceased, then, is that he is cherished not only because he was handsome and industrious but also because he was compassionate in nature. While the deceased gains stature through the use of praise, which highlights the qualities he possessed, the irresponsibility of ancestors whose dereliction of duty caused the senseless loss is magnified through vilification.

One thing Ebeleh Ondah's performance left no doubt about is the centrality of selflessness in the scale of values of the Igede, for in a society that is characterized by communal living, where everyone is expected to be his or her brother's keeper, to be otherwise is to commit an unpardonable crime. In this regard it is helpful to remember that at the time this performance took place such a sense of fellow feeling was one of the values of the Igede people most threatened by Western influence, which was then making itself felt in the form of aggressive individualism. The refusal of the mourner's brother to succumb to this new lifestyle (he was determined to hold to the old communal tradition of his people) constitutes the sterling quality lauded in the dirge.

The mourner's meditative, philosophical, and reflective tone, which joins intellect with feeling, traces the deceased's mobility to his background, especially to his father, referred to fondly in the metaphor of *Ugbakah* (Green Mamba) whose marks are unique (lines 25–28). Although the image connotes his physical grace and poised manner—the mamba is well known for moving with grace even under severe strain—what the singer criticizes their father for is his legendary generosity, which led him to

deny his own offspring a share of the "wisdom" that he gave so freely to others. Here the mourner indirectly takes us back to where she began, with the idea of the Igede concept of life as a market, and living as a trade in which the participants are wise not to share the secret of success with others. We learn that her father ignored this wise counsel and sold his ideas to other people. Not only did this give them material comforts, it gave the rival family an advantage over the deceased's in a competitive world where resources are limited and unequally distributed. She contrasts her own family's penury with the opulence of the rival family, whose members at every turn enjoy their relatives' wealth, which "grows for them like cowpeas on yam heaps" (line 28). The last image has all the poignancy and vividness for which rare similes are famous, suggesting as it does the evergreen bounty of the rival family's own material comforts in direct contrast to the abject, stark, gray destitution around them. By this image the mourner's despair is clearly established. Her vituperation has turned into a bitter flurry of words in the accusatory remarks about her ancestors. The tone is suggestive of the mourner's overriding object: persuading her late brother to reverse the bad example that had been set in the family. She wishes to take advantage of the immediate death in the family to reverse the living members' fortune. Because death is seen as a journey to the ancestral world, where the mourner's late brother would join the ranks of the dead family members now overseeing the lives of their offspring on earth, there is special relevance in the singer's plea that, if he "see[s] the proud one of Father Onda," he will convey to him urgent messages about the suffering that afflicts the family. A favorite device employed by the singer in pressing her plea is the language of praise, as when she describes her late father as *A y 'achiketeh-Onyogbonda* (the proud one of father Onda). In its literal sense the expression means someone who hates dirt so much he nearly never wants to walk on his feet; used in this context, it seeks a flattering effect in order to get the ancestors engaged in a dialogue with their offspring for the purpose of remedying the suffering afflicting them on this plane of life.

Nketia observes that, with regard to the ancestor, the Akan mourner may not only identify and allude to a "particular contribution" he has made to "the corporate life of the group or any deed or acquisition" he was noted for—"his character, his behaviour, his life that is worth noting"—but may also "address him in the same way as he may address the deceased" (Nketia, *Funeral Dirges of the Akan*, 23). Likewise Ebeleh Ondah makes a direct address to numerous ancestral figures. The first is "Father Kpete," who is also remembered as "Ojuta-the-rich" (lines 65–67). The

style adopted is that of the family genealogy. Kpete is the immediate family member who died before Father Ondah, and her tone is a combination of recrimination and conciliation, vilification and praise. This style reflects her state of desperation: She lambasts him for the family's history of neglect, because of his lack of ancestral protection, but follows with a gentle remonstrance, a plea for mercy. *Ojuta-oludu' m beko nyang/Adam hum ujijih kpinih-kpinih/Ujijih ny' ela jum kwehi ka* (Ojuta-the-rich, I call for you/My father gave me no answer at all/This silence pains me in no small way). The image presented of the singer's family as stranded chicks appeals to our emotions, and it reinforces the idea of the family members' helplessness, as suggested earlier by the metaphor of the mourner as a mute canary. The image of a canary rendered songless by a downpour that had drenched it the previous night is a most pathetic one; it calls to mind vividly what it means to be without a shelter in a tropical rainstorm. Just as its song is all a canary possesses—the loss of it being tantamount to denying the bird's existence—so the loss of their mother gravely exposes the chicks to predators, such as kites and eagles. Having lost the companionship and support of vital members of her family, the mourner is greatly disturbed by "longing" and hunger. In line 95 she refers to another ancestral figure, that of Ikangbiri, identified as a metaphorical piece of tobacco declared unfit for snuffing (line 96). The allusion is to his untimely and tragic death, for he died before reaching maturity; his death is yet another example of how the family has suffered endless victimization.

The performer rounds off her song with the central motif of the dirge—the link between the personal fate of the mourner and the general predicament of the family. The mourner says that her family's history is unique in the community, but not because its record is praiseworthy; rather because it evidences repugnance—hence the family's history is "not fit for recounting" (line 100). It is a history of shame and woe, and she has personally become like *egah il-agbeyi/L' ahi anyang nwu l' atah* (roadside ants/that women kill with their legs, lines 100–102). The "roadside ants" that women tread on heedlessly are an image of the mourner's worthlessness, her complete insignificance, like that of *ugbunogoh d' ugbeyi* (the condemned bowl on the road," line 103) that the mourner uses to instance her predicament. More important, these images express the low esteem in which her family is held. At this stage she calls attention to the indifference of her ancestors to their family's plight, and the statement about her terror at the arrival of Ihyejwo is an attempt to use the memory of a pattern of some dreadful happening to anchor a general truth. Ihyejwo

refers to a certain day in the Igede market cycle that seems especially inauspicious, as it is the day when most of the deaths in the family seem to have occurred. By equating her status with that of a slave she gives expression to her utter despondency, for in the Igede ethos a slave is considered no more valuable than any household pet. This is the penultimate image in the poem, and it encapsulates the paradox attending the family's decline, from the dignified status indicated early in the song to the subsequent state of utter degradation. It is no wonder she says she is standing upon a heap of twigs that has been set on fire and is burning her soul to ashes. The burning image appropriately summarizes the murky turbulence of her agonized existence, which has also been the experience of her family.

Few oral artists can combine praise and vilification as effectively as Ebeleh Ondah has done. However it turns out on closer examination that even a third category of Igede dirges—those apparently formless pieces that employ the mode of wild, staccato verbal outbursts punctuated by ululation—can be shown to draw upon a selection of technical devices, which all build up a heightened form of expression. The following seemingly chaotic assemblage of incantations exemplifies the manner in which the dirger can work up emotion by staying close to the store of associative references current in his society:

> Eduruh O chacha o kpa nyah!
> Ubwong eeh yeh yeh!
> Anu gw' Uwokwu ham Onyine,
> Eeh e eh!
> A l' onyi ka, eeeh! 5
> M j' ilom la l' enyi j' ogoh
> Am Ochonye!
> Epwa h' ugbah l' ikoh!
> Anu gw' Uwokwu ham Onyine
> Onyi nyam o ny' Ijegwu 10
> Ebi k' oh' Ijwoh
> Ijwoh gb' okirih

> Persevering bow string who never fails to return with game!
> Alas, aloneness!
> You please call me my mother's child
> Alas!
> Alas, the pain of aloneness, 5
> I weep myself as a stream weeps water

Poor me
The compound is now the abode of weeds!
You please call me my mother's child
My own child, that is nursed of Ijegwuh 10
It's like the misery which descended on Leopard
Leopard was thrown into incessant cry of lamentation!

This dirge was created by Moses Igo Owuloh—then in middle age—at the village of Ihigile to mourn the passing of his son, who had died from an attack of German measles the morning the performance took place. The composition achieves most of its effects through a cluster of key terms that the mourner employs to incorporate those things vital in the upbringing of an Igede child. *Ijegwuh* (line 10) is the most prominent of these, and it refers to a traditional Igede herbal preparation that mothers use in nursing their children. Because it is usually procured with much difficulty from the bush, its preparation connotes the parents' labor of love that has come to a sad end. The expression "persevering bow string that never fails to return with game" is eulogistic; it connotes the spirit of endurance and heroism to which the speaker had looked forward to seeing in his son. The irony in the poem, therefore, derives from the death of the child in whom much of the parents' hope had reposed, the child who was to have grown up and become a responsible member of his society, destined to distinguish himself as a "persevering bow string who never fails to return with game." The child is dead even before he has had a chance to prove himself. In reflecting on the specific incident of his son's death, the father recalls the history of constant deaths in the family and equates his suffering with that of Leopard, an animal who suffered a calamity of similar grave proportion in Igede folklore.

The power of the allusive reference to the Leopard to hold the Igede audience's attention derives from the fact that Leopard's story is a familiar one in their community. In this popular Igede tale, Leopard and Fire are intimate friends. Although Leopard makes frequent visits to Fire's home, he has never had a chance to return the compliment. His many invitations are all declined. When Leopard persists, Fire reluctantly yields to the pressure but during the visit burns down Leopard's home. Leopard loses all the members of his family as well as his property in the inferno, although he himself succeeds in making a narrow escape but not before receiving some burns that leave their mark on his coat.

Unable to bear the grief at the loss of all he holds dear and his personal deformity, Leopard runs away into the bush, where he remains to this day in a state of perpetual sorrow. In his lament Owulo plays on tradi-

tional associations and uses the image of hunting as a unifying device to evoke his unfulfilled fatherly expectations, foremost among which is his original hope that his son would one day distinguish himself in one of the community's favorite occupations. He uses the repetitive "alas" to underline the gravity of his hopeless mood, and the simile comparing his grief to the flow of a stream reflects the apparent everlastingness of his sorrow. The cryptic reference to Leopard's plight heightens the audience's understanding of the mourner's dejection at his bereavement. Thus, through some carefully chosen images that reflect aspects of the daily experience of his local community, Moses Owuloh succeeds in conveying the depth of the sadness experienced as a result of his son's death. Though praise and vilification are explored cryptically in Owuloh's song, their combination is adept and inventive.

Evidently then Igede ethos permits both women and men to compose dirges whenever a family member, or a friend, dies. In fact however, men tend to compose disordered, less philosophical, shorter funeral essays than women. Irrespective of its composer, the Igede dirge makes its full meaning because of the composers' use of praise and vilification techniques of poetic composition. When seen in its context, which includes the time, place, and circumstances of the event, and that shapes the psychological disposition of the mourner, the dirges, like the other funeral practices that they accompany, mirror the Igede life view—the people's philosophical and metaphysical universe. Underlying all Igede funeral ritual is the people's love of life, and the dirges that I have quoted assert their determination to preserve life. It is because the Igede—who like other African peoples—view the world of humankind as linked with the world of the dead and see their ancestors as forces that can be called on to ward off antagonistic forces ranged against their descendants, that they venerate their ancestors. In their attempt to win their ancestors over to their causes on this plane of existence the Igede mourners find poetic expression, especially the use of praise epithets, an effective means of soliciting ancestral grace. To understand the creative vigor and originality that Igede dirges demonstrate, we must have a proper grasp of the praise and vilification techniques they employ in conveying their reactions to the pain that is occasioned by awareness of their own transient existence.

THREE

Politics and Creativity
Using Praises for Conscientization

In contrast to the bemoaning quality of dirges or funeral laments, songs of political participation brim with exuberance and hopefulness. There is nothing surprising about the contradistinction. Dirge springs from a feeling of human frailty; it is an expression of the pain that arises from the knowledge of our common mortality. Deriving from the discomfiting knowledge that human beings are vulnerable to the capricious whims of forces larger than themselves—that they can suffer through the neglect of forces external to themselves and over whom they have no firm and permanent control—the end in view of dirge is sympathy. If the dirge contains any current of positive thinking, it is thinly layered, for those who give expression to the inescapable sorrow and hopelessness that emanates from the sense of the ultimate weakness of human beings are no idealists. Whereas dirgers perform ruefully, looking at life retrospectively, with a sense of the magnitude of resignation and self-reproach toward our collective inability to prevail over the crowning loss and deprivation of life, the loss of the one thing which we love most, the driving impetus for political songs is the consciousness that those still living have yet the capacity to make themselves happy by altering the direction of the political action in their community. The art of political expression is, then, an act of hope, an exercise in optimism. Because the realization that people possess the ability to improve their circumstances is exceedingly flattering, this optimism is the positive mark the singers attempt to leave on political songs through the use of praise and vilification techniques of poetic composition. The singers find cause to offer praise to, and invest with extolment, human behavior that can lead to communal uplift, while using vilification devices to condemn antisocial acts.

Among the many developments that I noticed had come with political awareness among Igede singers during the period in which this research was carried out was the increasing realization of the role education can play in political empowerment. The majority of the artists that I worked with had begun to form an expanded understanding of their power to ameliorate not just their personal deprivations, but also their situation as members of a disadvantaged group within the geopolitical arrangement of modern Nigeria. It was this awareness that compelled the most accomplished among these artists to seek involvement in intense political activism. As a matter of fact, two of these artists—Odeh Igbang and Micah Ichegbeh—were very explicit in claiming political engagement as their sole reason for becoming involved in artistic creativity in the first place.

All the issues come to light with great rhetorical force in Odeh Igbang's song *Omwu Ny' Ejeh Nyam* (Origin of My Song) in which Igbang specifically laments being orphaned which put formal education beyond his reach. The rendition of the song, translation and transcripts of which I present below, was performed when I visited the singer at his Adum-Owo village on July 9, 1981. Marked by intense dramatization, the occasion saw Igbang and the entire Etuh ensemble in astonishing display of their great sense of history and commitment.

Upon arriving at the venue where the performance took place just outside his compound, Igbang took his seat magisterially on his drum stand while his other three supporting drummers quickly positioned themselves by his side, also on their drums. All standing, the other members of the ensemble formed a semi-circle around their leaders. Igbang commenced the performance by beating his drum, and a great visual and auditory impact resulted, with the feather of a big bird with which Igbang had adorned his cap contributing massively to the whole drama. Throughout, Igbang sang alone, in accompaniment of intermittent drum sounds and choral responses from the other members of the ensemble. His voice thundered through the day—loud and clear. The atmosphere was solemn and grave. Here are snippets of the song (the entire repertoire is presented later).

'Mka ka jwuh keleh, ah!
'M y' ugbemah ch' ejih
Imahi tom!
'M y' ule ch' ejih
Olujwoh tom
'M bwuh inwuh chi ro ro ro!
'M beko jih idah!

Ah! eyeh! (lines 75–82)
I got to the place, alas!
I lifted the cutlass to cut the land
I was distressed!
I lifted the hoe to till the land
I was grieved!
I began to sweat profusely!
I opened my mouth and wailed
Ah! eyeh!

Despite the pervasive lamentative tone, this song is composed in extolment of self-empowerment. In it, Igbang explores with profound sympathy the predicament of his wider Igede community—a society that, through its negative attitude toward change (represented by Western education), has remained backward in modern Nigeria. He asks all Igede people to put the past behind them and urges them to combine modern and traditional values in their quest to transform their society. It is clear that Igbang dwells on his personal deprivation only as a means of making a forceful case for the privileges that the liberated Igede community can enjoy, privileges that can be obtained only when the people have freed themselves from the poverty, injustice, and exploitation that expose them to domination by other Nigerian peoples.

Omwu Ny' Ejeh Nyam (Origin of My Song) provides a clear instance of an Igede poet's use of a mosaic of techniques drawn from disparate poetic forms: elegy, praise, vilification, and love poetry. I cannot conclude a discussion of it without referring to its closing verses, in which the singer attempts to present both himself and his community as victims of an unjust social structure, victims who are nevertheless unshaken in their dignity.

Ongogohe a kpum abi ny' unye le ka eeh!
'M am a duh ka eeh!
Am aduh ka eeh, Oheh a dam le ooh!
Adadah eeh!
Adadah eeh!
Inene eeh!
Inene eeh!
Adadah eeh!
Inene eeh!
Uchu wo-orih-inene eeh!
'M anu y' uchu wo-ori eeh!

'M anu y' uchu wo-orih eeh!
Ony' inina ny' ojwe-ejee eeh!
Uchu wo-orih ony' adada
Anu kpum abi ny' unye k' ooh!
Anu kpum abi ny' unye k' ooh!
Anu kpum abi le k' ooh!
Et otu k' okpe-ejeh eeh!
Et o kp-ejeh eeh!
Anu y' ete-okpu-ojih
Ha gw' ugbah-owu-enu ooh!
Anu y' ete-o kpe-ejuh
Ha gw' ugbah-owu-enu ooh!
Ilah eeh! eeh!
Ilah eeh! eeh!
Ilah eeh! eeh!
Ilah bang epu-ete
Oduh rw' iru eeh! (lines 365–92)

No one should blame me for the lost race yet
It's not my fault at all!
It's not my fault; I am what God ordained
Alas! my father
Alas! my father
Alas! my mother
Alas! my mother
Alas! my father
Alas! my father
Alas! The toe-ensnared brother of mine
Alas! The toe-ensnared father of mine
Alas! The toe-ensnared mother of mine
Alas! I ask you all to take a look at the one whose toe is fastened
 to a rope!
Alas! I ask all of you to take a look at the one whose toe is fastened
 to a rope
Alas! The brother of the crippled
Alas! The toe-ensnared brother of mine
Don't you ever blame me for the lost race!
Don't you ever blame me for the lost race!
Don't you ever blame me for the lost race!
Alas! What a head-on collision with an obstacle

Alas! What a head-on collision with an obstacle
People view a head-on collision
It's yet better than being the one whose skin is to be flayed!
Alas! What a furnace
Alas! What a furnace
Alas! What a furnace
Alas! What a furnace
Alas! When the fire hurts your feet,
Your heart is burned to ashes!

This song is remarkable for its dramatic use of reverse praise epithets. Despite the sense of apparent futility of things, the song avoids self-pity. The concept of the race offers the poet a piquant image to describe both his life ordeals and the handicaps of his community, for they joined the wider Nigerian national politics with disadvantages. Two crucial images convey the message the poet wishes to put across, namely: the image of someone running a race with his or her legs tethered, and the image of someone who is involved in an incident in which he or she has a head-on collision with an object. Both help to give a sense of the magnitude of the obstacles that the subjects of the song face, and they underline the heroic spirit that enabled them to prevail over their circumstances. Far from being despondent, the poet is anticipative, for he takes heart in the belief that things could have been worse and that himself and his people are really lucky to have life if nothing else.

The significance of another of Igbang's songs *Nwu L' Opi Ny' Adang Me* (Improve Your Fatherland, Then) lies largely in its use of moral exhortations to urge receptivity to new ideas as the only wise political action open to Igede people in their search to achieve parity with other Nigerian peoples. The performance of this song utilized the third method of composition (described in chapter 1), whereby the group sings a chorus and provides an inspiration for Igbang to compose. The intensity of the musical accompaniment, as the group sang with agitated abandon, and the enthusiastic response of the audience, all this, unfortunately, cannot be captured in print.

Nwu L' Opi Ny' Adang Me

Chorus: Ume r' ilah, ahi ka d' ubilah nyamu le
Ume ny' odeheh rilah ahi ka d' ubilah nyamu
Ume r' ilah le, ahi ka d' ubilah nyamu

Igbang: Sardauna ti nwulah odeheh enumwu
Opi nyamu ti j' agwugwu 5
Abubakar ti nwula odeheh enumu
Opi nyamu ti j' agwugwu.
A k' Ibahi ikorota juwa,
A k' Abakpah ikorota juwa
A k' Ijos aka ye ka! 10
A yee, epwa nyamu j' agwugwu!
An ala-apwu ny' aligede
Anu totu pilee ham oh!
Onongohe m' eru ny' eheh
Gbuh igwuh ny' eheh ka ka 15
On' o mile mil' olugbah aka kpa ch' enyi lee
Inu nyang a hwoh l' owa ejih aka biri lee
Akamah y' eng ka
A j' abw odeheh la ka
Oligwuh nyang a jih k' enumwu 20
Ijwuh nyang a r' ilah
'M ediye ojuju r' ediy' odayih ka ka
urwoh pile nyamu y' ahi da w' aji le, oh!
Abe pa a t' ugbeyi-ugbeyi
Utujwoh ch' oke nyam ochi ka 25
Anu y' Ogwugwuh adawa l' ida
O y' ururu ny' owa nyi b' ela
Ogwugwuh a m' onyi nyang
A kp ehi mi mi ka moo!
A kp ehi mi mi ka moo! 30
An' alupwu ny' aligede
Anu t' otu pile h' am oh!
Anu ka d' eru
Anu d' oliduh ka ka!
Anu ka duh k' w' ojah 35
Anu d' okpila ka ka!
Anu ka d' eru
Anu d' ochaga ny' el ka!

Improve Your Fatherland, Then

Iruh: When the grass burns, we hunt its field
When the grass of the world burns, we hunt its field
The grass has been burned, we must hunt the field

Igbang: Sarduana did better the world in his day
His fatherland was left in a mess 5
Abubakar bettered the world in his day
His land was in a mess:
If you go to Iboland there are tarred roads,
Go to Hausaland there are good roads
Once you reach Jos you won't see any of that 10
You see, his fatherland is in a mess!
You educated ones of Igede
Do get yourselves composed
No one who answers the call of the community
Ever dies for answering a call to public duty 15
A kindly mouth is what a widow uses to fetch water:
It is when your mouth is grumpy it spoils the land
Until suffering has afflicted you
You cannot understand the world
Your friend was away the other day 20
And your yam got burned in the fire
I say a tiring trip is not exactly a postponed trip
Urwoh hangs head downward,
Abe is perpetually on the road
Utujwoh hiccups incessantly: 25
You see Ogwugwuh their father weeping;
He says he is an unlucky person
Ogwugwuh, when bearing your children,
You take good care with bearing them
You take good care with bearing them 30
You educated ones of Igede
You do try and compose yourselves for me
When you are sending someone a message,
You do not send the blind person
When you are sending someone for news 35
You do not send a deaf person
When you are sending a message
You do not send an impatient one

The impact of this song was immediate. As a large portion of the audience spontaneously took up the opening chorus and sang along with the ensemble, Igbang sang animatedly, spurred on by the choral tune. Many of the elderly members of the audience responded with laughter. Moved by his eloquence, others nodded their heads in deep appreciation. The response

of children was ecstatic: they danced all over the square. Topical and deeply reflective, the song drew the attention of the audience to the problem of political leadership in Igedeland. A good example of the use of mixed forms—vilification, reverse praise, proverbs, metaphor, analogy, and so forth—the performance of this song was rated by a large cross section of the audience whom I interviewed as a great success. Everyone agreed that Igbang was a wise individual whose store of wisdom is inexhaustible.

That Igbang gains his knowledge mainly from the observation of everyday Igede reality is made obvious by the central image of this song, which he derives from one of his people's familiar occupations—hunting. The immediacy of the song's appeal on his audience demonstrates the people's mental agility as well as their willingness to confront some of the bitter truths about their existence. For by depicting the political backwardness of their society, using powerful images the singer means to encourage his Igede audiences to learn from their past mistakes and never allow the opportunity of change to slip by them again. This too reflects the singer's courage. Meanwhile note that the emphasis of the song is on communal responsibility and the need to break free of political passivity. Coming barely two years before the 1983 elections scheduled to usher a new group of leaders into major positions in Nigeria's Second Republic, the song also sought to educate those aspiring for leadership positions about the necessity of selfless service.

And yet the moral center of the song is a leader who would place Igede's interest uppermost on his scale of priorities. The song contrasts such a leader with the figure of the first prime minister of Nigeria, Sir Tafawa Balewa, who is reputed to have taken the entire nation to be his constituency. The poet justifiably vilifies Balewa, for Balewa's death during the first military coup of January 15, 1966 must have convinced him that Balewa was not appreciated for his vision. Hence Igbang pitches his camp instead with a more parochial leader—a leader who would regard his own locality rather than the entire nation as his primary constituency and then overcome every obstacle in order to bring that local community their share of the nation's wealth. Although this might be Igbang's despairing reaction to the aggressive politics of ethnicity within the country at the time, the conclusion reveals the poet's sense of realism. What Igbang wants is to see the Igede community at par with the other communities in the country before contemplating any programs of fairness, and the conclusion clearly manifests his courage, an attribute that is typically associated with the oral artists in traditional African society.

There is a widespread recognition of the major role songs play as vehicles for pointed commentary on issues of immense political, social, or

economic significance. In the traditional milieu, in particular, the function of the social critic is a major one, accepted happily by many oral artists. Leroy Vail and Landeg White have brilliantly shown, using songs from southern Africa, how criticism expressed in song is licensed criticism (Vail, *Power and the Praise Poem*, 41). Whether or not one agrees with the view put forward by Vail and White in opposition to the opinions of Archie Mafeje (in "The Role of the Bard"), A. C. Jordan (in his book *Towards an African Literature: The Emergence of Literary Form in Xhosa*), and Mbulelo Mzamane (in his essay "The Uses of Oral Forms in Black South African Literature"), that it is not the poet who is licensed by literary convention, it is the poem (Landeg White, *Poetic License*, 36), one can hardly dispute the fact that it is personal courage which, in the first place, inspires singers of the caliber of Igbang to express bitter truths that are capable of provoking the anger of certain segments of their audiences. At a time when it was politically incorrect to champion ethnic interests to the detriment of national ones, Igbang threw courtesy to the wind; this is what makes his utterances carry a dangerous, critical, and subversive stance. In pitching himself against the current of thought at the national level, Igbang reveals himself to be a truly local community hero, championing narrow Igede interests. It is on this level that he can be viewed as one who airs antiestablishment views and confronts political issues through the medium of song in a way that others would not dare.

The pervasiveness of the worthiness of the attitude of such performers as Igbang, who exhibits much traditional heroism and carries out his work with a high sense of social responsibility to his immediate community, becomes more obvious when contrasted with the practices of their colleagues, such as Nkrumah's personal poet, Okyeame Boafo Akuffo, who succumbed to temptations of self-interest and patronized the aristocracy.

The practices of Nkrumah's personal poet illustrates clearly the case of bad adaptation because, though he took from the Ghanaian praise poetry tradition *Apae* (the awe-inspiring appellations) he used his borrowed material primarily to flatter his master. Kwesi Yankah informs us that Nkrumah's personal poet caused the realignment of traditional poetry to take cognizance of one supreme leader to whom all the chiefs owed allegiance (Yankah, "Creativity and Traditional Rhetoric," 89). We know that this is a corruption of the Ghanaian Apae tradition because the poet used his art to suppress, rather than to expose the notorious aspects of Nkrumah's rule—disreputable behavior that A. Boadi, in his "Praise Poetry in Akan," says is customarily the central provenance of the Apae.

By contrast what makes Igbang's songs interesting is not only his fidelity to the spirit of the Igede poet in terms of courage but rather the

innovative language that he employs. Replete with poetic constructions derived from Igede communal traditions, his compositions are the creations of a highly original, committed, and inspired individual voice. In *Nwu L' Opi Ny' Adang Me*, this harmony between moral intrepidity and verbal dexterity or rhetorical force comes through many devices, all of which are subsumed under the general category of praise and vilification. For example, the song's opening proverb, *Ume r' ilah ahi ka d' ubilah nyamu* (When the grass burns, we hunt its field), is highly succinct. It urges that just as hunting is mandatory when a burning bush signals that the time is ripe for it, so every mature person should take on the responsibility of political participation at the appropriate moment. While lauding responsibility, the song indirectly condemns irresponsibility. Because it alludes to a generally well-known and accepted practice, it struck an immediate note of recognition in virtually every member of the audience.

The saying *Ongongihe m' eru ny eheh/Gbuh igwuh ny' eheh ka ka* (No one who answers the call of the community/Ever dies for answering a call to public duty) rests its power on the Igede belief in the primacy of the community. According to this belief, even the ancestors have a mandate to safeguard everyone embarking on projects whose intent is the overall well being of the society. Using the case of Tafawa Balewa, a leader who failed to heed the old wisdom and was punished for his deviant behavior, the singer then presses home to his audience the necessity of community service. The counsel here is that no Igede person should substitute his or her personal utopian dreams for the cause of the larger community. Both the poet and the majority of the audience believed that Balewa died because he failed to draw inspiration from ancestral support within his locality. This is a mild criticism directed at a national leader fifteen years after his death, but the vague moral exhortations and calls for greater local loyalty in the interests of community development are subversive in the wider campaigns for Nigerian national unity, ideals to which successive federal regimes have expended enormous energy and resources to achieve.

The *Ikorota* (tarred roads) that were made available for Igboland and Hausaland but denied to the residents of Jos, which is not far from Bauchi—the then prime minister's home—is the symbol for the modern amenities that Balewa was rumored to have withheld from his local community. This, for the singer and his audience, was Balewa's greatest crime. Thus, over the problematic issue of deciding which of the competing claims of the state and the local community should be primary, the singer minces no words in declaring his stand with his community.

The Igede society, like many other rural communities, depends for its survival on the face-to-face contacts of its members; as such, it encourages attitudes such as humility, generosity, and fellow feeling, without which there cannot be harmony within the community. On the other hand, the society presents arrogance, excessive individualism, excessive pride, and self-centeredness as inimical to cooperation. The proverb, *On' omile mil' Olugbah aka kpa ch' enyi le* (A kindly mouth is what a widow uses to fetch water) elaborates the search by the singer to utilize this authority of tradition in a modern context. The key concept employed in this particular proverb is encapsulated in the image of *Olugbah* (the widow), an apt image to convey the numerous disadvantages that the Igede people suffer as a group. It is a familiar image. Every Igede person knows the extreme helpless status of the widow. Deprived of a husband, usually the family's breadwinner, aged and without the support of children (if she had any, they most certainly would have been claimed by the cities), the widow is habitually forced by her abject poverty to depend for her survival on the goodwill of her neighbors. The expression *Ch' enyi* (fetch water) is metaphorical; it symbolizes all the help the widow gets from her neighbor's goodwill—food, shelter, and clothing. The relevance of this proverb lies in how it employs the humility—indeed, even the poverty—of the widow's circumstances to make a forceful call on Igede sons and daughters in leadership positions to resist any pugnacious acts that might divert their attention from their community's mission, which has been placed in their trust. For, overall, the proverb sounds an indirect warning to the audience against coming to politics with such passions as arrogance, vulgar ostentation, and the general culture of greed, all of which characterized the lifestyle of politicians during the Second Republic.

The emphasis upon the supremacy of the community that finds expression in a multiplicity of devices in Igbang's song reflects his obsessive concern for the health of the Igede people as a group. Taken together, the string of ploys in lines 18–21 stresses a common theme: the fact that no individual however powerful or successful can be self-sufficient. The recognition of the necessity of solidarity and cooperation is embedded in the idea of a world full of imminent danger and insecurity that requires the collaboration of individuals for the purpose of survival. Obviously the *Ijwuh* (yam) that got burnt (*r' ilah*) in the absence of a helper refers to the aspirations of individuals who require collective effort for their enhanced realization. In a rural community, such as Igede, whose farmers habitually subsist on *ijwuh ojujuh* (roast yam), both on the farm and at home, the impact of the saying is immediate for every farmer knows the hunger

he or she has to endure when having to look for a fresh yam seedling to roast because an original one was lost to a flaming wood fire.

The proverb that says, *M' ediy' ojuju r' ediy' odayi ka ka* (I say a tiring trip is not exactly a postponed trip), also hinges its potential for popular appeal on a commonsensical observation. It is the Igede equivalent of the English saying "One who is slow and steady wins the race." Both constructions counsel patience and care in every undertaking. In its context, the Igede variation of the proverb warns the aspiring politicians in the community to approach their task with caution, not haste, which might lead to inimical mistakes.

But it is in the allusion to the experience of *Ogwugwu* that the most moving picture emerges from Igbang's image-making strategy. Because this usage capitalizes on the well-known anguish of a bird in Igede legend who has the misfortune to have fathered children that are all sickly, it is particularly impressive. These unusual birds who are seen daily in the Igede natural world include *utujwoh*, who hiccups incessantly, and *urwoh* and *abe*, who could die at any time from exposure to cold and accident as they perpetually hang head downward from tree branches or land on the road. The appropriateness of Igbang's employment of the vilification term Ogwugwu to characterize the Igede group derives from the originality and passion with which he expresses himself. The image is very striking; it starkly highlights the misfortune afflicting Igede people—who lack the right caliber of sons and daughters to lead them well—and it poignantly illustrates the enormous endurance capacity of the group. The song derives its appeal from the intensity with which it urges understanding of the way in which the necessity of care in choosing a life partner also holds true for political partnership. In spite of the overwhelmingly gloomy picture, Igbang ends the song on an optimistic note, by explicitly dreaming of the future birth of the illustrious children—to whom he speaks with authority and vision, intelligence, and patience—as being the prerequisites for the overall development of the fatherland. His sense of balancing realism and dream might explain his huge success in eliciting an immediate and meaningful response from his audience.

Ichegbeh resembles Odeh Igbang in that communal concerns are the center-piece of his compositions, and he is at his best when manipulating proverbs, maxims, images, and praise and vilification techniques. Ichegbeh talked about his poetic aims with me in an interview on July 28, 1981. "As we are one people, whom God has delivered together," he told me, "let us all Igede people try and see how we can live and work amicably together." He added:

The songs that I sing ... the music that I play ... I do these things so as to teach our people our history, the things that happened to all of us together.... What we have in common is what is ours. All of us must come together. You educated people must show the light. Farmers ... I farm ... because I love the land, and it is the something of my father, which he passed on to me.... Indeed all professionals—traders, hunters, everyone of us—must unite. We children of Igede need to do what other groups are doing to help themselves. Let us get involved in communal development. The making of progress is something people struggle for ... it is only through unity that we can make any headway. I see my songs and music as contributing to that effort to achieve a political unity of all people. My work also concerns economic well-being. You see our people migrating to the farmlands of western Nigeria. You have seen how the absence of opportunities at home has led to extreme hardships. (Interview with Micah Ichegbeh, July 28, 1981)

Thus, Ichegbeh defined progress in terms of political order: peace, security, and pan-Igede unity. Healthy political conditions alone, he thought, could guarantee both individual and group welfare in the society. And so entertainment alone is not Ichegbeh's goal but rather the role of influencing the political, economic, and moral life of his people. Education is the most crucial task he wants Adiyah praise songs to accomplish. He believes that morality and politics are connected together. As he himself puts it:

The fear of the Lord must guide us in everything we do. No effort that we make without guidance of the wisdom of God can bring any result. Rulers, those who lead us, must be responsible individuals, not people who drink from morning till night, tell a lot of lies ... untrustworthy people. Let us choose those we can have faith and trust in ... those people in whom we entrust the fate of our people in their hands have to be good people. Nowadays things are no longer as normal as we expect them to be.... Fathers and sons, mothers and daughters are fighting. Greed and the love of money have dominated all human endeavors and aspirations. All these things must change.(Interview with Ichegbeh, July 28, 1981)

Accordingly, Ichegbeh conceives the creation of his songs as a means to formulate healthy ideas that could result in the harmonious existence of all Igede people, not only with themselves but with Nigerians and all man-

kind. Thus he seeks through his songs to discourage all attitudes that negate justice, responsibility, fair play, love, and understanding.

With respect to his Igede audiences to whom he specifically addressed his songs, Ichegbeh aimed to resolve the ambivalences, whereby the people's potential for greatness was precariously balanced against its ruin by animosity, and the massive potential conflict between various interest groups in this apparently unified community.

> We, Igede people, descended of one unit. . . . We come from one place of origin. But you have seen massive divisions today. If you move in the land you are no longer sure of your safety. It causes lack of peace of mind greatly. I use songs to take hold of the past for the benefit of those who have forgotten it . . . the children born away from home in foreign lands, and those yet to be born . . . all of them will come to learn about their past. (Interview with Ichegbeh, July 28, 1981)

As I shall show, this self-conscious foregrounding of Adiyah's didactic intent is a major source of its aesthetic appeal. It testifies to Ichegbeh's creativity that the themes, values, and visions of beauty portrayed in his songs are those that have been of interest through historical times and in all cultures: the struggle between anarchy and order, conflicts of power, quests for freedom, perceptions of justice and injustice, and so on.

The rendition of the song *Awolowo kp' Ubwo kaka gw' Ishagari* (Awolowo Did Dare to Touch Shagari) demonstrates pointedly that even though his immediate audience is the Igede people, Ichegbeh understands that in order to have an enduring appeal, he must transcend the local and immediate. The song celebrates political victory and, by so doing, mocks political defeat. The result of the performance was a real victory for Ichegbeh's group. The audience yelled in jubilation and rose in unison to roar out a thunder of applause so loud that it was heard many kilometers away from the site.

> Awolowo kp' ubwo ka ka gw' Ishagari
> Imaa ka mile
> Ima ka mile e e e !
> Imaa ka mi
> J' abwo k' Omakwu kp' ubwo ka ka gw' Ogo Okpabi 5
> Imaa ka mile, Ima ka mile e e e
> Imaa ka mi
> NPN, UPN
> Ima ka mile

Ima ka mile e e e 10
Imaa ka mi

Awolowo did dare touch Shagari
A duel is in the making
A duel is in the making, surely!
A duel is in the making
Just like Omakwu did dare to touch Ogo Okpabi 5
A duel is in the making
A duel is in the making, surely!
A duel is in the making
[Between] NPN, UPN
A duel is in the making 10
A duel is in the making, surely!
A duel is in the making

The song is a good example of brashful expression of praise by Adiyah. It seizes on events that transpired during the national elections that took place in Nigeria in 1979 (two years earlier). The elections had been intended to usher in civil rule in the then newly adopted presidential system of government, commonly known as Nigeria's Second Republic. Awolowo refers to the late Chief Obafemi Awolowo, the defeated presidential candidate and leader of the Unity Party of Nigeria (UPN), while Shagari is the victorious candidate of the National Party of Nigeria (NPN), who became the first elected civilian president of Nigeria.

Omakwu and Ogo Okpabi were the two contestants for the constituent assembly vying to represent the Otukpo/Oju local government's area constituency. Omakwu, who is a native of Idoma, was fielded by the NPN. Ogo Okpabi, an Igede, contested the elections on the platform of the Nigerian People's Party (NPP), and was declared the winner in that election. The legal battles that ensued when Chief Awolowo went to court to contest Shagari's election were also paralleled at the local level by the legal actions that Omakwu had instituted in a bid to get Okpabi's victory nullified.

While it is tempting to read the song as a declaration of Ichegbeh's allegiance to a particular party, this will, however, not be exactly correct. It is important to note that many complex issues were involved. For instance, in the geopolitical arrangement in the country at that time, UPN drew its representation largely from the Yoruba-speaking states of the old western Nigeria and Bendel State, and NPN dominated the old North,

while NPP was supported predominantly by the Ibo-speaking states of the old Eastern Nigeria. Igede, located in Benue State, is part of the neutral Middle Belt.

For the above reason, what interested Ichegbeh was the oppositional representation of the winners (Shagari and Okpabi) versus the losers (Awolowo and Omakwu)—an arrangement that had favored the Igede candidate. When asked, a few members of the audience showed that they understood that, rather than celebrating the cult of heroes or the victory of any particular party, Ichegbeh was showing his distaste for the bitterness that had characterized party politics in the country. They deplored along with the poet the situation in which politics was conceived as a battlefield and one's political opponents were regarded as enemies that must be fought with every available weapon.

It is in this context that, they explained, Awolowo's dare to touch Shagari becomes an apt obloquy to express the political gesture—his contest of the elections—which was received as a physical blow that the opponent had to return with a heavier blow. These members of the audience also showed that they were aware that in many parts of the country many similar implacable confrontations had actually taken place between political opponents during the 1979 elections in Nigeria.

A close look at the song's poetic properties reveals the singer's adept handling of many complex issues by means of suggestive language reminiscent of what David Cook formulates, in his captivating book *African Literature: A Critical View*, as comprising a true poetic language—one that is typified by its greater concentration of effects. Cook notes that it is "the greater technical complexity of a poem [that] makes it capable of bringing together many aspects of an experience, not one after the other, but at the same time." Although Cook recognizes that "certain forms of prose ... make the same attempt," he does rightly state that it is predominantly the role of poetry to "explore the limits of expressing many different matters simultaneously" (44). The audience members who I interviewed also confirmed the song to be the work of singers fully aware of, and responsive to, the power of the word as an instrument for affecting the human mind.

The performance of the anthem song *Oheh m' Aligede L' Ilohi* (God Willed, We Igede Won Our Freedom), which takes up the preoccupation of the preceding tune, makes it even clearer that what the singers seek is unity among all Igede people: the singers are not interested in any frivolous display of linguistic competence for its own sake but are out to celebrate and champion the gains of unity and the attendant political power.

Oheh m' Aligede l' Ilohi
Oheh mi, Aligede l' Ilohi, eh eh
Aligede l' Ilohi, eh eh
Aligede l' Ilohi, eh eh
Oheh mi, Aligede l' Ilohi, eh eh
Aligede l' Ilohi, eh eh 5
Ahi d'ewu eneh ka,
Aligede l' Ilohi, eh eh

God willed, we Igede won our freedom
God willed, we Igede won our freedom, truly
We Igede won our freedom, truly
We Igede won our freedom, truly
God willed, we Igede won our freedom, truly
We Igede won our freedom, truly 5
We did not have to fight a war
We Igede won our freedom, truly

In this brief benedictory song, the singers rivet attention on the deeper significance of freedom. They create an indirect link between an Igede son's political victory over the representative of Igede's erstwhile oppressors, the Idoma. The involved and enthusiastic response of the audience, expressed through vigorous dance and chorus, showed the communal nature of the *Adiyah* event; in that event, Ichegbeh was merely the leader, directing a drama that relates the collective dreams and aspirations of the group.[2] It also was clear that the group aimed through its songs to expand the awareness of the audiences so that the members could perceive Ogo Okpabi's victory over Omakwu as the direct outcome of unity among Igede people and a sign of hope and confidence in the future.

Nevertheless one fact that the group leaves no one person in the audience in doubt of is that the group harbors some fears about Igede people's preparedness to safeguard the political gains they have made. Although this is the topic of the main song, *Egoh Ny' Igede* (The History of Igede), Ichegbeh had to preface it with an introductory tune, a sort of warning, entitled *M ja ka y' ela* (I Am Going to Speak Out!).

M ja ka y' ela!
Akpam ny' ongo yala, m' ja ka yala
Akpam ny' ongo y' ala, Mja ka y' ala
Okwute O ny' Oibe,
Akpam ny Ongo yala mti-ti yala

Am a mira ny' ala-iya-ya ka, oh 5
Akpam ny' ongo y' ala, mja ka y' ala
Mja ka ya lee, ehe ehe!
Mja ka ya lee, oho oho!
Am a mira ny' ala-iya-ya ka, oh
M ja ka y' ala! 10

I am going to speak out!
You regard me as someone who speaks out, so I'm going to speak out
You regard me as someone who speaks out, so I'm going to speak out
Okwute, son of Oibe
You regard me as some one who speaks out so I speak out
I never intended speaking out, alas 5
You regard me as someone who speaks out, so I'm going to speak out
I am going to speak out, surely!
I am going to speak out, unfailingly!
I never intended speaking out, though
I shall speak out 10

This helped cast the audience in the right frame of mind for the bitter truth contained in *Egoh Ny' Igede* (The History of Igede), a song in which Ichegbeh identifies an important attribute lacking among the Igede people: the sense of self-preservation. An arresting feature of the prefatory song is the several modes of oral praise expression it employed. For instance notice how the sneering, threatening tones of the Igede words *ehe ehe, oho oho* contribute to the build up of the poet's own courage. Okwute Oibe refers to the man who hosted the occasion. Ichegbeh says that the invitation thrown at him to perform is the equivalent of a challenge to speak out. The expression *ongo y' ela* (someone who speaks out) is thus a praise epithet connoting not only ruthless honesty and courage but also uncommon discipline and devotion to one's vision and community. These are the qualities to which the poet gives his fullest support in the main song of the evening *Egoh Ny' Igede* (The History of Igede).

Although the poem had never made it into print, there was clear evidence from the night of the performance that *Egoh Ny' Igede* would in time become a major event in the Igede literary tradition. The song possesses a truly grand theme. What the singer did, in order to establish his case for a crucial quality he found absent among his people, was to create a song that took the members of his audience back to their earliest recorded history. Like Wole Soyinka, who showed his fellow Nigerians simi-

lar unflattering images of their inglorious ancestors when his play *A Dance of the Forests* opened to celebrate Nigeria's independence in 1960, Ichegbeh's overriding aim was to shatter any illusions of grandeur the members of his audience might have had of their past. For this reason, he unfolded his story in a vilification style by shunning pose and pretentiousness for moving honesty that bordered on severity and clinical realism. I present here both the transcript and my translation of this lengthy legend, which clearly shows the awesome creativity of the composer.

Egoh ny' Igede

M l' egoh okpokpoh k' am ka gbeh
M l' egoh okpokpoh k' am ka gbeh
Orih k' anu k' uru, m l' ojah k' m ka jah
Orih k' anu k' uru, m l' ojah k' m ka jah
Uka ny' ogbanye, uka ny' ogbanye-ogbanye 5
Uka k' or' uka ny' ogbanye
Ahi bw' ihu Niger
Ahi bw' ihu Niger
Ihu Niger Aliged' a bwuh w' igele le
Aligede bal' alora mila n' epwa 10
Aligede bal' alora mila n' epwa b' awule
Uka m' d, onu ch' ejih igbino m' bing yekee,
M' am bw' ogene gene ka
Chaji m' bw' ogenegene ka
M' j' abw' ogbile la ka 15
Duh k' en' ogwuh gbuh ejih le
Ahi bw' iye bw' egbita
Oh, ahi bw' ihu Niger
Ahi bw' ihu Niger
Uk' aligede bal' alora mila n' epwa b' awule, 20
Aligede bal' alora mila n' epwa b' awule,
Uka k' ineheh chijah
Ameh mila kwamu
Enyi kwamu kwehi ka
Enyi kwamu kwehi ka 25
Enyi kwam' anyang a g' amu-enyih
Aligede k' epwu-ogoh ka ka ch' enyih
Ahu k' epwu-egoh ka ka ch' enyih
Alora k' epwu-ogoh ka ka ch' enyih

```
                Ahu k' ogoh ka ka ch' enyih                                    30
                Aligede y' enyih chi ka, oh oh oh!
                Alora mila y' enyih chi ka, oh yeeh oh, ogoh!
                Oowa le, alora a b' ota ny' Aligede eneh epwu-ogoh
                Alora b' ota ny' Aligede eneh epwu-ogoh,
                Uka ib' ota ny' Aliged' eneh, ih' ogbohkeke                    35
                Alora h' ogbohkeke
                Alora b' ota ny' aliged' eneh ih' ogbohkeke
                Uka ib' ota ny' Aliged' eneh, in' ih' ogbohkeke
                Adegede ny' adam am a mi ka ka oh!
                Adigede ny' adam am a mi ka ka eyeh, eeh eeh!                  40
                Aligede b' ora bih yekee oh,
                Iwa nyi w' ogbohkeke ka, nyi y' ota-ota ny' iwa h' iwa!
                Aligede b' alora yekee, oh, iwa nyi ka je w' ogbohkeke ka!
                Nyi y' ota-ota ny' iwa h' iwa!
                Ori k' anu nyi y' ota-ota ny' iwa h' iwa ka, iwa bal' anu nyi ka d'
                    ewu!                                                        45
                Oow' alora w' aligede ela yekee,
                Iwa w' aligede ya, ela-onyeweh nyi kpeheh kpukpu!
                Ela-onyeweh nyi kpeheh, el' onyeweh inyi kpeheh!
                Ela-onewe nyi kpeheh odeheh lume!
                Iripara nyi nwul' ojeh, Iripara nyi nwul' Ijeh                  50
                O nwula ota l' ale eyeh eeh eeh!
                Imakanike nyi nwul' imotoh, imakaniki nyi nwul' imotoh,
                Nyi nwul' ota ka eyeh eeh eeh!
                Alora j' abwo k' ika ho ka ka
                Alora j' abwo k' ika ho ka                                      55
                In' ih' ogbohkeke h' aligede, aligede ny adam am ati mi ka ka
                El' oowa adu mila j' omu-ewu le
                Du k' aligede bal' ora mila d' ewu
                Alora bal' Aligede mila d' ewu
                Alora j' abwo k' ika h' al' ale                                 60
                Aligede j' abwo k' i ka h' al' ale
                Alora j' abwo k' ika ho ka ka
                Uka k' iwulejih ny' ew' oda da
                I wulejih ny' ew' oda da,
                Iwulejih ny' ewu-oda t' awule                                   65
                Alegede wulejih l' uda le, oh!
                Iwulejih L' okoni
                Iwulejih L' ema oh!
                I wulejih L' ema
```

Alora ka wulejih ny' ew' odada, 70
Iwulejih l' unyire,
Unyir' o kp' ojeh o ch' onu-ineh
Ole k' or' okpe ny' adam
Ny' oka y' abwo m' abwo kpa ka ka, oh!
Ny' oka y' abwo m' abwo kpa ka ka, oh! 75
Anu je k' anu k' uru!
Ubwo nire bw' orogoh-orogoh ny' adam ooh! ohah!
Ubwo ka nire bw' orogoh-orogoh
An' Aligede, m' olinyi ka, anu ya jem oh!
Ewu rw' onginyi l' aleheh eeh 80
Ewu by' onginyi l' aleheh!
Ewu rw' anginyi l' aleheh lume!
Aligede bal' alora mila n' epwa
Aligede bal' alora mila n' epwa
I d' ewu t' awule 85
Alora nw' aligede kw' ehi ka, oh, ohah!
Alora nw' adigede cheche ka,
Chaj' alora mila r' okwu
Ubwo nira bw' orogoh-orogoh le
Ubwo ka nira bw' orogoh-orogoh le oh! 90
Alora nw' adigede ny' adam eeh ayoh
Ang' imanyi-imanyi ny' aliged' ile ki hih
I r' unye k' Edumoga l' oduh
I r' unye k' op' ny' Edumoga l' oduh
Anyi ny' al-edumog' ile k' ijuwa b' alora ya 95
Alujih ny' anu nyi ru le ka
Ny' jw' epwa ny' adidiwa!
El' oow' el' oow' ati du k' Imayika Ichegbeh ya
Enu k' olujih nyang a dang ijwuh
Aka r' awe-ikpe-egbeh rih rih le! 100
Alora wulejih ka ka juh k' Edumoga l' epwu-oduh jijih jih
I mi mi kw' aligede bwa
Aligede wulejih l' epwu-oduh jijih jih jih
Alora kw' Aligede b' opi ny' Edumoga l' epwu-odu
Aligede wulejih b' opi ny' edumoga ka pw' ariri ny' ugbeyi 105
Aligede y' ira-okpokpoh h' awul' uka k' ip' ariri ny' ugbeyi
Iwa ny' w' uje-ugbeyi
Aligede w' uje-ugbeyi kiloloh
Aligede k' epw-ame ka ka ch' apwu
Aligede k' epwu-ame ka ka ch' apw-ijih 110

Iy' apwu d' uje peh peh peh
Iy' opi d' uje huleh huleh
Aligede k' epu-ame ka ka kp' ibaa
Uka k' ahi pye l' uka ny' ojeh ihikichu l' uturu,
Alora ja kw' unyire ja wari ki ka t' Aligede ayirejih 115
Onwu m' onwu je yekee,
Oheh nwung ka, opi r' iyoh ka ka oh!
I jaa kw' unyire ja wari!
Angiwa a ch' abwo kp' uje wurum!
I kw' unyire ja wari, 120
Alora ch' abwo wurum, ch' abwo kp' uje wurum
Iwa ch' abwo kp' uje wurum, ch' abwo kp' uje wurum!
Oligede kpeheh b' epwu-ame wari, kpeheh bw' epw-ame wari
Oow igbileh ema ny' a bw' ohi
Aligede gbileh ema ny' awa b' ohi pila la la lah! 125
Igbileh ema nyawa ka ch' alor' egbejuh,
Oow ipw' iwoh i l' egbapwu ny' unyire
Iwoh o le-egbapwu ny' unyire
Iwoh o le-egbepwu ny' unyire,
Owa r' ehwong-oju-ubwo ny' aligede 130
Du k' enu m' enu ka ch' onginy' egbeju ka ka,
I y' ehwong j' ub' ododuh ka,
A y' ehwong ny' ogirinye j' ubwo ododuh
Ukpoh ny' ogirinye ja ka wuung!
An' aliged' upwuma-iwoh kwurita, m m' onu leh? 135
Inyam am r' ito m ja t' onu woh!
Aligede ch' alor' egbejuh, ch' alor' egbejuh
Oow' aligede d' owiwihyih:
Wiih wiih yiih iih!!
Wiih wiih yiih iih!! 140
Aligede wulejih ja je keleh ka pw' Oyongo le
Oyongo mi ch' uka ch' uka d' uwa
O mi ch' uka ch' uka d' uwa
Aligede hw' ehi k' uhyeh i ch' w' ejih
Aligede j' abwo k' ika ho ka ka, ooh 145
Ikp' enyih golo ny' adida
Ojiga b' Aligede yekee,
Uk' owa r' uka ny' urenu le, oh!
Okojih onyonyi j' w' apwu nyamu
Uka k' ow' apwu kpa, apwu-inyewe ja juuh ruwa 150

Aligede kp' enyi golo l' ojiga,
Ojiga b' Aligede yekee, anu nyi y' ang iruyeh j' ejih,
Anu nyi ka kp' oyeh ny' oba ka ka oh!
Anyang a kp' uhyeh ny' uturukpah le
Uka k' anyang ch' ehi ka y' upwu ny' uturukpah le 155
Inyiyo ch' ewoh da da k' ika y' upwu ny' oho nyaa
Ugbeyi y' ang iwaa le, ooh
Inyiyo chim am ewoh eeh eeh!
Oowa le, ich' abwo b' enyih Oyongo le lee ee!
Ang' iruyeh a ch' abwo, anyang iruyeh a ch' abwoo 160
Du k' Oyongo a papah iruyeh duwa le, ooh!
Enu m' enu ka keleh, iyah a ka yoo
Uka k' Oyongo p' apah iruye duwa gida gbah,
Papa iruyeh gida-gbah, Oyong' a papah iruyeh gida-gbah
Ongo ny' ogbanyi-ogbanyi ny' adigede 165
Ong ole k' or' ongo ny' ogbanyi-ogbanye
O h' ang oj' eje h' aligede, eeh eeh!
Ong owa y' eputu-ubwo b' oye-uka, oowa y' epetu-ubwo b' eyeh-uka
Akachwu-iru ny' ongowa ru duwa le
Iru duwa d' ale we! 170
Enu m' enu ka keleh, a ka dayi lo yoo ka ka!
Anu j' abwo k' omila duh k' Imaika Ichegbeh je ee?
Ongo nepwa b' egejih odayi lo j' abwo k' egejih y' ebi ka ka!
Adam an' epwa b' Oyongo chih le, eeh!
Adam an' epwa b' Oyongo chih le, eyeh eeh aah! 175
Aligede kpeheh ny' oba kpu kpa, kpeheh ny' oba kpu kpa,
Imi j' nw' aligede ny' adam!
Aligede y' ang oririh ka
Ij' abwo k' ika ho ka
Imih nw' aligede ny' adam 180
Anu kpitiya ny' ewu ny' Ibiafra kaah?
K' imih nw' al-Ibahi lume?
Alobahi l' ang oririh ka, oh!
Adada bal' inene, m r' Isoja k' epwu-ame ka
Oj' aka kp' oyih k' eru le! 185
Uka k' alo-obahi l' ang oririh ka, ooh!
Ikpang iy' ima ka
Oprimamah a r' ima od' oho le!
Inyi inyiny' omila la, aligede oh!, ehi ka y' ugbeh ny' okojih
I chi ehi k' y' ugbeh ny' okojih, j' abwo k' onwu ba 190

Aligede b' ogogoh inene yekee:
Ogogoh ny' onyang, ony' inam eeh,
Kp' ugbeh ny' okojih k' onu jabwo k' ol' amila ya jehi!
Ogogoh ny' onyang ony' inam, kp' ugbeh ny' okojih k' onu yee.
Ogogoh ny' onyang ony' inene oj' abw' o ka ho ka 195
O hw' ehi k' uhyeh, o mila y' opi,
Inene j' abwo k' oka ho ka
Anu j' abwo k' omila duh k' aligede b' ogogoh ny' onyang ony' inen'
 i nyi?
Ogogoh ny' onyang m' anyi h' epw' wuuh le
Ogbuh l' en' owa j' apyobwuna h' aligede ka ka! 200
Inene a kp' ugbeh ny' okojih k' onu ye, ah!
Inene a kp' ugbeh ny' okojih k' onu ye le, ooh!
Uka k' inene kp' ugbeh ny' okojih k' onu yee lee, oh oh!
Inene nyam a kp' ugbeh ny' okojih k' onu yee oyoh eeh eeh!
Aligede t' ela woh yekee, anyi nya mila la 205
Inene a y' ubwo nya a behbeh beh
Inene pwo k' epwo-ogoh ka ka nw' enyih
Uk' ojaa ny' epwu-ogoh ka ka nw' enyih
Oya nyi l' ile weri-weri,
Nyi l' ile weri-weri, 210
Ong owa r' ugbochokoh ny' adam le!
Ogbochokoh r' oje
Ugbochokoh r' oje
Oje a r' ogbahi ny' enme le
'M mon' anu ya jem me! 215
Enu m' enu k' abya mam,
Am akp' ilam ki l' inyih ma ma l' enu ka!
Oliye ti? Chaji ichiri nyi-enu ja k' egoh!
Iyah Ez' adam, aah!
Iyah Ez' adam eeh eeh! 220
'M gw' ogboh ny' op' adam!
M gw' ogboh ny' op' adam!
Oowa l' aliged' ihyekw' aj' ediye nyawa
Aligede wujejih ny' ediye nyawa, ah, ahah!
Aligede wulejih ny' ediye nyawa ka' kw iga ny' utu-okenge, 225
Utu nw' ejih-ejih bede
Angihe ch' ehi ka ka y' iloh
I gbil' ema ijaa kwuoo
Ang ikila bw' oyeh okila ny' ugbehi ru

Uk ije ka pw' ariri ny' ugbeyi le 230
Oow it' awul' ela-ela woh yekee:
Any' adidiwa-ihyekwuh nyi ti k' ale?
Iya nyi y' uwo nyi ja kwu-uwo!
Iy' uw' ikw' uwo
Duh k' ah' a rih Uwokwu le! 235
Iy' adidiwa-ihyekwu nyi ti k' ale?
Anina bw' orogoh-orogoh
Ino, anina bw' orogoh-orogoh le,
Anina ny' Aligede bw' orogoh-orogoh ooh!
Anina ny' ahi bw' orogoh-orogoh ooh! 240

The History of Igede

I have a history to narrate
I have a history to narrate
If you listen, I have a story to tell
If you listen, I have a story to tell
In the beginning, in the very beginning of time 5
At the time when it was the beginning of time
We came from the River Niger
We came from the River Niger,
It was from the River Niger the Igede came to this place.
The people of Igede and the people of Ora did live together 10
The people of Igede and the people of Ora did live together
When I first saluted the earth I said to you
That I did not come of intricate ways
Because I do not come of intricate ways
I do not know what Ogbile looks like 15
Which is why whenever a death occurs in the land,
We pass two to three ways
Alas, we came from the River Niger
We came from River Niger to this place
When the people of Igede and the people of Ora lived together 20
The people of Igede and the people of Ora did live together
When the dry season commenced,
The green grass had become scarce
Water was scarce in no small way
Water was scarce in no small way; 25
Water was scarce and women did not have water

An Igede person went to the stream to fetch some water
A wife went to the stream to fetch some water
The person of Ora went to the stream to fetch some water.
A wife went to the stream to fetch water 30
The person of Igede did not get water to fetch.
The person of Ora did not get water to fetch either
Then, the person of Ora broke the [earthen] pot of the woman
 of Igede in the stream
The person of Ora broke the pot of the woman of Igede in the stream
When they broke the pot of Igede, they apologized 35
The people of Ora apologized
The people of Ora broke the pot of the people of Igede and apologized.
When they broke the pot of Igede they apologized
The Igede of my father did not accept at all
Alas! my Igede ancestors did not accept, 40
The people of Igede told the Ora people,
That they do not accept apology, that they should be given back
 the very [broken] pot
The people of Igede told the people of Ora that they would not
 accept apology!
That they should be given back their original pot!
That if they were not given back their pot, they would go to war 45
Then the Ora people replied to the people of Igede
They replied to the people of Igede that a new matter had arisen!
That a new matter had arisen, a new matter had arisen!
That a new matter had arisen in the world, indeed!
That a repairer repairs a bicycle, a repairer repairs a bicycle. 50
But he has never repaired an [earthen] pot
A mechanic repairs motor cars, mechanic repairs motor cars
But he doesn't repair [earthen] pots
The people of Ora did not know the line of action to take.
The people of Ora did not know the line of action to take 55
Indeed, they gave apology to the Igede but the people of Igede
 of my father refused
Which is the root cause of the trouble;
Which is why the people of Igede and the people of Ora went to war
The people of Ora and the people of Igede did go to war
The people of Ora did not know what line of action to take 60
The people of Igede did not know what line of action to take
The people of Ora did not know what line of action to take.

When they set off for the war
When they began to fight each other
They started to go to war with each other 65
Alas! the people of Igede started with bows,
They started with the [dane] gun,
Alas! they started with cutlasses,
They started with cutlasses
The people of Ora started to go to war, 70
They started with the horse
The horse with quarter-barrel
Which is what our father calls Okpe!
To cut the long story short
To cut the long story short 75
If you do not know, listen:
The hand slips from the beginning of time, indeed!
The hand slips from the beginning of time
You people of Igede, if this is not the truth, please tell me!
War favors one with ancestral libation 80
War disfavors one with ancestral libation
War favors one with ancestral libation truly!
The people of Igede and the people of Ora were indeed neighbors
The people of Igede and the people of Ora were neighbors
They went to war against each other 85
The people of Ora killed the people of Igede in large numbers!
 Which served them right!
The people of Ora killed the people of Igede in no small numbers
Because the people of Ora were in the right
The hand slips from the beginning of time
Alas! the hand slips from the beginning of time 90
The people of Ora killed my Igede ancestors in large numbers
The few people of Igede that survived
These ran to Edumoga in the night
These ran to Edumoga in the night
But the people of Edumoga, Ora's neighbors told them 95
That their enemies had not yet escaped
That they were in the home of their fathers!
This matter is the reason that I, Micah Ichegbeh, said
That whenever your enemy ushers yam into the mortar for you
You must surely eat a coarse foofoo! 100
The people of Igede started off for Edumoga in the deep of the night

They chased the people of Igede from there
The people of Igede set off in the deep of the night
The people of Ora chased Igede people from Edumoga in the night
The people of Igede left Edumogaland and got far on the way 105
The people of Igede gave one another one wisdom when they
 reached far on the way
That they should dig a pit on the road
The people of Igede dug a wide pit on the road
The people of Igede dug a wide pit on the road
The people of Igede went to the bush to cut leaves
The people of Igede went to the bush to cut twigs 110
They covered the pit lightly with the twigs
They spread a thin layer of earth on the twigs
The Igede went to the bush to hide
When the day broke at the hour of nine in the morning
The Ora people were riding down their horses to destroy
 the people of Igede 115
Every one knows that,
If God has not killed you the Earth cannot get meat to eat at all
They were riding down on their horses!
Those people fell heavily into the pit
They were riding down on their horses 120
The Ora people fell heavily, fell heavily into the pit
They fell heavily, fell heavily into the pit
The person of Igede came out of ambush, came out of the bush
Then they brought out their cutlasses from their sheaths
The people of Igede brought out their cutlasses swiftly
 from their sheaths. 125
They brought out their cutlasses and beheaded the people of Ora
Then they flayed the skin of the horses
The skin from the horse's neck
The skin from the horse's neck,
It is the Ehwong on the forearm of Igede people [ehwong is
 the mane of a white goat, worn only on the left forearm] 130
Which is why whenever you have not beheaded a human being
You do not playfully put on Ehwong
If you do playfully put on Ehwong
The curse of Ogrinye will afflict you! [Ogrinye is an association of
 veterans among the Igede]
You, the thirteen clans of Igede, do I tell a lie? 135

Mine is only a question that I ask you!
The people of Igede beheaded the people of Ora, beheaded the
 people of Ora,
The people of Igede shouted for joy:
Wiih wiih yiih iih!!
Wiih wiih yiih iih!! 140
The people of Igede set off and reached Oyongo
Oyongo was full to the banks
It was full to the banks
The people of Igede looked up and down!
The people of Igede did not know the line of action to take 145
They offered water as libation to the ancestors
The juju told the Igede people that,
Alas! the time was the dry season,
Every plant was shedding its leaves
After shedding its leaves, new leaves will spring up 150
The people of Igede poured a libation of water to the juju
The juju told the people of Igede that if they do not put seven
 things in the ground
You people cannot cross the river!
Then the women climbed on uturukpah
When the women saw the fresh leaves of uturukpah 155
Their bodies shook with anxiety to get leaves for their soup
When the eyes see them
My own body trembles severely!
Then they fell into the water and drowned in Oyongo.
Seven people fell, seven women fell, 160
Which caused Oyongo to split into seven tributaries instantly
Whenever you go there you won't fail to see it!
When Oyongo has split into seven parts, widely,
Split widely into seven parts, Oyongo split widely into seven parts.
The person who was the first Igede person, 165
The person who was the very first
He made a sign for the people of Igede, truly;
That person placed his palms on the bank, he placed his hands
 on the bank
His fingerprints appeared instantly on the bank rock!
They are still there today! 170
Whenever you go there you will not fail to see them!
Do you know how Micah Ichegbeh knew this?

A person who lives close to trees will not fail to know their movement!
It is my father who lives close to Oyongo!
It is my father who truly lives the closest to Oyongo 175
The people of Igede completed crossing the river, completed the crossing of the river
Hunger was killing my ancestral people of Igede!
The people of Igede had no food
They did not know what to do [to put an end to the hunger]
Hunger disturbed my ancestral Igede people 180
Do you not remember the Biafran war?
When hunger disturbed greatly the Igbo people?
The Igbo had no food
Fathers and mothers, I was not a soldier on the war front
But it is gossips that lead a thief to the farm! 185
When the Igbo lacked food, alas
If they cooked they lacked salt
The wall gecko became their salt!
So it was for the Igede people, before their eyes saw some fruits
They saw a certain fruit, very large in size 190
The people of Igede told an old woman these words:
Old woman, my sister,
Taste the fruit and tell us how it feels!
Old woman, my sister, taste the fruit and see how it feels!
Old woman, my sister, did not know the line of action to take. 195
She looked up, she looked down!
Mother did not know what line of action to take!
Do you know why Igede people so requested of old woman?
Old woman had emptied her belly of all children
If she died night or day she was of no value to Igede! 200
Alas! mother did taste the fruit,
Mother did taste the fruit truly!
When mother tasted the fruit,
My own mother did taste the fruit!
The people of Igede asked her a question, how did it feel? 205
Mother waved advisedly to them,
Mother descended to the stream to have a drink of water
On her way back from the stream where she had drank
She said it tasted appetizingly!
That it tasted appetizingly! 210

That thing is my father's ugbochokoh
Ugbochokoh is a garden egg
Ugbochokoh is a garden egg!
Garden egg preceded kola nut!
If I lie, you tell me! 215
If I was ever fathered by the hare
I would not renounce it and take myself to the elephant to father
 late in the day
The reason is because the late cowpeas will not germinate well!
Alas, my own magnificent father!
Alas, my own magnificent father! 220
I give praise to my fatherland!
I give praise to my fatherland!
Then the rest of the people of Igede continued their journey
The people of Igede continued their journey, alas!
The people of Igede fled their journey and reached the shade
 of dwarfish utu tree 225
Utu's large fruits were hanging close to the ground,
Some saw a snake
They pulled out their cutlasses and chased it
Others took the other side of the road and went away
When they got midway on the journey 230
They asked each other a question:
That where have their other brothers and sisters gone?
They said, they saw Uwo [Igede name for the specific type of snake]
 and are chasing Uwo
They saw a snake, they chased a snake
Which is why we are Uwokwu! [chasers of Uwo snake]. 235
They asked where have our other relatives gone?
Kinship was from the beginning of time,
Truly kinship was from the beginning of time.
The kinship of the Igede people was truly from the beginning of time!
Our kinship was truly from the beginning of time! 240

In this song, the singers bring together spontaneity, structural coherence, economy, and culturally loaded information in a bid to effect a drama of communal havoc engendered by human mischief and irresponsibility. Ichegbeh appropriately casts his narrative in the form of the historical epic, a form usually favored in recounting people's migrations. He comes alive as an artist engaged in a delicate exercise to balance a felt compul-

sion to recreate the painful memories of his people's past with the need to draw attention to some of their praiseworthy attributes.

Time past, time present, and the future are interwoven when the poem opens (lines 1–12). He begins with invocative formulas that do not refer to a specific date in order to underline the timeless relevance of the topic of his narrative, which he later links up with the dominant device for conveying the ceaseless cycle of the seasons in lines 21–31.

Next, the singer wins the listeners' confidence in his version of the story by declaring his credentials (lines 13–18). An arresting allusion that nevertheless needs to be explained is the vilificatory reference to Ogbile, used as a symbol of falsehood. Ogbile was a man of doubtful character in legend. When he died suddenly, an inquest was commenced to find out the cause of his death. The one member of his family who had staked a claim on his good character was brought to shame. The reference is therefore to be taken along with the proverb about the inherent controversies that deaths bring out—controversies that, as we learned in chapter 1, stem from the practice in which the Igede people characterize deaths as either good or bad. Because it is a very disgraceful thing in Igedeland for one's relation to die a bad death, which, by the people's tradition, cannot be mourned on an elaborate scale, what many families frequently do is to cover up the deceased's guilt of any foul deeds in order to turn up the judgment in the family's favor. Ichegbeh disassociates himself from such dishonorable groups; he means to say that he is an honest person whose words are good. The poet's obsession with honesty appears at first abstract; however, he soon makes it an integral part of the theme of sincerity as a guiding principle of life, a principle whose violation would result in much suffering later in the main plot of the narrative.

Throughout the song, Ichegbeh portrays tolerance, good neighborliness, love, and friendship as the other desirable attributes, and it is praise and vilification techniques that help him in realizing this objective. Thus he repeats several times over the claim about the homeland of the Igede and the Ora being around the River Niger, which made the two peoples neighbors. The idea of repeating the effort that was made by the offending party, the Ora people, toward finding a peaceful solution to the crisis that begins (when a woman of Ora breaks the pot of an Igede woman), is to emphasize that the action should have yielded love rather than the animosity it engendered. Praise and vilification forms assist in drawing up a contrast between the noble magnanimity and patience of the Ora people, on the one hand, and the priggish narrow-mindedness of the Igede people, on the other, and they prepare the audience for the moral injunction high-

lighted by the high price the ancestors of the Igede ultimately pay for their inconsiderate behavior.

On the surface, *Egoh Ny' Igede* comprises a historical account of the origin of the Igede as a group in Nigeria's Benue State. But in the event, it also embodies creation stories regarding how Igede knowledge about certain food crops and about certain sacred practices came into being. On a deeper level of meaning, the song is about survival, about political power, the struggle for its control and retainership. Thus the song contains numerous episodes featuring what Fritz Pointer refers to, in a different context, as the painful trial of skill that usually dominates historical epics (Pointer, *In Praise of Kambili*, 43). Among these tests are such obstacles as human betrayal (lines 96–102), hunger (lines 180–89), and a river in full tide (lines 142–46), which the Igede people have to overcome during their escape journey. In each event, they find solutions that are reminiscent of the sort of answers that Isidore Okpewho has dubbed responses of supernatural dimensions (Okpewho, *The Epic in Africa*, 105). While the poet is not recommending that the divination or the human sacrifice that provided these answers in the past be resorted to in contemporary society, he emphasizes the way in which the moral of forgiveness is permeated and reinforced through the concept of *deus ex machina*, namely: that it is even against the law of divine justice to crucify a repentant offender.[3]

Thematically, the passage also offers an excellent example of the role reversal that Dan Kunene has also observed from his study of Southern African heroic tales, a phenomenon in which the hero then becomes the monster-killer, the deliverer (Kunene, "Metaphor and Symbolism in the Heroic Poetry of Southern Africa," 300). Up to this time the poet has presented the Igede people as villains, and in consonance with this presentation, he has had no eulogies to sing for his ancestors. Then, as the Ora people persist to carry through their mission to annihilate the Igede, the poet suddenly takes the side, openly, of his community. The statement *Alora ja kw unyire ja wari ki ka t' Aligede ayirejih* (The Ora people were riding down on their horses to destroy the Igede people), is repeatedly stressed but with variation (lines 115–22) in order to appropriately show how the manner in which such relentless pursuit has become so excessive that it supports the moral that vengeance carried to an extreme extent turns to vindictiveness, which is bound to be returned on its perpetrator.

Actually an earlier warning had occurred in that scene where the Igede outwitted their first major opponent, the Edumoga people. The significance of the proverbial reference to the destiny of the Igede people as predestined by God suggests that, their mistakes in the past notwithstand-

ing, the Igede are now destined to prevail over their obstacles. The satiric reference to the coarse foofoo that one's enemy inevitably serves him (lines 99–101), however, reflects the extreme difficulty the people must contend with before their deliverance. The entrapment of the Ora people is memorably captured with the ideophonic expression *wurum*. The expression connotes the depth of the enemy's fall—a fall from which there can be no escape. The singer now has reason to celebrate his ancestors' resourcefulness because the battle lines have shifted. Having succumbed to the urge to retaliate the injury they have suffered, but in a manner that far exceeds in seriousness the original provocation, the Ora people have become the bully, and the Igede people the innocent victims of the Ora's unchecked brutality. This is the reason that the defeat of the Ora people thus constitutes a well-deserved poetic justice for the Igede. The battle has been transformed into a contest in which the Igede race pitted their wit and won, against the brawn of the Ora people. The *Ehwong* on the forearm of Igede people symbolizes this triumph of wit; it is not an expression of a propensity toward carnage or bloodletting. *Wiih wiih yiih iih!* (lines 130–41) commemorates the sense of joy that follows the battle victory; but what they celebrate is not any abstract notion of heroism, but rather the substance of life—death's antithesis. It is a celebration of political power, the victory to determine one's own destiny and life.

It is this quest for life, which must be secured against all odds, that leads to the discovery of food—*Ugbochokoh* or a garden egg—which sustains life. It was the leaves of *uturupa* that the women desired to use for making soup. The death of the seven women represents the motif of sacrifice as a prerequisite condition for salvation. Its effectiveness lies in the way the river Oyongo divides, allowing the Igede people passage into safety.

In his pioneering study of Mande epics, Charles Bird has been struck by the important role women play in the lives of the heroes of those epics. He notes, for instance, that although the hero Kambili plays an important role, the storyteller goes to great pains to show the debt he owes to the women in his life (Bird, *Heroic Songs of the Mande Hunters*, 282). In *Egoh ny' Igede*, a similar central role is ascribed to women in securing life for their community. And yet Igede women are the least liberated group in the society. As we have noted, fingers are pointed at them whenever a marriage fails to produce a child; in fact, a woman's true value in the Igede society is found in the number of children she can bear. Igede is a thoroughly patriarchal society, and the suffering of a childless woman in this society is so great that she is not only maltreated on earth, at burial her

body is denied even those ritual privileges that would insure the speedy repose of her soul in the world beyond (see Idikwu, *Burial in Igede*, 87).

It is interesting how gender politics of discrimination against a barren woman is enshrined in *Egoh ny' Igede*. In raising this issue in his song Ichegbeh probably wanted to motivate contemporary Igede women to assert themselves, but he also wanted to emphasize the necessity of a more open society in which men would treat their women more affectionately. In this regard, the poet is enjoining Igede men to regard their women companions first and foremost as humans, with equal rights, rather than as organs for the production of children. He is making a call for power sharing between men and women, and for an atmosphere that would not only lead to better communication in the home but also bring about greater societal harmony, enhanced economic productivity and political stability. However Ichegbeh subsumes the women's theme as an integral aspect of his larger theme of pan-Igede unity, solidarity, and survival.

Political messages of this nature have dominated every one of Ichegbeh's songs, and the popularity of the songs has been greatly enhanced by relays on both radio and television, at the state as well as the national level. On the farm and at village social gatherings, snatches of some of Ichegbeh's Adiyah popular tunes can also be heard coming from the lips of his devoted fans. The political uncertainty in Nigeria at large, growing moral decadence, and rivalries among the grassroots populations, all these form perfect subjects for the performances of Adiyah. Adiyah resembles Etuh a great deal in this important sense: the group draws lessons from societal ailments, and its songs reflect the composers' determination to restore harmony and decency in their community through effective techniques of poetic composition. As we shall see in the next two chapters, among the devices that assist the singers in their efforts to employ praise and vilifaction to grasp a sense of the immensity of experience, imagery or word pictures and proverbial usage are the most important.

FOUR

The Image Burden
Form and Function in Praise Songs

Before we explore in this chapter the nature and function of imagery in the artistic structure of Igede praise songs, it may be useful to define the relationship that exists between words and music in Igede song tradition in general. Oral literature scholars have repeatedly stressed the role of music in the performance of oral poetry, and the contribution of music to the performance of Igede praise songs and vilification songs is undoubtedly immense. According to Okpewho (cf. Tedlock), the relationship that exists between music and words in epic performances is one of almost total dependence of the latter on the former:

> The traditional bard is to a large extent a music man.... [S]ide by side with his responsibility to keep faith with words is his desire to deliver a good musical performance. To be sure, it would be disastrous for the bard to lose track of his tale completely. But many a time music has come to the rescue of a straying imagination; when the details of the tale become entangled or uncontrollable, the bard can count on the music to sustain the performance while the loose ends are being tied together.... The performance will simply not come alive if the musical support is either defective or oppressive, if the right sort of warmth has not been generated. (Okpewho, *The Epic in Africa*, 59).

Christaine Seydou lends support to this idea, but she shifts emphasis from the notion of dependency to a theory of complementarity. According to Seydou, "music and words are inextricably intermeshed; one is not subordinate to the other, rather each is superimposed on the other and each fulfils its role and unveils its part of the epic's total significance" (Seydou, "Epic Texts," 319).

This observation is certainly applicable to the performance of Igede songs; indeed we have seen that Adiyah and Etuh, in particular could not conceivably exist without the musical accompaniment. This close link between music and words is most noticeable in cases where the singer waits for his drummer to provide a rhythm that will inspire his singing, or when he himself sings a song and then provides material for the drummer, who elaborates on the theme that has been provided for him. In any case, both Ichegbeh's Adiyah association and Odeh's Etuh ensemble accord considerable importance to the musical accompaniment of their poetic delivery. The scenic presentation of their performances is also crucial in producing the overall impact they have on their audiences. While at all the recording sessions that I attended, there were in Adiyah seven male instrumentalists and an unspecified number of men and women dancers, who together provided the choral responses to Ichegbeh's singing; Etuh had no women members, but dance was given a comparable importance by the ensemble. Like Adiyah, Etuh also had a strong choral arm that was strengthened by the playing of such instruments as slit-drums (ogirigboh), basket-work maracas (icheche), single-headed membranophone drums (ubah), and metal gongs. Almost all the members of the two groups were impressively dressed. Their ceremonial dress included three *Imwu* (costumes; the singular is *Omu*), and such garments as *Ibelibeli* (a colorful velvet material worn by the most graceful and accomplished dancer in the group) and *Onyantu* (a garment of rough raffia worn by a male dancer whose traditional function is to make aggressive and threatening gestures). Each *Okwumu* (costume-wearer) was dressed in an extensively braided head mask. In addition, the women dancers in Adiyah habitually tied *Iworoh* (rattles) around their ankles to add rhythmic accompaniment to their dancing. The large feather adorning Odeh Igbang's red cap, the three stands of *Ijachi* (vibrating clappers tied to emblematic spears), *Okoh* (horn), and several *Ekwure* and *Opikeh* (trumpet) players—all add greatly to the distinctive regalia and tone of the Etuh ensemble. Although the impact of Igede praise songs resides to a large extent in the seriousness with which the performers approach their performances, the effectiveness of the songs is ultimately dependent on the use of imagery. Most people have an interest in message and verbal expression; they do not go to performances merely to be treated to rhythm, melody, and spectacle. Imagery is a crucial poetic resource because it is indispensable to the communication of information in the most vivid possible manner. In the words of R. N. Egudu, the significance of imagery lies in the fact that it enables an artist to make an arresting point by "liken[ing] one thing or idea to another

whether or not there is any natural similarity between them; it endows things or ideas with qualities they do not normally possess; it represents persons by objects that are normally associated with them; it represents an idea, or thought, or an emotion by an object, action, or situation without mentioning that idea, thought, or emotion" (Egudu, *The Study of Poetry,* 19). Here Egudu aptly summarizes the power of imagery to bring together many different concepts and things by means of evocation. As a device of indirection and suggestion, imagery enhances the power of poetry to make sense, to communicate. Among the elements of imagery found in Igede praise songs are metaphor, simile, personification, allusion, proverbial usage, ideophone, and exaggeration. Indeed the performers invariably deploy a montage of images that present them as artists engaged in a cultural crusade. This phenomenon can be seen clearly in Micah Ichegbeh's Adiyah performance of *Ahi kp' Ahi j' Igede* (Let's Preserve Igede), an injunction for the spirit of cultural nationalism to prevail among all Igede people. This particular rendition was performed at a social gathering at Onyike in Central Igedeland on July 27, 1981.

Ahi Kpahi j' Igede

'Md' onu ch' ejih ny' ogbanye
'M d' onu ch' ejih ny' ogbanye
A m a d' onu ch' ejih ny' ogbanye.
'M bw' ogene gene ka, ooh
Am a j' abw' Ogbile la ka, ooh! 5
'M bw' ogene gene ka, ooh,
'M b' ogene gene ka, ooh,
'M j' abw' ogbile la ka
Enu m' enu k' ogwuh gbuh ipi le
I ka kp' oyeh kp' ihyeh kp' ita. 10
Y' el' ilehi jem, y' el' ilehi jem
Enwa y' el' ilehi jem eeh!
El' okpokpoh r' el' olepwu nyam Igede
Ela okpokpoh r' el' olepwu nyam Igede 15
El' oowa r' ekee:
Aligede j' Igede je ka, i y' ij' ikila
Aligede j' Igede je ka
I y' ij' ikila 20
El' owa r' el' olepwu nyam lume
Am a ti' r' ubwo-okpokpoh o ny' Ichegbeh
Egbeju-okpokpoh kp' oloh ny' imiye

O r' ebih ka?
Inyam r' ito ka m jw' to to 25
Am a r' ubw~okpokpoho ny' Ichegbeh
Ubw' okpokpo ka je h' ekila d' egbeju ka
Olujwoh, Onwu m' onwu kp' ihih jw' oja ny' adawa,
Am Maik' Ichegbeh m kp' ihih jw' Igede ny' adam titi 30
An' anyi ny' Igede ny' adam
Iged' upum' iwoh kwur' ita,
O rinyi k' Anu ya jem
Egbele m' uyah nyam' ododuh ka ka, oh!
Am a l' ubwo lipi h' anu 35
An' aligede ny' adam
Onwu m' onwu mila y' oja ny' adamu ya yah.
M y' oja ny' Igede ny' adam
M y' oja ny' Igede ny' adam.
El' oj ny' epwu ny' Eka 40
El' oowa ji ny' Ebi onyi-inamu ka ka, oh!
Am a kp' uhyeh ka ka hya, Ene k' ama w' ejih ka ka yileh.
Am a kp' uhyeh ka ka hya, Ene k' ama w' ejih ka ka yileh
Am le 'mka y' oja ny' Igede ny' adam ooh!
Igede kpu kwee, m woh l' iraah gbeh-gbeh. 45
'M kay oja ny' Igede ny' adam.
Apw' onyogoh rwahi gbeh-gbeh kaa?
'M ka y' oja ny' Igede ny' adam ooh ooh!
nwu m onwu y jah ny adwa
50Am le m ka y' oja ny' Igede ny' adam 50

Let's Preserve Igede

I pay my respects to you, to start with
I pay my respects to you, to start with
I am paying my respects to you, to start with
I do not come on zigzaggy paths,
I do not know what Ogbile looks like 5
I do not come on zigzaggy paths
I do not come on zigzaggy paths
I do not know what Ogbile looks like
Whenever a death occurs in the land
We pass two to three ways 10
Tell me the truth!
Tell me the truth!

Dear, tell me the truth eeh!
One thing is the matter in my soul about Igede
One thing is the matter in my soul about Igede 15
The matter is . . . I tell you:
It is: Igede people do not understand Igede
But they speak other languages!
Igede people do not understand Igede
But they speak other languages 20
That is what is the matter in my soul.
But I am the one-hand son of Ichegbeh ooh!
If one head carries load meant for two
Is it not a wonder?
Mine is only a question I am asking! 25
I am the one-hand son of Ichegbeh
One hand cannot make a headrest for the head
It is difficult
Every people honor their languages
I, Micah Ichegbeh, also honor my father's tongue 30
You sons of my father's Igede
The thirteen clans of Igede
If it is not so, tell me
Egbele does not fight in vain
I do give you an apology 35
You sons of Igede
Every one should speak his or her language
I will speak my father's Igede
I will speak my father's Igede
What is in Ekah's mind 40
May it not be in Ebih, his brother's mind!
I climb up to pluck before I descend down to gather.
I climb up to pluck before I descend down to gather.
As for me I will speak my father's Igede;
When Igede just hints, I understand the sense instantly 45
I will speak my father's Igede,
Does not an old cloth brighten faster in the wash?
I will speak my father's Igede

One of the ways in which the poet demonstrates his positive social commitment is by criticizing the apparent lack of ethnic consciousness among Igede sons and daughters—a phenomenon that Ichegbeh holds respon-

sible for the continuing decline of Igede culture. He himself resolves to take up the challenge to champion ethnic identity (lines 22–50). The term "language" is an incorporative expression for the totality of cultural values; for this reason, the neglect of the Igede language is seen metaphorically as a neglect of the values it embodies. The expression "one-hand child of Ichegbeh" is obviously a praise epithet for the poet-hero as it indicates the major handicap that he has had to overcome on the way to achieving the feat of cultural revival. Similarly the reference to himself as one head carrying a load meant for two is another instance of self-praise, since it is connected with the enormous difficulties the hero faces in the course of fashioning out an adequate headrest for the burden he already bears.

Apart from the use of metaphoric and symbolic language, Ichegbeh plays on another aspect of Igede speech patterns—its rich allusive references. The analogy drawn between the poet-speaker's role as a man who solitarily is waging a war for the preservation of his native culture and the struggle of Egbele, a figure in Igede legend who does not fight in vain, is another example of passionate boasting. The mention of other characters in Igede legend (the brothers Eka and Ebih who embody the contradictory qualities of indolence and industry) helps underscore the poet's image of himself as an agile, brave, selfless person.

At this point, Ichegbeh makes an impressive effect by developing a montage of images. The speaker is an extraordinary person who "climb[s] up to pluck/before [he] descends down to gather," a farming image that conveys an impression of the heroism of a poet who can carry the unbearable burden of working solitarily with fortitude and humor.[1] The significance of the above image is heightened by an audience aware of the fact that the Igede are predominantly farmers engaged in subsistence agriculture—an occupation that is particularly tedious because the Igede continue to use rudimentary tools, such as hoes and cutlasses. Often, these farmers lighten the tedium of their work by joining in collective labor, which in turn encourages communal singing. By presenting his role (of championing Igede culture) as being like that of a farmer working alone, Ichegbeh thus gives a vivid picture of the hardship involved in the task he has assigned himself.

Micah Ichegbeh also likens his relationship with Igede culture to that of a washman. In this context, an old cloth in the wardrobe, which brightens fastest when put in the wash, becomes an apt metaphor to express the joy he derives from his duty—a satisfaction embedded in the bond of familiarity that he enjoys with his native tongue. And so he declares, chau-

vinistically, that every tribe should stick to its native tongue. Although this line sounds a note of cultural insularity, the primary connotation of his words clearly points to his single-minded identification with his roots in Igede culture. Indeed, the depth of the poet's involvement with Igede culture is so great that in another poem, entitled *A y' ujih j' urube ka* (Do Not Bear Malice Toward the Thatch), he refers interchangeably to himself and Igede culture as the thatch roof, a primary material that predated zinc in that area. Thatch thus becomes a metaphor for that which is original, pure, and indigenous as opposed to the imported zinc. Here, Ichegbeh overtly celebrates tradition in a manner reminiscent of negritudinist modern African writers, such as Gabriel Okara and Okot pBitek.[2] He sings:

A y' Ujih j' Urube Ka

I nw' iyoh otukah l' onu ham le, oh!
I nw' iyo ny' inyih l' onu ham le, oh!
Ol' onahi nw' iyo ny' inyi l' onu ham am le oh
Adada, 'm kp' uru jwa w' iyoh!
Igbeneh ch' ekwuh h' ekwuh obeh! 5
Igbeneh ch' ekwuh h' ekwuh
K' am l' ubwo-olopi nyang
Ong m' ong ny' aluma je ka ka
Am i Mayika Ichegbeh, m kp' ubw' ohe, am a kp' okila kpa kpa!
Enu m' enu ka t' onginy' Igede too too 10
O kp' ang abw' iyeh ale, ongongowa m' anyi-ewah!
Onyi r' ang ny' Ohe-oluyeh le
Ongo m' anyi-ewoh omila chim ubwoh; yeh, eh eh!
Am a kp' oja m ka j' anu
Ayidepwa 'm jing obeh ny' uga-ogwogwu 15
Aka bwuh utu-utu, aka bwuh ega ka
Ole r' ohohe ka ka . . .
Ubwoh wang orih-rih h' onu
Onu ka je pwa ka
Ah! m ya, ubwo w' ang orih-rih h' onu 20
Onu ka je pwa mi ka, ooh!
Ati yem l' iyinah wee?
Oji-utu kw' ego
Iwo j' egeh' oka yeh nwa ka!
Oyoh yoh yoh yoh eeh! 25
El' okpokpoh m la la m ka ya tong ahu

El' oowa r' eekee,
Enu m' enu k' onyi ny' oludu mila b' ewu
I nw' emwu hoo,
Onyi ny' okpehika b' ewu 30
I nw' oheh-o-pw-ela hoo!
Iny' aduh Abya ya
Enu k' onyi ka t' inina-owa epwa
O ny' a dur' uchapwu jeng-jeng!
Ubariri je ka m' onyi l' ilomu ka 35
O ka je m' onyi la la Ubakpah ka
Uka ny' ogbanye-ogbanye
Uka ny' ogbanye iloh ti pwah onyi ka rih ogbih ka
Ojigah o r' ogbih
Iloh mila woo-mileh 40
Inyinyi, Utu meh ny' ebgu-owu-wu ka
Gbeeh k' ole-egbu kp' egbu
Ka w' utu l' enu
Oow' aligede a y ela okpokpoh j' apyobunah
Yekee, eny' o l' ijah nyi chi chi kil' o-luwa 45
A kp' ahi ka,
A mila yeh yeh eeh eeh!
Ib' Upah ereh ka
Upah mw ekeh-iwu
Ejih unu-okpokph, iga nwa nwa l' uwa ka 50
Ongo d' iwee, o k' ubeh ny' inamu ka yoyi
Inya duh kam ya
Ma m bw' ogene-gene ka
M j' abw' ogbile la
Iweh kwum l' iweh kw' anu. 55
Iweh kw' anu, i y' egah dejih ka
I dejih odeheh kila-kila
Oowa r' ebi ny' alebih
Am ichirih-kegoh-onyi-Ichegbeh
Mk' ajeka! 60
Aje nyi-ichirih iwa r' ijwuh-itoo
Am i kpa-uhi-ka-i-mila-kpa-abwo-ela-onyi-Ichegbeh
Abwo-el' ar' onginyi le
Am oho-odiye-diye-o-nyi-Ichegbeh,
Ogoh h' ong onahi 65
A nw' okirihyeh doo ka!

Anu k' ur' anu ka woh!
Ongongoha ujih j' Urube ka
A y' ujih j' Urube ka!
A y' ujih j' Agana ka 70
Anyi m ti ho eneh!
A y' ujih j' Urube ka
Am oho-ohyehye ny' adigede
Urube a r' oghahi ny' Ojeh le
A y' ujih j' Urube ka 75
Urube pwa
A y' ujih j' Urube ka
M ti binu yekee,
A yi Ujih j Urube kah
Urube pwa le! 80
ljaki, ony-Ijwoh, Imaika-Agi,
Ona, a y' ujih jw' Agana-onyi-adang ka!

Do Not Bear Malice Toward the Thatch

They have killed a great animal with the mouth for me!
They have killed an elephant with the mouth for me
A kind giver has killed an elephant with the mouth for me
And daddy, I am quartering it with the ears!
Twin child of my mother's womb, thank you. 5
Twin child of my mother's womb, I have apology for you
The public cannot know that
I, Micah Ichegbeh, I am double-handed!
Whenever you see one in Igede,
If he carries things in both hands he is a parent of twins 10
A child is something of God,
Anyone who is a parent of twins here [among the audience] shake my hands, take!
I have a story to tell you,
Kind giver, I thank you immensely 15
May you meet with good luck not ill luck
This is not the first time
If the hand offers food to the mouth,
The mouth cannot decline it
Alas, I say, if the hand offers food to the mouth 20
The mouth cannot decline the offer

What do you see in me?
The tsetse fly lands on the ankle
There is no blood it can get to suck!
Oyoh yoh yoh 25
One thing I have to talk over with you,
The matter is,
When a rich man's child escapes death on the war front
They kill a goat in celebration for him!
If the son of poor person escapes death on the war front 30
They kill God-for-bid in celebration for him.
It is just as the Hare says
That on the day he would meet his mother-in-law on the way,
He is in rags!
Wasp cannot have a child on her own. 35
She cannot bear children like the spider!
In the beginning, in the beginning
The snake refused to eat millet,
But the rat that eats millet,
The snake swallows it! 40
So Utu had no plans to smear camwood
Until the camwood man brought camwood
To rub Utu late in the day
Thus, the Igede say one useful thing:
That one finger in water rubs another 45
You do not look for
But you found!
No one invited kite to brew wine
But he has fetched twigs all over the place!
Given one egg to boil, the kite filled his mother's home with twigs! 50
If you doubt, go to his mother's room and see wonders!
That is the reason I say
I do not come by zigzaggy ways
I do not know how Ogbile looks
Because I lack space, my hens lack space 55
The hens lack space and have nowhere to lay eggs
They lay their eggs in the open yard
Which is an ill-omen
I, the pea-seed-turned-into-pods son of Ichegbeh
I do not contain any seeds 60
But it is the seeds that one preserves for cultivation

I, the one-without-beauty-but-with-manners son of Ichegbeh
Manners are the essence of personality
The draw-soup son of Ichegbeh:
The stream is kind to you 65
Do not throw a dead toad into it!
Listen and hear my story
No one should bear malice toward the thatch roof
Do not bear malice toward the thatch roof
Do not bear malice toward Agana! 70
What have I done!
Do not bear malice toward the thatch
I, the draw-soup of Igede!
The thatch is the elder of zinc roof
Do no bear malice toward the thatch! 75
The thatch has objected!
Do not bear malice toward the thatch!
I told you never,
Never bear malice toward the thatch
The thatch has objected! 80
Jack the son of Ijokoh, Micah Agi,
Ona, do not bear malice toward Agana, your father's son

The images of the poet and Igede culture that emerge in the poem (both becoming fused) derive their effect from the African idea of home as shelter and the place for communal oneness. According to D. P. Kunene, the world "out there is a jungle. The hero who turns his back on the courtyards and cattle-folds and grazing fields of his home is entering this jungle with all its beasts and monsters" (Kunene, "Journey as Metaphor," 189). Professor Kunene is referring specifically to the significance of home to the traveling hero in African literature, but his definition of home as a place that embodies all that is familiar (and so represents sanctuary) is similar to the sense in which Micah Ichegbeh uses it in his song.

The poet's conception of home as sanctified explains the reason that he objects to the use of zinc to fortify it, for zinc is seen here as a glittering but superficially attractive and essentially corruptive element. The series of juxtapositions of the old and the new (a related contrast of good and evil occurs in lines 28–65) helps strengthen the idea of the superiority of tradition over that which is imported. The genuineness of tradition is even suggested by its simplicity, a quality to which the poet constantly alludes. What would ordinarily be regarded as an inadequacy of tradition—the

lack of spaciousness—is, in fact, presented as a hidden source of strength. The praise names "I, the draw-soup son of Ichegbeh" and "I, the pea-seed-turned-into-pods son of Ichegbeh" suggest the need to go beyond appearances in any assessment of the poet and his culture; the essence of a people, says the poet, is an inner quality, not an external facade, which may be deceptive and illusory. The image of tradition as a kind stream into which a dead toad should not be thrown clearly suggests its life-giving potential.

From his study of this genre of African poetry, Oyin Ogunba concluded that the typical African chant of the praise type tends to extol greatness rather than goodness (Ogunba, "Traditional African Poetry," 44). All of Ichegbeh's performances that I recorded conform to Ogunba's idea of the typical praise poem. For example, the feat lauded in *Ahi kp' Ahi j' Igede* (Let's Preserve Igede) is the poet-speaker's singular commitment to his culture at a time when the pull of foreign influence is particularly compelling. In practice, the love shown by Ichegbeh toward his roots manifests itself in his adept use of the Igede language—playing on its resources of sound through rhymes, repetitions, assonance, puns—and his uncommon ability to charge an old saying with fresh interpretations. The poet also shows remarkable ability in creating a new alignment of meanings through new and startling constructions.

Similarly, in both *A y' ujih j' urube ka* (Do Not Bear Malice Toward the Thatch) and *Obeh Ohoho* (Thank You), the subject of commendation is the heroism of those who were willing to part with cash gifts for Ichegbeh's songs.[3] The two songs were performed on July 25, 1981, at the home of my cousin, who played host to the poet at my invitation at the Ibilla Barracks in Central Igedeland.

Both pieces demonstrate the fact that the Adiyah form has a built-in scope for the individual artist to express himself in any way he desires to do so. They also show how imagery is the most striking and the richest single device in the structure of the poems. In practice, Ichegbeh builds up the image of the hero by deflating those of other protagonists. In the piece *A y' ujih j' Urube ka* (Do Not Bear Malice Toward the Thatch), exaggeration is one of the main strategies through which the colossal status of the hero is registered. For example, the poet describes the gift of a lobe of kola nut offered him by one of his patrons as an elephant (line 14), and he repeatedly refers to himself throughout the poem as an extraordinary person who can perform actions that are beyond the reach of ordinary mortals.

The most notable feature in *Obeh Ohoho* (Thank You) is the dexterity

with which the poet uses the conventional techniques of antithetical constructions to underline his own insignificance before the towering image of the subject of his praise.

Obeh Ohoho

Ayid-anjwoh m d' ang owurabah
K am a d' ang owuraba
Adada 'm d' ang owurabah!
Igbeh m' igbeeh r' igbeh i gwu-anu?
Igbeh m' igbeeh r' igbeh i gw an al' ale eeh! 5
Am a l' ubwo-olo-opi nyanu, am a l' ubwo-olopi nyanu,
An' Aligede, am a lo-ogbokeke h' anu!
Adida-o-lepwa, am a l ubwo-olopi hang
I y' anginyi l' ela-olepwu ka, oh!
I y' anginyi l' ela-olepwu ka, oh! 10
Angikila kp' el' ol-epwu d' ona
M ka kp' inyam d' onu-ododuh ka ka
Ije ka y' anginyi l' ela-olunu
I y' anginyi l' ela-olepwu ka
Ale-eji ka kp' ela-olepwu d' onaa 15
Am l' ela-olepwu r' udu-okpukpu nyam lume!
M kp' inyam d' onu-ododuh ka ka, oh!
I hwung chi-iketeh kpa j' ediye
Aka j' ugbeyi-oluru ka,
I hwung chi-iketeh kp' j' ediye 20
A ka j' uk' a puw' ale-ale?
M r' igwu t' ikpekpe le, oh!
Ugbema nyam aka je bi-enyi ka ka
M d' ikpala-eru le, oh!
M k' ubeh ka nu-uneh yata ch' odedeh 25
M k' ubeh ka nu-uneh y' ata ch' odedeh
Ukoh ka je chim ka ka!
Okwute, m j' ing obeh ny' epwa lee, oh!
Okwute m j' ing obeh-otuka lume
Am a j' ing obeh ny' epwa lume. 30
M l' ela-okpokpoh k' am ka ya:
Adida-olepwa m l' ubwo-obopi ny' ang
Ubwo ti w' Ojutu ka ka hw' iye, oh!
Ah ah yo yoh ooh ooh!

M l' oja-okpokpoh ka m ka j' anu 35
M l' oja-okpokpoh k' m ka j' anu
Anu k uru ka woh me
Idumh ka r' ogwuh riri kpa
I kp' ogwuh bw' epwa ny' Idumh
Ogwuh onyi k' orih ny' Idumh ka 40
Idum ri t' oye-le-ehi-ododuh ka!
Ino j' abwo k' ejih rir' apwu le
Ichiri ka mir' apw inyi we ee?
Egah lume gbeeh bw' ujih
Ich' on' ujih nyawa kpa ka ka. 45
Imanagogoh ka t' anu ri-r' ododu
I ka je b' anu k' ube ka.
Imanagogoh ti r' ang ole-pwuame
Imanagogoh ti r' ang ole-pwuame
Unu r' ang ol-ubeh le, oh! 50
Unu r' ang ol-ubeh le, oh!
Anu-Aligede, m me-on anu ya jem me
Unu r ang o-lubeh ny' ahu nyam ka?
Okpengeh tejuh nyamu m' ugbo
Okpengbeh r' ugbo ka 55
Okpengbeh r' ang ole-epwuame
M Ugbo ti r' ang oriri ny' Adigede.
Onaru gbil' Ijwoh
Onaru gbil' Ijwoh
Onaru gbil' Ijowh 60
O r' Ijwoh ka,
M m' on' anu ya j' Agana!
Ijwoh beko odeheh ya,
Ijwoh bek odeheh ya
Ijwoh y' ela-ilomu gedeh-gedeh: 65
Uturu k' or' Ihyejwo-cheheh-Ihyokwu,
Ijujuh l' uturu gbeh-gbeh-gbeh
Onyiyoh ohe nyi kpehe-odeheh ka
Onyiyoh ohe nyi kpehe-odeheh ka
Onyiyoh ohe nyi kpehe-odeheh ka 70
Uka k' ahi mila pye l' uturu, iyeh aha!
Uka k' ahi mila pye l' uturu, iyeh aha!
L' ukah ny' oje-iruyeh l' uturu
L' uka ny' oje-iruyeh l' uturu

L' uka ny' oje-iruyeh l' uturu 75
Ijwoh keleh ka kw' inya-ugbeyi
Ijwoh keleh ka kw' inya-ugbeyi
Ijwoh ch' ehi ka ka y' ediyoh,
Ijwoh ch' ehi ka ka y' ediyoh
Ijwoh too-ela woh yekee 80
Ahu Ediyoh ol' ogbe-kilo-kilo
Ale-al' a ti ti ti jwa je ka?
Ale-alati ti ti jwa je ka?
Ediyoh w' Ijwoh ela ya,
Ediyoh w' Ijwoh ela ya 85
O nyi bw' inyahi k' inyahi-inyahi
O nyi bw' inyahi k' inyahi-inyahi
O nyi mila r' onguga ka oh!
Duh k' ediyo k' iweh-onyogoh nyamu
Duh k' ediyo k' iweh-onyogoh nyamu 90
Adada mila r' onguga ka ka
M bw' Uwokwu, m w' Obarikeh
M bw' Uwokwu, m w' Obarikeh
M r' ong uga, anu ya jem me!
Epwa nya-alumah ale le le 95
Epwa nya-aluma ale le le
Epwa nya-aluma ale le le

Thank You

Father of children, I welcome you
I welcome you
Father I welcome you
Is every kite a hen-picking kite?
Not all kites are kites that pick the hen 5
I apologize to you, I truly apologize
People of Igede I apologize to you!
Kind host, I apologize to you
One is given away by the word of mouth
One is not given away by thoughts 10
Others shout with theirs,
I will not shout with mine in vain
One is given away by the word of mouth
One is not given away by thoughts

Fools reveal their thoughts carelessly 15
As for me, thoughts are great riches!
I do not shout in vain with mine
If you are lifted shoulder-high on a walk
You cannot feel the weariness that comes with traveling a
 long distance
If you are lifted high on the shoulder 20
You would not realize when you get to your destination!
I have befriended Ikpekpe
My knife cannot be lost in a river
I have sent the thunder on an errand
I go to bed with my legs stretched outside [the door] 25
I have no fears!
Okwute, I thank you for the entertainment
Okwute, I thank you for the entertainment
Okwute Oibe, I thank you greatly for the entertainment
I thank you greatly for the entertainment 30
I have only a word to say:
Kind host, I have apology for you,
For what does the hand pick tsetse fly?
Oyoh yoh, yoh ooh ooh!
I have a story to tell you 35
I have a story to tell you
You listen and hear me
The people of Idum do eat human flesh, no doubt
But when corpse is traversing their territory
The corpse that does not belong to Idum people 40
The Idum people do not eat it for the sake of seeing it!
In the same way as a soil supports the growth of grass
Can the cowpea in like manner grow luxuriant leaves?
The ants are too numerous in their assembly
Yet they are never completely at home 45
The cuckoos peck with the chicken in vain
They cannot follow the chicken to roost;
The cuckoo is a thing of the bush
Cuckoo is a thing of the bush
The chickens are things of the home 50
The chickens are things of the home
People of Igede, if I lie tell me
Is the chicken not a thing of my wife's room?

Okpengbeh bears its fruit bunch like the banana
But Okpengbeh is not banana 55
Okpengbeh is a thing of the bush
Banana is food crop of Igede.
Tiger copies Leopard's marks,
Tiger copies Leopard's marks
Tiger copies Leopard's marks 60
But he is not Leopard
If I lie tell me
Leopard made a public announcement
Leopard made a public announcement
Leopard made his points clearly: 65
On the day of lhyokwu coming after lhyejwo,
Early tomorrow morning
No animal should leave his home
No animal should leave his home
No animal should leave his home 70
When the day broke in the morning,
When the day broke in the morning
At the hour of seven
At the hour of seven
At the hour of seven 75
Leopard stood guard on the road
Leopard stood guard on the road
He beheld Rabbit
He beheld Rabbit
Leopard asked him a question 80
You Rabbit, the longtailed
Where are you going?
Where are you going?
Rabbit answered Leopard:
Rabbit answered Leopard, 85
I am going from my place to my place
I am going from my place to my place
I am not a stranger oh!
Which is why Rabbit goes back to his old place
Which is why Rabbit goes back to his old place 90
And father, he is never a stranger!
I came from Uwokwu to Barracks
I came from Uwokwu to Barracks
If I am a stranger tell me!

> This is our common home 95
> This is our common home
> This is our common home

The person referred to metaphorically as the father of children and the kind host is his patron. The praises are, however, directed at the ordinary, routine issue of his being alive to the social responsibility of supporting a family. Ichegbeh contrasts his own humble status with the elevated position of his patron, who he praises for the magnanimity of not allowing the poet's tattered appearance to put him off. Note the image of the poet as a friendly kite; the play is on the tonal variation on the word *Igbeh* (singular form is *Ogbeh*), a good example of the word play that features prominently in Ichegbeh's songs.

The sight of a flying kite descending wildly to poach on harmless chicks pecking about a compound is a common one in Igedeland. This action of the kites is considered an act of aggression that finds a parallel in the behavior of a human visitor who abuses the generosity of his host and tears the family apart with gossip. Ichegbeh says that he is not such a blabbermouth, but a man of honor who is reticent and prizes self-control.

Readily proclaiming that he regards the favor bestowed upon him by his host as a rare privilege, Ichegbeh compares his gratitude to that of a tired traveler who is lifted shoulder-high during a trek and can no longer feel the weariness that comes with traveling a long distance. Another set of images that stresses the poet's feeling of indebtedness toward his patron and that needs clarification is that image of his supposed friendship with an Ikpekpe, and the idea of being a magician who has sent thunder on a mission and goes to bed to sleep with his legs stretched out through the door.

The allusions to Ikpekpe and to thunder hold the attention of the audience because it is composed of people who are aware of Igede traditional social life as well as religious beliefs and practices. Although their land is surrounded by many rivers, the Igede are generally poor swimmers who regard the sea as a dangerous place. Not infrequently Igede farmers caught in their fields by a sudden downpour have lost their lives or their farm implements when they attempted to cross a rapidly swelling river that stands between them and their homes. Ikpekpe (in neighboring Cross River State) traditionally are regarded as a nation of professional swimmers, whose assistance can legitimately be regarded as a guarantee of security against the scourge of water. In fact, the Ikpekpe's control over water symbolizes the heroism of the tribe that the poet is praising.

In the same light, the Igede people believe that certain medicine men possess the ability to send thunder on offensive errands during a rainfall. However, in order to safeguard himself against the anger of the messenger (it is also believed that thunder usually returns and reports to his master after accomplishing the mission), a magician is required to observe certain rituals, one of which is to sleep with his legs stretched through his door and out into the rain. In his supposed friendship with Ikpekpe and in his alliance with thunder, the poet is therefore viewing himself as a lucky person in the company of able hands. For this reason, he suggests, he is certain that he will not come to any harm in his dealing with the world.

The network of proverbs used to enhance the image of the subject of the poet's praise (lines 33–62) goes further by showing the manner in which Ichegbeh draws on the repertoire of a communal, traditional, expressive vocabulary. E. N. Obiechina describes the proverb as the kernel that contains "the wisdom of traditional people" and as "philosophical and moral expositions shrunk to a few words"; for him, proverbs form "a mnemonic device in societies in which everything worth knowing and relevant to day-to-day life has to be committed to memory." As Obiechina notes, anyone who can use proverbs fittingly in traditional societies is held in high esteem because the use of proverbs is regarded as one way of demonstrating knowledge derived from "a detailed observation of the behavior of human beings, animals, plants, and natural phenomena, from folklore, beliefs, values, attitudes, perceptions, emotions, and the entire system of thought and feeling" of a society (Obiechina, *Culture, Tradition, and Society,* 156). Because more will be said on proverbs in the next chapter, suffice it that, like other African groups, the Igede cherish proverbs and have deep respect for anyone who can use them appropriately because proverbs are the repository of the wisdom, values, and lore of the race; proverbs are crucial to analogical explanation that the people consider necessary for eloquence and clarity of expression in their society—a society that regards oratorical skill as an enviable mark of distinction.

The recurrent use of proverbs in Ichegbeh's poetry must be seen against the background of the importance attached to this method of composition. It testifies to the poet's knowledge of and commitment to his cultural heritage, and it characterizes him as a resourceful individual who can manipulate his community's linguistic resources with great facility.

Given the potential of an apt proverb to evoke a charged mental picture of an idea that the speaker wishes to convey, it is hardly surprising that Ichegbeh constantly exploits proverbs in his performances. In the poem

under discussion, the reference to the poet's host as having picked a tsetse fly points to the magnanimity of the patron; the poet is the tsetse fly, a parasitic insect that sucks blood from its host's body and offers nothing useful in return. Ichegbeh elaborates on the picture of his host's generosity by using an ideophone to evoke a dramatic scene in which his patron is reacting to an injury inflicted by the sting of a tsetse fly with which he has voluntarily associated himself.

The idea of Idum people eating selected corpses, and not just anyone in sight, expresses praise for the poet's host by indirection: it refers to the fact that, irrespective of the injury to his person, the host is a wise individual who is guided by a high sense of responsibility in selecting those who can benefit from his liberality. This sense of responsibility is what the poet is anxious not to betray when he expresses the hope that cowpeas, which have enjoyed the bounty of a rich soil, should give a high yield in return. The patron is the rich soil supporting the cowpea, which in this case represents the poet.

What this image means is that the poet, on second thought, is dissatisfied with the image of the tsetse fly and seeks to see himself as being engaged in a more symbiotic relationship with his host, although he is quick to add that, no matter how hard anyone else tries to emulate the good-heartedness of his patron, no one really could actually do so. The idea of the unsuccessful attempt made by a cuckoo to emulate the chickens and that of Okpengbe to resemble a banana, as well as the suggested difference between Leopard and Tiger, all collaborate to convey the impossibility of being what one is not. Despite their differences in character and achievement, the poet believes that he is nevertheless united with his host by a common humanity; this idea is reflected in the folktale that tells of the coexistence of Leopard and Rabbit in the same environment (lines 63–97). Leopard, a fierce, terrifying, powerful creature (as in William Blake's poem "Tiger") represents the poet's host, while Rabbit (like Blake's "Lamb") is a gentle and serene animal. He is the one who symbolizes the poet. His plea is that, with some understanding, the poet and his host—though not blessed with identical gifts—can collaborate fruitfully. This plea fittingly closes the poem because, in celebrating the larger attributes of his host, the poet is honoring the aggregate values of his community—values embodied by the hero, who is engaged in an act of commemoration that seeks to bring about his atonement with his cultural heritage.

In his use of imagery, Ichegbeh has demonstrated that he is a genuine poet who expresses himself with remarkable resourcefulness. Although

his images are drawn from his local Igede surroundings, his voice is an original and creative one that has breathed fresh life into traditional usages and endowed them with new interpretations. While Ichegbeh generally uses the Adiyah form to engage in social commentary, to improvise dirges, and to perform ribald verses, our discussion of his work in this chapter has been restricted to his use of it in his composition of praise poetry. Such poetry is valuable not only for the insight it provides into the values, social life, practices, and behavior of the Igede people, but it is valuable for the remarkable power of language, form, and imagination with which the poet explores experience.

Perhaps no other Igede oral artist except Odeh Igbang has demonstrated equivalent linguistic dexterity. The significance of Igbang's *Omwu Ny' Ejeh Nyam* (Origin of My Song) lies not only in the rare opportunity it offers audiences to observe the sense of the indomitable spirit that enabled Igbang to overcome unusual obstacles in order to become a figure of great significance, but there is significance also in the power of language it expresses. *Omwu Ny' Ejeh Nyam* is much more celebrative than lamentative, for while making in it a number of claims about the personal sufferings that inspired him to invent the Etuh genre, Igbang also provides for his listeners a composite portrait of his artistic genius. *Omwu Ny' Ejeh Nyam* is based substantially on the traditional story of two brothers—Odugboh and Okoh—which appears to be widespread in the Benue region. For example, the same story also has provided the Idoma artist and scholar S. O. O. Amali a variant for his Idoma-English mimeographed play-text *Onugbo Me Oko* (Onugbo and Oko), whose focal point is the rivalry between two brothers as a result of the younger brother's jealousy over the elder's privileged status. Despite superficial resemblances, however, Igbang's composition differs in essential thematic details. Igbang provides a much broader moral vision than did Amali. Incorporating in his rendition a complex array of issues, including his personal predicament, and the political disadvantages of his local Igede community, Igbang weaves a narrative of the power struggles taking place at the wider national level, and he exhibits great imagistic power through a deployment of traditional usages in fresh and inventive ways.

In contrast to Amali's simulated modernistic style, Igbang employs an essentially folk style that relies primarily on oral conventions. Robert Armstrong states in his introduction that Amali's concerns are to relate "his poetic and dramatic version of an Idoma traditional ancestral story [to] certain themes of modern life and to adopt it to the needs of the stage." He adds, "Perhaps the most significant feature of the play resides in the

depiction of customary judicial procedure as administered by the elders." But Amali does not develop traditional rhetoric in any extensive manner in his play. By contrast, one of Igbang's central preoccupations in *Omwu Ny' Ejeh Nyam* is the necessity to conserve the Igede identity by means of the linguistic dexterity that characterizes Igede expressive culture.

Throughout the three-hour performance given when I visited the poet at his village of Adum-Owo on July 7, 1981, Igbang's skills as a performer were strongly visible. The occasion was a social get-together that took place in the open square in Igbang's home. Attracting a large audience comprised of more than a hundred people—including boys and girls, young men and women, as well as some elderly people—all of whom had put off all their other engagements for the day in order to attend the performance, Etuh performed with exceptional motivation. Because Igbang's inspiration came from the core of his soul, from the love that he bears for life, and the great significance he attaches to socially conditioned experience, he was able to use a story about an event in the animal world to objectify the human experience.

By beginning the narrative with the direct address that he used to enforce silence among his audience, Igbang evidenced the sensitivity with which he accepts his role as the keeper of his community's stories.

> An' aladum m j' in' obeh le!
> Anu kp' uru mimi
> K' anu w' ojah nyam me
> Hee!
> Odeh ony' Igbang
> Awe ka j' ang ojah lee (lines 1–6)

> You people of Adum I salute you!
> You listen carefully
> So you can hear my story
> Alas!
> Odeh son of Igbang
> Is about to tell you a story

Here, the poet's prefatory remarks emphasize that rhetorical adroitness is a crucial component of his compositions. The choice of the term *ojah* (story) in reference to the performance is deliberate: Igbang wished to cash in on the great appetite the Igede have for gossip. Even though purveyors of gossip are hardly ever the most responsible members of the Igede community, because of the quality of its humor, exaggeration, phraseology,

symbolism, and charming use of fiction, ojah, the most primitive of the Igede arts, is evidently also one of the most popular of them all. Igbang recognized that ojah can indeed be a most useful vehicle for instruction and knowledge; and so, he cast his narrative within the framework of ojah, so as to convince his audience that he was addressing his message to a known and specific community among whom the storyteller may not be a respected individual and opinion-molder but is undoubtedly a beloved individual. Thus Igbang showed awareness of the provenance within which his voice is held in the community by invoking his name as the bearer of the address, and in so doing enlisted the audience's expected interest in his compositions.

Having established the basis for his claim on his local audience to have continuing confidence in his work, Igbang then moved on to offer a vivid picture of the exact nature of the message he wished to impart: the deprivation that led to the birth of the Etuh performance genre, and its similarity with other experiences with which his audience can relate.

> Yah, yah m m m
> Ode Igbang
> Owa kpa kpeheh lee!
> Om' oduduh nyamwu k' okpa kpeheh
> O wa 'm we ka ya jenu le le.
> Eru-onyeweh ole
> K' igoment wee wuh wee
> Obwuh oyih nyam
> Odomwu bwuh uka nyam
> Ang oduduh m kw' abwo-abwo ny' amu le
> Onyoguh m r' inyi
> Omwu nyamwu
> Ale le le!
> Owa kp' ayilo ole kpeheh le
> Ah! (lines 35–49)

> Yah, yah mmm
> Ode Igbang
> He invented it!
> The origin of it, why he introduced it
> That's what I will reveal to you
> The new farm that
> The government is cultivating

It started in my time
It started in my generation
The reason that I am deprived of it
Is because I am an orphan
This is the origin of it
Here it is!
It brought this ensemble into being
Alas!

The most moving aspect of the narrative explores the ordeals of the singer in a down-to-earth language that is aesthetically appealing mainly because of the composer's ability to sustain the mood of the song through an image-laden language that utilizes an appropriate control of rhythm involving ideophone, repetition, parallelism, vowel harmony, and metaphor in a most skillful manner.

I m' am le 50
'M j' adam koh!
I m' am le
'M j' adam koh!
'M m m m m m
Uka ny' ubeh-upwu nyam 55
Aliticha kwum
kp r' kp r' kpr kp r' kp r!
K' epwu ny' okwo ka wuuh
I kp' am ka juh keleh
Ongol' o kp ehi ri rim le 60
O wari purah purah
O r' abwo h' olegbejuh
Nyi t' ubwo hoo h' owa me
O nyi ka kpo mi ka
Nya tu hyo hoo h' owa mee 65
Hee!
Olegbejwuh mw' uru yem ching
Ong onyila i ti ho l' okpokoh,
O chim da le le!
O jw' ubwo 70
O kpam ka jwu w' epwa
Ahi pye, o y' am nyi k' eru
Oduh hi, o y' am nyi k' eru
Ahi pye, o y' am nyi k' eru

> Since my birth, 55
> I have not known my father
> Since my birth,
> I have not known my father
> M m m m m m!
> At my school age, 55
> The teachers chased me
> Kp r kp r kpra kp ra!
> Into a forest of thorns and caught me
> They brought me there
> My foster father 60
> He rushed down very quickly
> He pleaded with the headmaster
> That I should be released to him
> That he would not support me [at school]
> That I should be released to him hee! 70
> The headmaster took a deep look
> [Because] Good things are achieved with money,
> He turned me over!
> He handed me over to him [to the foster father]
> He brought me down home 75
> At daybreak, he ordered me to the farm
> At nightfall, he ordered me to the farm
> At daybreak, he ordered me to the farm

Here Igbang defines his predicament through a narrative structure whereby he imbues an allusive reference to a story in the animal world with an associative quality that is an artistic end in and for itself.

Among the Igede, the story of the two brothers Odugboh and Okoh is a very popular one; most men, women, and children all know by heart the tragedy that struck the loving pair when a group of birds enlisted Odugboh in a scam to murder his elder brother Okoh (the king of the bird's kingdom), so that he can inherit the throne. One of the most frequently remembered events in Igede folklore is the story about the manner in which the peace of mind and life of relative abundance of the two brothers is abrogated as a result of the misconduct of the younger one. It is truly a story that breaks everyone's heart. But Igbang's newest contribution lies in the dramatic intensity with which he gives expression to Odugboh's dastardly act of murdering his own brother because of greed.

Igbang reenacts with exceptional freshness the disappointment that Odugboh experiences when his instigators betray him. Aware that the general outlines are well known to all and sundry among the audience, he tells the story in such a way that his narrative emphasis is as much on the misery that befalls Okoh as on the unhappiness of Odugboh. In this way, Igbang lends his performance a special appeal. He captures well both the rhythm and the spectacle of the event, and he reverses as well as subverts the conventions of digressive narrative, placing emphasis less on *what* happened than on *how it happened.* He delivers word portraits whose awesome beauty alone can be a justification for their existence.

> Inyi ka leeh
> Oowa l' or' ogbogboh ny' ela:
> Ang k' onginyi ka y' ela;
> Oduduh k' Odugoboh j' idah ugbilejih
> K' ahi je ka
> Ahi meh ye kee
> O ja hul' ehwu
> Tubwoo, olujwoh a too le. (lines 136–43)

> So it is
> It's like the namesake of a matter:
> What causes one to speak out;
> Why Odugboh cries in the wilderness
> In our ignorance
> We think that
> He is laughing
> But, in fact, it's a grief he feels

Before moving to the main line of his presentation, Igbang had to introduce another event from Nigeria's recent history; with this he intensified his effects by heightening the audience's capacity to assimilate his message. This supportive narrative is offered by the military coup d'état of Col. S. D. Dimka, which took place on February 13, 1975.

Igbang might have been aware that most people in the audience would remember that episode painfully as the one in which Nigeria's then head of state, Gen. Murtala Mohammed, lost his life only five years earlier; this explains the reason why Igbang wisely chose not to dwell on the details regarding how Murtala met his death. By focusing at greater length

on the lessons to be drawn from the story, he reveals the true nature of his narrative skills.

> Or' Ogbogboh ny' ela nya
> Dimka bal' Imuritala
> Idimka, Imuritala
> Idimka, Imuritala
> Imuritala, Imuritala. (lines 131–35)

> It's the namesake of the matter of
> Dimka and Murtala
> Dimka, Murtala
> Dimka, Murtala
> Murtala, Murtala

> Oduduh k am a d' ona ye kee
> An' aligede eeh
> Ongongoh' a j' awul' ujih ka
> Akachw' im' onginy' a kil' onginy' ata ka
> Ha!
> Yoo-la-ka-okeleh-mee
> Ojaa keleh nyamu kpokoo
> Nyamu kpokpo, kpokpoo
> O ja kil' ata ka
> Oja ch' uchwu ka. (lines 160–69)

> This is the reason why I warn you that
> You people of Igede
> No one should bear malice toward another person
> Having ill-feelings toward a person won't cause the person actual mishap
> The person will continue steadily making progress
> The person will not stumble on his path

In this segment of Igbang's song can be found the use of enigmatic proverbial sayings to warn about the harmfulness of coming to human relationships with such passions as envy, hatred, and rancor. The singer effectively underlines the desirability of kindly disposition, human kindness, or warm-heartedness through the suffering Odugboh ultimately brings to himself. Igbang explores the story through numerous stylistic

The Image Burden 129

devices, all of which help re-create the experience as a living drama whose unfolding is taking place before his audience. Ideophone is preeminent among these forms.

In fact, Igbang's preponderant use of ideophonic expressions constitutes an integral part of his strategy to achieve a visual realization of the essential details of the event, and his usage confirms the point made by a scholar who describes ideophone as a significant imagistic device through which African oral artists evoke "a sense for movements and gestures, vivid situations and attitudes, emotions and feelings, colors, and presence and absence of sound" (Mphande, "Ideophone and African Verse," 122). Ideophone finds its most profuse use at the climactic moments in Igbang's narrative and the following excerpts illustrate why:

<pre>
Oowa l' Odugoboh a yekee 210
Onyi nw Okoh k onyi ka ri adirahu?
I mi yr t t t t t t t t t!
I mi yr t t t t t t t t t
I mi yr t t t t t t t t t
I mi imi imi imi! 215
Aa hee hee! Odugoboh y' ela nyi juwa ka
Ela k inyi ya l' onyi woh le
O nyi ka nw' Okoh ony' inin' owa le!
Hee! iwa bal' Okoh iwa bwuh inina le,
I wa bwuh inina le 220
Iwa bwuh inina le
Yah!
O h' ebile ka ju k' epwa hee! Yeeh!
O h' acham nyamu pilee
O y' onu obih doo 225
O y' akuchwu-ita doo!
O nwoo ka
O y' ineh doo,
O nwoo ka!
Iruyeh kpem kpem kpem kpem! 230
Inmo iwoh kuru-iruye
O jwoo
Br t t t t t t t t t yah! hee hee
O nyi Okoh ony' in' owa
Oduh nyi ka hyoo 235
Ijujuh l' ewuh-utur' ugbeyi ny' eru.
</pre>

> Then Odugboh said: 210
> If he kills Okoh will he be king?
> They agreed with one voice
> They agreed with one voice
> They agreed with one voice
> They agreed, agreed, agreed! 215
> Alas! Odugboh said that all things will be considered
> What they said he has heard it,
> That he will kill Okoh his brother!
> Alas! He and Okoh did come of one womb!
> They came of the same mother, 220
> They came of the same mother
> Yah!
> He made the journey home, alas!
> He carried his dane gun
> He put a measure of gunpowder 225
> He adds three fingers!
> He is not satisfied
> He adds four
> He is not satisfied
> ... Seven tight measures! 230
> Seventeen bullets!
> He loads them
> Br t t t t t t yah! hee hee!
> And he says, Okoh his brother,
> That misery will descend on him sooner than he knows it! 235
> Early tomorrow on the way to his farm

The passages quoted above underline the power of ideophones to capture action and to heighten interest in the story by lending visual and auditory form. In lines 212–15, ideophones help raise in the minds of the audience serious questions, making audiences contemplate whether or not Odugboh will fall easy prey to the enticing plot. Will Odugboh be able to overcome temptation or will he not?

Of course, the audience does not have to wait for long before they find the answer; Odugboh's yielding to the temptation of material gain is an overwhelming act of misdemeanor, and ideophone expresses this in lines 216–18. The narrator emphasizes the evilness of Odugboh's action by attempting to capture the full sense of the horror. When Odugboh chooses to exchange blood for material gain, he acts out of extreme cruelty. Through

the graphic pictures painted by ideophones in lines 223–33, audiences gain a clear idea of the sacrilege and brutality of the action as they literally see Odugboh's action as he loads the gun with which he murders his own brother.

The actual murder of Okoh is the most gruesome of all, and the use of ideophone brings the scene vividly to life in all its terror.

<pre>
Ahi pye l' ewu-uturu, hee
Odugobo wulejih
L' ewuh-uturu, gbeh gbeh gbeh
O te o te o te o te o te o te te te 240
O keleh ka kw' ugbeyi nyi-eru
Hah! hah hah heh eeh
Ela ny' odeheh a lume le
Anu kp' uru mimi k' anu woh me
An' aligede ny' adam! 245
Hah hah! eyeh!
Oowa le, ahi pye l' uturu
Okoh hwang ny' eru
Oyegiri ny' eru
La la la la la la la la la la 250
Ka ka pw iga ny' Odugboh
Hee!
Odugboh y' ila y' okiletu
Mimi mi mi mi mi
Aah eeh! 255
'M kp' ehi ka y' ebi
An aladum m m onu le
Inyi ka leh?
Ah! ilah chaah!
Bla tah tah tah tah tah 260
Bla tah tah tah tah tah
Bla tah tah tah tah tah
Bla tah tah tah tah tah
Bla tah tah tah tah tah
Bla tah tah tah tah tah 265
Bla tah tah tah tah tah
Okoh hi kpa ta milejih
O kp' abwo w' eji
Kpa kpa kpa kpa kpa kpa kpa!
</pre>

Okoh o ny' inam'
Okoh ny' inam' onwu we ee!

Early the next day on the way to his farm
Early in the morning, alas
Odugboh starts out,
Very, very early,
Ote Ote Ote Ote Ote Ote te te 240
He goes to lay ambush on the way to the farm
Hah! hah! hah! eeh!
What a piteous matter!
Do you listen carefully and hear
My father's children, Igede! hah! hah! alas! 245
Then the morning breaks,
Okoh leaves for the farm,
He begins to go to the farm,
He gets down the road 250
He reaches Odugboh's place [his place of ambush]
Hee!
Odugboh takes a good aim at his victim's chest
He aims it precisely
Aah! eeh! 255
I have carried my eyes to see evil!
People of Adum, do I tell a lie?
Wasn't it so?
Then the fire opens
Bla tah tah tah tah 260
Bla tah tah tah tah
Bla tah tah tah tah
Bla tah tah tah tah
Bla tah tah tah tah
Bla tah tah tah tah 265
Bla tah tah tah tah!
Okoh crumbles to the ground
He tumbles on the ground!
Kpa kpa kpa kpa kpa kpa kpa!
Okoh, his brother, is the one so killed!

The significance of ideophone as an essential imagistic device lies in how it encompasses key actions in the narrative: the picture of Odugboh's loading of the gun, his faltering steps as he walks to the spot of his am-

bush, the fearful blast of the gunfire, and finally, Okoh's death struggle. With this device, the performer relives the events of Okoh's death in the hands of his brother in new and shocking ways.

The parallel drawn between the fates of Okoh and General Murtala Mohammed helps to demonstrate the manner in which events in the animal world shed light on human existence. In both instances, the devious behavior under attack is betrayal.

> O r' ogbogboh ny ela nya
> Dimka bala Murtala
> 'M we ya jenu le
> Anu kpuru mimi k anu woh,
> K' anu woh, 275
> K' anu woh,
> K' anu who
> Yah!
> Ekoh da r...
> Yr t t t t t t! 280
> Any' ichinu r' unye gb d gb d gb d gb d
> Ka ka juh keleh
> I gw' Okoh duw' ipi
> Ayuuh! ebi ny' ole bee?
> I doo doo doo doo doo doo doo 285
> Ka juh w' epwa!
> Any' ichinu chonu,
> Iny' ebi nya ho le, ebi ny' a ho le
> Ongongohe nya ho kaa ka

> It is the namesake of the case involving
> Dimka and Murtala...
> I am telling you,
> Do listen carefully and hear,
> So you may hear, 275
> So you may hear
> So you may hear
> Alas!
> There was wild crying
> Y r r t t t t t! 280
> The birds filed out together
> They went down to the place
> They found Okoh on the ground

> Wonderful! what evil is this?
> They carried it [Okoh's corpse] 285
> All the way home
> All the birds turned up
> They said it was evil that caused it, evil caused it
> No one else did it

In pursuing the social relevance, which Igbang intends his songs to serve, he ends *Omwu Ny' Ejeh Nyam* with an emotive expression that conjoins his personal ordeals as a singer and the tortured identity of his community. By placing the Igede identity within the parameters of the wider Nigerian political situation, Igbang underpins the didactic emphasis of his song that stresses the necessity of endurance and survival in the face of seemingly insurmountable obstacles.

Because Murtala's tragic death occurred in a world they know, the audience relates directly to the story, which provides them also with a sense of moral reinforcement against the kind of mindless greed, dishonesty, and lack of sympathy that led to the deaths.

> Ongongohe a kpum abi ny' unye le ka eeh 365
> M am a duh ka eeh eeh
> Am a duh ka eeh, oheh a dam le ooh!
> Adada, eeh! Adada eeh! Inene eeh! Inene eeh!
> Adada eeh! Adada eeh! 370
> Uchu wo-orih-o-nam eeh eeh!
> Uchu wo-o-orih-adada eeh! eeh!
> Uchu-owo-orih-inene eeh
> M anu y' uchu-owo-orih eeh!
> M anu y' uchu-owo-orih eeh! 375
> Ony inina ny' o-jwe-ejee eeh!
> Uchu wo-ori, ony' adada,
> Anu kpum abi ny' unye k' ooh!
> Anu kpum abi ny' unye k' ooh!
> Anu kpum abi le k' ooh! 380
> Ete-otuka-o-kpe-ejeh eeh!
> Ete-o-kpe-ejeh eeh!
> Anu y' ete-o kpu-ojih
> Ha gw' ugbah-o wu-enu ooh!
> Anu y' ete-o kpe-ejuh 385
> Ha gw' ugbah-owe-enu eeh!
> Ilah eeh eeh!

Ilah eeh eeh!
Ilah eeh eeh!
Ilah eeh eeh! 390
Ilah b' ang-epu-eta
Oduh rw' iru eeh!
Imurtala gogoh ny' ila nyang eeh!
Imurtala gogoh ny' ila nyang eeh eeh!
Imurtala gogoh ny' ila nyang eeh! 395
Imurtala gogoh ny' ilah nyang eeh!
Imurtala olujwoh a tong ka eeh eeh!
Murtala olujwoh a tong ka eeh!
Idimka j' omu ny' ela lume eeh!
Idimka j' omu ny' ela lume eeh! 400
Idimka j' omu ny' ela lume eeh!
Okejih-ahuru nyang eeh, oka n' ile ka
Obasanjo kw' omwekpa nyang le oh!
Okojih-ahuru nyang ka n' ile ka oh!
Olujwoh a tong ka ooh! 405
Olujwoh a tong ka ooh!

No one should blame me for the lost race yet 365
It's not my fault
It's not my fault; it was God that ordained me so!
Father eeh, My father eeh!
Mother, eeh! my mother eeh!
Father eeh! my father eeh 370
The toe-ensnared-in-rope brother of mine eeh!
The toe-ensnared-in-rope father of mine eeh eeh
The toe-ensnared-in-rope mother of mine eeh
I said you people should see the one whose toe is
 fastened to a rope eeh!
I said you people should see the one whose toe is
 fastened to a rope! 375
The brother of the crippled one, eeh eeh!
The Toe-ensnared-in-rope brother of mine
Don't you blame me for the lost race, ooh!
Don't you blame me for the lost race, ooh!
Don't you blame me for the lost race, ooh! 380
Head-on collision with an obstacle, eeh!
Head-on collision with an obstacle

> You people see a head-on collision with an obstacle,
> It is still better than being the one whose skin is to be flayed!
> You people see a head-on collision with an obstacle 385
> It is still better than being the one whose skin is to be flayed
> Fire eeh eeh!
> Fire eeh eeh!
> Fire eeh eeh!
> Fire aah aah! 390
> When a fire hurts you in the foot
> The heart burns to ashes eeh!
> Murtala, condolences to you, eeh!
> Murtala, condolences to you, eeh!
> Murtala, condolences to you, eeh! 395
> Murtala, condolences to you, eeh!
> Murtala do be comforted, eeh eeh!
> Murtala do be comforted, eeh eeh!
> Dimka has caused great mischief, ooh!
> Dimka has caused great mischief, eeh! 400
> Dimka has caused great mischief, eeh!
> Your throne will not be eaten by termites, oh!
> Obasanjo has taken over your place, ooh!
> Your throne cannot be eaten by termites, oh!
> Do be comforted! 405
> Do be comforted, eeh!

This segment of Igbang's song derives its impact largely from the reliance on extended imagery. The concept of the race offers a piquant image to describe the life ordeals of both the singer and his community, because they joined the wider Nigerian national politics from a disadvantaged position; the idea of joining a race with one's legs tethered is a picturesque way of expressing the community's disadvantaged condition.

That Igbang's story of his betrayed aspirations can stand for the situation of his entire community is confirmed by at least one writer, Moses E. Ajima, who establishes 1932 as the date when the first formal (that is, Western) school was created in Igedeland. After detailing the great resistance that the Igede had put up toward the British colonial administration and the educational system that came with it, Ajima states that "the first son [of Igede] to be given a certificate of literacy imparted in western education did not get it until 1939" and adds the following revealing information:

> In those early days of Western education in Igedeland, not only were the children reluctant to go to school, even worse their parents did not want them to. The parents were skeptical about sending their children to school to acquire Western education. Only parents with many children were willing to allow one or two to go to school. Such children (those sent to school) were considered to be too lazy to go to farm or were very heady, stubborn, arrogant, mischievous: children who were considered not very useful to the family that [sic] were sent to school. (Ajima, "Western Education and Its Contribution to Igedeland," 144)

Igbang's experience during his formative years may be considered to be representative of the experience of many other Igede youth of his generation because he grew up at a time when he received no encouragement to go to school. The lack of educational opportunity became a major disadvantage to both Igbang and his entire community because education later became synonymous with access to power—economic, political, and social. Thus, for Igbang and his community to find themselves without education has meant, correspondingly, to be condemned to an eternal world of powerlessness, to a situation of economic impotence, as well as social humiliation. Ultimately, then, *Omwu Ny' Ejeh Nyam* is a celebration of both Odeh Igbang's personal heroism and the endurance of his community. On a personal level, Igbang's victory lies in his ability to overcome the disadvantages inherited by him at his birth. By transforming himself into an adept singer and later becoming a chief in his community, Igbang shows the indomitable human spirit. Since 1988, when Igbang was installed as chief among his mother's Anyogbeh community, the Etuh has not been performed. However his transition from the commoner status to the elevated position of a chief must be considered an important achievement—something that is as singular in its occurrence as it is in its potential impact. Although it remains to be seen whether or not the wider Igede society will follow in Igbang's path and ultimately prevail over its circumstances, there can be no doubt that Igbang has provided a sterling example for his community. Through his use of startling imagery within the medium of songs, Igbang has made an enlightened attempt to rouse the consciousness of both his community and the world at large. Now it is up to the people themselves to take up the challenge to redress their disadvantaged situation. Like the similar activities performed by Micah Ichegbeh's Adiyah, the actual impact of Odeh Igbang's performances is yet to be determined. Nevertheless the mere fact of the existence of the forms alone signals hope for the future.

FIVE

Proverb Usage in Igede Praise Songs
The Dynamics of Performance

Of all the imagistic devices within their armory, proverbs comprise the single most effective rhetorical strategy that Igede composers use in capturing the sense of the immense texture of experience, idea, emotion, or philosophy. So crucial is the proverb an element of expressive rhetoric that Odeh Igbang chose it as the name for his association; as for a praise singer like Micah Ichegbeh, he has achieved his influential position in his society partially at least because of his performance skills, and proverb usage is integral to the overall impact that he has on his audiences. For these reasons, this study cannot be concluded without an extended discussion of that all-important element.

Among active oral artists in Igede today, Ichegbeh is the artist who best understands how to employ the tradition of proverbialization, which is an indispensable component of his people's oral expressive culture.[1] Ichegbeh uses proverbs with extraordinary resourcefulness, and his practices demonstrate his deep conviction of the time-honored effectiveness of proverbs as expressive devices that encode both the received wisdom and values and the totality of his community's worldview. His use of proverbs demonstrates clearly his gifts as an individual artist who can deploy appropriate language and style to suit particular purposes.

For the greater bulk of contemporary Igede population, as for other peoples worldwide who still live in a largely oral culture, proverbs are the spices of speech. As terse, philosophical, memorable, and enchanting expressions, proverbs are the main ingredients needed to drive home an elder's wise counsel or to rebuke forcefully and beautifully. And yet, proverbs are an enigma since the apt ones, like all good poetry "embellish or

elevate . . . a message and show superior sophistication, education, eloquence, or sensitivity in the use of . . . language" (Boadi, "The Language of the Proverb in Akan," 184). Boadi's remarks in the specific context of the Akan proverbs are applicable to the Igede, for they too employ elaborate word decorations as an indispensable part of rhetorical skills.

While undoubtedly the Igede recognize the value of proverbs as wise philosophical sayings that can beautify communication, only the wise ones among them can understand, or use, proverbs, appropriately. Because in Igede a misuse of proverbs can expose a person's folly even more markedly than a savage verbal abuse, the people respect highly those individuals who are so deeply steeped in the oral culture of their society that they can use proverbs effectively. And this respect evidently derives from the people's conviction that proverbs possess immense powers that move human beings emotionally and intellectually. Ichegbeh belongs to this generation of traditionalist Igede, who regard proverbs as signifiers of the wisdom and beauty of traditional thought and the knowledge of all those people who can use them well. My primary concern in this chapter is the function of proverbs as a stylistic device that Ichegbeh employs in order to begin his performances in the form of opening glees, as well as to close them.[2]

Though sprinklings of proverbs percolate throughout the entire duration of his singing, it is at the opening and the closing of his productions that proverbs find their most intense and profuse occurrence. Why does Ichegbeh employ proverbs in this manner? It seems to me that this condensation in the use of proverbs is not simply the expression of his own ideological position but a reflection of the pervasive sense of formal conventions that persists among the Igede in general. Although Bjorn Ranung has attempted in his 1972 study *The Music of Day and Dawn* to draw our attention to this issue, his discussion is inadequate because he was unable to include the songs of Ichegbeh's Adiyah ensemble.

The collaboration between some medley of proverbs and songs that Ichegbeh plays upon should be expected to have a double resonance, a spectacular effect that neither of the forms could have if it were in operation alone. As many recent studies have shown, in Africa the song form offers the most direct, immediate, and effective means of communicating ideas, feelings, moods, and emotions. If the proverb communicates ideas, beliefs, social customs, and traditional authority by indirection or suggestion (Abrahams, "Introductory Remarks"; Mieder, "Popular Views"; and Yankah, "Proverbs"), the song mode can be more than simply straightfor-

ward in effect. This is why during intense moments, such as the political pressure, for example, that existed during the Biafran war in Nigeria (Agu, "Songs and War") or the Zimbabwean war of liberation (Pongweni, *Songs that Won the Liberation War*)—songs have been effectively used as vehicles for sending speedy messages to give spirit to the fighters. Even in peace time, songs reach the collective consciousness of African peasants quickly because they are expressed in a language that is shared widely among the population. It is in this context that Karin Barber and P. F. de Moraes Farias are correct in describing songs as an art form produced by the people, using their own rhetoric (see Barber and Farias, introduction, *Discourse and Its Disguises*).

Ichegbeh is a singer who believes the role of proverbs in song hinges on their use to give a rounded representation to Igede cultural life. In his commentary on Igede cultural milieu, we observe a serious effort to deploy long-cherished proverbs in conveying and entrenching cultural values. One of the things we learn about the Igede from Ichegbeh's songs is that they are an intensely hard-working group. While he presents the traditional occupations of the Igede, such as farming and subsistence agriculture, fishing, hunting, and trading, in a positive light as distinctly honorable pastimes, he also pictures the Igede as highly individualistic people keenly favorable toward competitive ventures. As a people who place primacy on group solidarity and survival, the pivotal belief on which their social life revolves is that any individual can excel in any endeavor and generate as much wealth as he or she possibly can (and thereby enhance his or her social position); but such an individual is expected to be generous with the wealth. Consequently Igede people condemn tight-fistedness, jealousy, avarice and theft as actions that breach etiquette. As a corollary, the Igede encourage and reward charity with gratitude. Regarding the suppression of the attributes desired by his people as a grave violation of traditional moral wisdom, Ichegbeh not only articulates these goals in his songs, he himself lives up to the ideals he preaches.

Indeed such was the procedure observed in the opening song of the performance on the evening of July 28, 1981. Despite a recent death in his family, Ichegbeh accepted my invitation to perform at my cousin's house at Barracks. The song comprised an associated web of proverbs that Ichegbeh used to solicit the goodwill both of the host and the audience toward one another. Let us look at my transcription and translation of the song.

Eje Ny' Owurabah

'M d' an' owurabah, M d' an' owurabah
Am a d' an' owurabah l' ume
Obiyoh-Okpo-kpoh kpehi koko-ogari,
Oo kp' anyi-ikilah kuwaah
Obiyoh-Okpokpoh kpehi ko ko-ogari 5
Ookp' anyi-ikilah kuwaah
Ejih ny' ewa r' oga ririh
Inyi-unu r' ochichi
Obiyoh-okpokpoh kpehi ko-ogari
Okp' anyanumu ka ka rih 10
Ejih ny' ewa r' ny' udiyoh
Ma, iny' onyinam' unu r' ochanyanu
Inene y' ela-ojwapobwuna jem
Inene y' el' ojwapobwuna jem
Inene y' ela-ojwapobwuna jem 15
Inene y' ela-ojwapobwuna jem
Uka k' a w' ahw-aru kpila, aka wijah
Hw' aru-kpila me, ka wijah!
Anyi-iyoh okpokpoh in' ati nepwa bawule
Ino Inepwa bawule 20
Anyi-iyoh okpokpoh n' epwa bawule
Anyi-iyoh okpokpoh n' epa bawul' ale kakoh!
Olugah nyam Adad' olepwa ole,
M jing obeh ny' ugah lume
'M jing obeh ny' ugah 25
Epwa k' m' utu
Epwa ny' ang k' y' ahi-owawa;
Imi ka jee nwoo ka ka!

Welcome Song

I welcome you, I welcome you all
Indeed, I am welcoming you all
When a grasscutter chances upon a grazing land
It invites others to the place
When a grasscutter chances upon a grazing land 5
It invites others to the place
The egg of bush-fowl is for eating,
That of chicken is for hatching

When a grasscutter finds a grazing land
It invites its relatives to graze 10
The egg of bush-fowl is for the frying pan
Whereas, that of its sister, chicken, is for hatching into chicks
Mother gave me a useful advice
Mother gave me a useful advice
Mother gave me a useful advice 15
Mother gave me a useful advice
When you pretended to be deaf, you hear wild gossips
Pretend to be deaf and hear a gossip!
It used to be animals of a kindred family that lived together
They normally lived together, 20
Animals of a kindred family lived together
[But] Animals of a kindred family no longer live together
My kind host, the father of this home
I thank you greatly for your hospitality
I thank you for your hospitality, 25
The home will receive peace
Your home will be blessed with abundance;
It will never see hunger or want!

Clearly evident from the literary point of view is the passionate manner in which Ichegbeh demonstrates his conviction of the inestimable value of using to convey wise counsel the authority of tradition embedded in proverbs. For instance, the first proverb about the grasscutter who found pasture and generously invited his compatriots to a share of it alludes to a popular Igede folktale. It derives its impact from its employment of a homely metaphor drawn from the animal world to comment on the life of humankind.

In the story, a young, enterprising grasscutter chances upon a patch of green grass during a period of great famine. Everyday the grasscutter would retire there and feed well, but it refused to take others along. However, unknown to it, a human hunter had deliberately cultivated the grass to serve as a bait for his trap. The inexperienced grasscutter, without the guide of those older and more knowledgeable than it, ultimately falls into the trap and is gunned to death by the hunter.

Used in this song, the lesson that Ichegbeh draws with the proverb is that those like his host, who come by unexpected wealth, should not act selfishly as the proverbial little grasscutter did but instead should be generous with the wealth. Because nobody can predict when danger will occur, says the proverb, it is wise to share one's fortune with others, so that

in times of trouble one can get help in return. Ichegbeh praises his host for his legendary magnanimity, for his willingness to share what he has with others, but he is quick to warn the visitors not to take their host for a ride. This is the counsel encapsulated by the proverb *Ejih Ny' ewa r' oga ririh/Inyi-unu r' ochichi* (The egg of bush-fowl is for eating/That of chicken is for hatching). In urging resistance to bad temptations, the singer throws a challenge both to the host and his visitors to enter into a reciprocal relationship: the host is encouraged to continue typically to be bounteous with his hospitality, and the visitors are to respond to what they enjoy with gratitude not ingratitude, ready in turn at any moment to share equally the little they have with the host.

The Igede believe that humility is the best life policy to adopt in order to ensure social harmony; whether one is dealing with enemies or with friends, one must be cautious at all times. This is the appropriate behavior the singer enjoins when he refers to *El' ojwapobwuna* (a useful advice) that *Inene ya jem* (Mother gave me): *Uka k' a hw' aru kpila, Aka wijah* (When you pretended to be deaf, you hear wild gossips). This proverb is related to another Igede proverb that says *Onu o mile Aduh k' olugbah ch' enyi lee* (Humility enables an orphan to get a cup of drinking water). Both are quoted on occasions that demand the employment of deft survival tactics—for example, to alert a socially lower person as to where power discrepancies are great and tell him or her to resist any pugnacious attitudes that might sour his or her relations with the authority rather than improve them. Implicit in the singers' construction of the proverb is the need for the visitors to comport themselves in an appropriate manner before their immediate benefactor so that peace and understanding can prevail. Because many similar occasions, at which alcohol is freely drunk, constantly result in fighting and other forms of disorderly behavior, the advice was timely and appropriate.

Thus, in lamenting the pull of many antisocial attitudes that discourage social cohabitation among the modern day Igede people, the poet uses the proverb *Anyi-iyoh okpoh in ati n epwa bawule* (It used to be animals of a kindred family that lived together). The song bemoans the reversal of the norm of social intercourse as a tragic failing of contemporary society. Once again, the proverb makes a forceful attempt to transfer experience from the animal world to make a condemnation of the deadly crimes, such as greed, jealousy, aggressive individualism, and selfishness, that are tearing apart the old and cherished values of the Igede people.

The singer concludes the song with blessings directed at the host whose home, he prays, will never witness any of the crises afflicting the wider society. His action is in conformity with one of the central tenets of Igede

religious beliefs: the idea that a visitor who—after having eaten food provided by his host and blessed him—proceeds deviously with evil plans against his host, and as such he has engaged himself in an act of self-destruction because the gods themselves will defend the host by turning the food inside the visitor's body into poison. On this occasion, Ichegbeh is employing the usage as a gesture of the goodwill he feels for his host, and his action confirms his firm identification with key aspects of Igede religious practices.

During the entire performance of July 28, 1981, it was such engagement with the core cultural values of his community that endeared the performances to the audience. The event had drawn together many Igede people from different economic, educational, and social backgrounds to share their common interest in Adiyah. For reasons having to do with the cosmopolitan nature of the performance setting, pockets of linguistically diversified groups also were in attendance. Judging from the audience reaction, which was noisy and enthusiastic, the occasion made a resounding aesthetic statement. It showed the excitement that could be produced through an alliance of inventive music, dance, and songs composed and delivered in the Igede language.

New friendships were struck and old ones revived; the occasion provided lovers a reunion opportunity after lengthy periods of separation. Wine, beer, and the local gin (ogogoro) were freely distributed and consumed. The atmosphere was hilarious. Audience participation was encouraged, as the bard interrupted his singing occasionally to create rapport with the audience through riddle sessions. As for the content of the songs, they had ranged over many important issues—such as pan-Igede unity, what the difficulties were in forging that unity, cultural nationalism and the acculturation problems that were obstacles to it—as well as the strains of living in a modern society characterized by such crimes as prostitution, armed robbery, murder, political thuggery, children's disrespect of elders, and so on. A good time was had by all.

For this writer, finally—as for a good number of the audience-spectators I interviewed—the closing song of the night's performance is the one that remains in the consciousness the most permanently as a clear demonstration of Ichegbeh's capabilities to *kpejeh d'etuh*, that is, to use songs to proverbialize. This particular song, which ended the performance extravaganza that had lasted nearly four hours, began typically with the lead drummer pounding heavily on his instrument, and from whom the players of rattles, bells, and horns took their cue. Though none of the ensemble members showed any signs of tiredness, the bard demonstrated

exceptional creative vigor and urgency in the way he carefully gathered together in the song a connected string of proverbs using many of the themes of the evening's performance—such as dignity, humility, generosity, communal living, the reward for showing gratitude, and so on.

Neither my diary entry nor pen can convey to readers the entire context of the cheers and tears drawn by this song from the audience, but the translated and transcribed texts of the performance reflect a fair picture of the situation.

Ejeh Ny' Okpahi

Oyoh iyoh e-e, am a l' ela-okpoko m k' ya j' adigede ny adam eeh!
Mri inina ny' unu le ooh!
Inina ny' unu d' ejih ch' epwu ch' epwu ka, yoh e-e eeh!
Inina ny' unu d' ejih ch' epwu ch' epwu ka, yoh e-e eeh!
Unu d' ejih le okpu j' unu 5
Unu d' ejih le okpu j' unu
Embirih ga ga rih rih kpa, Embirih ga ga ri ri kpa
O dayi l' oka tirekpe k' epwa nyilomu ka ka
Embirih ga ga rih rih kpa, Embirih ga ga ri ri kpa
O dayi l' oka tirekpe k' epwa nyilomu ka ka 10
Adada 'm m' onu ny' epwa ny' inam am a ham oduh le,
Igwuh nwum duaa, O tom olujwoh le, eeh!
Okpahi me la la l' iweh oda ka ka, ya oh oh oh!
Okpahi me la la l' iweh ti da ka ka, oh oh!
Onyuchi j' epwu ny' enyi l' oh! 15
Oka je ch' igo ny' enyi kpa ka ka, ooh!
Okirihyeh d' onu ny' epwato-ogoh ka,
Oka je ch' igo ny' epwu-ogoh ka
Onyang a ji l' obwe-bw enyi, onyang a ji l' obwe-bwe-enyi
Onyang oliny' a je d' onu ny' ogbe da ka ka 20
Ong o ji l' obwe-bwe-enyi, onyang oji l' obwe-bwe-enyi
Onyang oliny a je d' onu ny' ogbe da ka ka
Ama l' ito kam ka to, ito nyam am a ri ye kee:
Onyang olinyi' a m' onu ny' omwomw' odu, anu nwoo l' ogbe ka ka
Ongo ji l' obwe-enyi, anu ka nwoo l' ogbe? 25
Ongo ji l' obwe-enyi, anu nwo l' ogb' oha ka ka!
Okpahi me la la l' iwoh oda ka ka, okpahi me la la l' iwoh ka ka
M d' an' Okpahi le, m d' an' okpahi le,
Opi-ijuh a ka m' eneh i ka mw' eru ka

M d' an' okpahi le, am a d' an' okpahi ny' ale le 30
Agi, m d' ang owuraba ny' ogbanye, le le m d' ang okpahi le
Ahi b' ata ny' Igbeh okaa h' epw ale, ahi ka n' epwa kpeheh ny oyongo,
Opi ny' ijuh ka m' ineh i ka mw' eru ka
In' Ugaru bw' ukpila k' oka k' opa ka
Ugaru kw' opa k' o ti ka k' al ale? iyeh e-eh e-eh 35
In' el' okpokpoh ko tam am olujwoh, elowa ri ye kee,
Ang i k' epwa-ame ka ka dir' Iyoh dire m' ang ihwe-epwah l' ehi ka
Am ka m k' epwa-ame ka dir' Iyoh
M dire m' ang i kwu-epwa l' ehi ka otom olujwoh
Itenge miri nyamu oduduh ka o-oh! 40
Itenge miri nyamu oduduh ka o-oh!
Isoja d' ewu ny' awa da, Isoja d' ewu ny' awa da
Ewu bw' ilah' omila bw' agagah ka ka
Ewu-okpokpoh bwum agagah ale, ewu kwum bwe-ekpe
Oheh-o1uhyeh hyam ukpojih o l' ekpe-t' ale 45
M j' ediye m w' omi ny' oheh e-eh!
Onyi ny' ony' inam a gbuh iye e-eh
Egbejuh beh okwunyih eneh
Ugbehi-onamu dayi l' oka gw' enyi ka ka
El' o gw ela w' eru ra le 50
Iny' ati duh, in' or' ela-ododuh,
Anu ka yem am d' uk' ole ka ka
Okwumwu r' ihih ny' ojiyah
Ojiyah r' ihih ny' okwumwu
Opejeh r' ihih r' ny' okwumwu 55
Jabwo k' okwumw r' ny' opejeh inyinyi
Anu kpahi me, o-oh, m jaa ru le
Anu kpahi me o-oh, m ka k' uwa
Anu kpahi me o-oh ahh!
Anu kpahi me o-oh iih 60
Anu kpah me o-oh!
M ti binu ya, anu kpahi me o-oh,
Okpahi me la la l' iweh-odada ka,
Okpahi me, o-oh, m jaa ru le!

Goodbye Song

Alas, I have one thing to tell my father's Igede people!
I have become a mother hen, alas!

Alas, the mother hen does not lay all the eggs in her belly!
The mother hen does not lay all the eggs in her belly, alas!
When the hen lays eggs the anus pains her 5
When the hen lays eggs the anus pains her
After a mother goat has finished foraging for food
She never fails to retire back to her own home
After a mother goat has finished foraging for food
She never fails to retire back to her own home 10
Father, even if I admit to a liking of the home of my own mother,
Alas, if death should meet me there, I would still be grieved!
Saying a goodbye word is nothing like the actual absence
Saying a goodbye word is nothing like the actual absence
A fish that lives inside water 15
It can never avoid water
A toad can never legislate against going to the stream!
It can never avoid the stream
A woman with an early pregnancy, a woman with early pregnancy
That type of woman is one who never avoids the penis 20
A person with a young pregnancy, a woman with early pregnancy,
That type of woman is one who never avoids the penis
I have a question to ask; my question is:
If a woman accepts fucking, you do not have to kill her with
 the penis!
One with a young pregnancy, will you kill her with the penis? 25
One with a young pregnancy, if you kill her with the penis it
 is not fair!
Saying a goodbye word is nothing like the absence itself,
Saying goodbye is nothing like your absence itself
Alas, I say goodbye to you, I say goodbye to you!
A yamland cannot end before one moves the farm 30
I say goodbye to you, Agi, I did welcome you earlier, now I'm
 saying goodbye!
If we insist on Igbeh being conducive of home we will go to live
 beyond Oyongo
A good yamland cannot end before one moves the farm
Indeed, Ugaru did not leave Ukpila with the intention to move
 to Opa, alas!
But if Ugaru doesn't go to Opa, where else will he go? 35
One issue that distresses me; the matter is that,
Those of us who go to the bush to hunt game animals

> Never satisfy the expectations of those who stay behind at home
> I who go to the bush to hunt game I never satisfy the expectations
> of those at home
> This distresses me
> Itenge's bloated shape is not without a cause! 40
> Itenge's bloated shape is not without a cause!
> Soldiers do fight their wars, they fight their wars
> An attack from the front never takes them by surprise!
> One war took me unawares today, one war pursued me
> from behind!
> The god of the sky has cut the muscles at the hind of my ankle 45
> I walked and heard the voice of god eeh!
> A child of the child of my mother died
> And when headache worries the nose
> Eye, the brother, does not fail to water
> A matter greater than the farm has sold the farm 50
> That is why, if it were a lesser matter,
> You would not have seen me up till now
> The mask is the honor of the village meeting ground,
> And the village meeting ground is the honor of the mask
> The crossroads of the village meeting ground is the honor
> of the mask 55
> Just as the mask is the honor of the crossroads
> Goodbye everyone, I am leaving
> Goodbye everyone, I will go there
> Alas, goodbye, all!
> Goodbye everyone, truly! 60
> Goodbye everyone, unfailingly!
> I did tell you goodbye ooh,
> Saying a goodbye word is nothing like your absence itself
> Goodbye, I am going!

Frank Kermode writes in *The Sense of an Ending* that terminating any work of fiction presents a difficult problem for all artists; there is no doubt that it is an even greater dilemma for oral artists who have a live audience before them—an audience whose interest and pleasure they can ill-afford to jettison or disappoint. Ichegbeh acknowledges this dilemma. He begins the closing song by proclaiming this irksome job, the difficulty he has in telling the audience the truth they must accept: that the occasion they are so evidently enjoying will sooner than they know be terminated. This is

the message expressed by the exclamatory words *Oyoh Iyoh* that open the song. That expression connotes the sense of regret the singer feels about the end he is to bring soon to what has been a most thrilling engagement.

To assuage the distress of his fans, Ichegbeh quotes two proverbs that draw on the experience of animals to comment on the experience of humankind. He says: *Mr' Inina ny' Unu le, ooh/Inina ny' Unu d' ejih ch' epwu ch' epwu ka yoh* (I have become a mother hen ooh!/The mother hen does not lay all the eggs in her belly, alas! lines 2 and 3). The proverb is extended, with variation, in the next three lines to connect with another one presenting the following idea: *Embirih ga ga rih rih kpa, Embirih ga ga riri kpa/O dayi l' oka tirekpe k' epwa ny' ilomu kaka* (After a mother goat has finished foraging for food/She never fails to retire back to her own home, lines 7 and 8). The two proverbs convey the same notion, that everything has a limit, and they both employ the poignancy of metaphoric expression to concretize the message.

Ichegbeh goes further by defending his claim to rest as something supported specifically by Igede custom: *Adada m m' onu ny' epwa ny' inam am a ham odu le/Igwuh nwum duw' o tom olujwoh le eeh!*(Father, even if I admit to a liking of the home of my own mother/Alas if death should meet me there I would still be distressed, lines 11 and 12). The proverb hinges on the patriarchal essence of Igede culture. Although Igede society encourages individuals, especially its menfolk, to regard the mother's home as a place in which they can seek refuge in times of trouble, at the same time it insists that as soon as he has resolved the problem that drove him out there, anyone taking advantage of such a gesture must terminate the stay and return to his father's home immediately to face his responsibilities. Thus, even though the Igede regard the mother as a sanctuary, as do their Igbo neighbors, they consider it a disgraceful act for a man to be so overwhelmed by the maternal affection abounding in his mother's home that he takes permanent residency there. The poet is using the proverb to make it abundantly clear that his decision to retire home is taken not on account of being badly treated by his host but in recognition of his duty as a responsible visitor who does not forget that his status is a temporary one.

Ichegbeh loses no time in making emphatic his determination to follow the injunction laid down by Igede tradition for a responsible visitor not to overstress the resources of his host. And he has a ready proverb for expressing such a notion: *Okpahi me la la l iweh oda ka ka ya oh oh oh* (Saying a goodbye word is nothing like the actual absence, lines 13 and

14, 62). This proverb is a savage parody of the despicable antics of one irresponsible visitor presented in Igede folklore. Tales relating the experience refer to a certain man's visit to his in-laws' home, where he was treated to a sumptuous meal and a rich supply of wine. More than three times, he interrupted the proceedings to make his departure announcement, only to sit down again and say *Or' okpokpoh ole me* (One last cup). Irritated by their visitor's greed—when he stood up one more time to repeat his departure announcement—the in-laws humorously used that expression; afterward, the expression became the standard words quoted by others in similar circumstances.

To further his intention to elaborate that when a visit (ordinarily an act of homage) is prolonged beyond reasonable limits it will turn into an act of greed, Ichegbeh has this to say: *A hi b' ata ny' Igbeh ookaa h' epw ale, ahi ka n' epwa kpehe ny' Oyongo/Opi ny' ijuh ka m' ineh ika mw' eru ka* (If we insist on Igbeh being conducive of home we will go to live beyond Oyongo/A good yamland cannot end before one moves the farm, lines 32 and 33). The first counsel is derived from the experience of intertribal land disputes between the Igede and the Izzi people of Anambra State over their common borderland. Although these two farming communities are separated by a natural divide—the River Oyongo—the temptation for either group to cross over to the other side has been a great source of confrontation between the people because of the great fertility of the soil around the river's banks. It is in this area that the *Igbeh* tree—which is widely known to be helpful to the growth of yams—grows abundantly. The second proverb is an elaboration on the allusive reference in the first: taken together, they counsel the wisdom of taking well-timed action in order to forestall the occurrence of an embarrassing situation.

Next, Ichegbeh turns to his devoted fans with a word of consolation, and this brings on two related proverbs: *Onyuchi j' epwu ny enyi le, oh/ Oka je ch' igo ny' eny kpa ka ka oh!/Okirihyeh donu ny' epwu-ogoh ka/ Oka je ch' igo ny' epwu-ogoh ka* (A fish that lives inside water/It can never avoid water/A toad can never legislate against going to the stream!/ It can never avoid the stream, lines 15–18). By these statements, he means to give words of reassurance to his fans, that he has no intention of quitting the bardic profession; therefore they are not seeing the last of him. He only wants to go home to get reinvigorated so that he can return on another day to give them greater thrills.

In fact, Ichegbeh quickly gives his fans a foretaste of the excitement that he has in store for them, by constructing an extremely lewd proverb that sets the audience into prolonged fits of laughter: *Onyang a ji l' obwe-bw-enji, Onyang olinyi a je d' onu ny' ogbe da ka ka* (A woman with an

early pregnancy, a woman with an early pregnancy/That type of woman is one who never avoids the penis, lines 19–25). Ichegbeh was making a familiar recourse to lighthearted erotic or pornographic language as a means of appealing to the sexual impulses of his audience. As we saw in chapter 1, this is a favorite device among the bards. Significantly Ichegbeh's proverb is taken straight from the habit of the Igede to view pregnancy as a sign of a woman's sexiness—her insatiable appetite for sex. This explains why he made an immediate impact on the audience, the members of whom understood clearly the warning he was serving on them: namely, that, just as it would be foolish of a husband to oversex his pregnant wife and thereby bring about the destruction of the fetus inside her womb, because the penis is sweet to her, so it would be unwise also for the fans to take undue advantage of the singer's love of the musical profession and work him to death. Ichegbeh repeats an old proverb *Opi ny' ijuh aka mi, en' ika mw' eru ka* (A good yamland cannot end before one moves the farm, line 29). In its new context, the proverb warns that if the fans persist in following the sweetness of the songs to the end, they might end up killing the creator. This is a warning against greed and other forms of excessive behavior.

Igede culture requires that a good visitor show gratitude to his or her benefactor. Ichegbeh respects this tradition. He makes it emphatically clear that his decision to wind up the performance is not motivated by any dissatisfaction with his lodging, and he is unequivocal in acknowledging the fact that he has been offered hospitality on a scale he could never procure for himself in his own home. This is the notion carried by the expression *In' Ugaru bw' ukpilah k' oka k' opa ka oh!/Ugaru kw' opa ka oti ka k' ale e-eh e-eh*! (Indeed, Ugaru did not leave Ukpila with the intention to move to Opa, alas!/But if Ugaru doesn't go to Opa, where else will he go? lines 34 and 35). The proverb comes from an observation by Igede hunters. They habitually notice that Ugaru, a familiar bird in the culture, has a particular knack for being caught resting on the Ukpilah tree because of its great shady leaves. However, when the hunters attempted to shoot it, the escaping Ugaru bird will then be forced to hide on the Opa tree (which is its last option)—even though Opa provides a less supportive shade to shelter the bird. This proverb offers a very cautious way for the singer to tell his host that he is appreciative of the liberality he has enjoyed, that only duty compels him to seek retirement to his own home.

To his detractors, Ichegbeh directs a number of loaded sayings, beginning with *Ang ik' epwa-ame ka ka dir' iyoh dire m angi h' epwah l' ehi ka* (Those of us who go to the bush to hunt game animals/Never satisfy the expectations of those who stay behind at home, line 37). With this

succinct proverb, the poet is throwing a challenge to those people who think he is terminating the performance prematurely, that he has not achieved much, to try their hand at a similar project and see if it is easy. For Ichegbeh the implication of one's work not being properly appreciated means one would be left with no other option but to be one's best judge, and he has a proverb to cover such a philosophy: *Itenge miri nyamu ododuh ka ooh!* (Itenge's bloated shape is not without a cause! line 40). This proverb is the Igede version of the popular African Wellerism about the lizard who said he accomplished a high altitude jump and praised himself because no one else did so. The saying, as used here, registers the poet's rousing manifesto as an achiever who takes a resolute stand against every form of discouragement expected to follow in the wake of the resentment and envy that success inevitably provokes.

That Ichegbeh is an artist who consciously fights against complacency and is eager to improve upon his performance from day to day is shown in the last movement of the song where, in an obvious instance of his self-criticism, he explains instead of justifying any shortcomings that might have existed in his performance. People have to acknowledge the peculiar circumstances surrounding this particular outing, the poet argues, if they hope to evaluate the real success recorded. The first point to note, he says, is that: *Isoja d' ewu nyawa da, Isoja d' ewu nyawa da/Ewu b' ilah omila bw' agah ka ka/Ew' okpokpoh bwum agagah ale, ewu kwum bw' ekpe* (Soldiers do fight their wars, they fight their wars/An attack from the front never takes them by surprise!/One war took me unawares today, one war pursued me from behind! lines 42–44). The metaphorical reference to the singer as a soldier contributes to the pictorial effect of the proverb, strengthening the notion that without exceptional happenings the singer usually has no difficulty in meeting the demands of his profession with the expected efficiency and skill. Here the bardic profession is characterized as being essentially like the military, as one that is delicate and needs not only talent but also an enabling environment that produces excellent results. It is to encourage understanding of his achievement that the singer then continues to chronicle the intolerable obstacles that he had to surmount.

The lines *Oheh oluhyeh hyam ukpojih o l' ekpetet ale/M j' ediye m w' omi ny' oheh eeh!* (The god of the sky has cut the muscles at the hind of my ankles/I walked and heard the voice of god eeh! lines 45 and 46) contain hyperbolic expressions; they are not meant to be taken literally but are designed to serve as a colorful dress for the underlying idea that the singer had suffered a great bereavement. The reference to the sudden death

of his first cousin in terms of the idea that *Egbejuh beh okwunyih eneh/ Ugbeh onamu dayi l' oka gw' enyi ka ka* (And when headache worries the nose/Eye, the brother, does not fail to water, lines 48 and 49) is inventive; it means that the poet could not stand aloof when misfortunes afflict those close to him. Obtained from a common observation of the human body, here the saying is striking and original because it captures with precision the close bond that existed between the bard and his deceased relative.

In the closing movement of the song, Ichegbeh rounds out his presentation by saying that it is because he has great respect for his host that he suspended his overwhelming sense of duty toward his deceased cousin and decided to grace the occasion being hosted by his benefactor: *El' o gw el' a weru ra le/Iny' ati duh, in' or' el' ododuh/Anu ka yem am d' uk ole kaka* (A matter greater than the farm has sold the farm/That is why, if it were a lesser matter,/You would not have seen me up till now, lines 50–52). However, all the praises he has for his host notwithstanding, the singer also recognizes the great honor his own presence has brought him. Notice the significance of the expression *Okwumwu r' ihin' ny' ojiyah/ Ojiyah r' ihih ny' okwumwu/Opejeh rihih ny' Okwumwu/Jabwo k' okwumwu r' ny' opejeh inyinyi* (The mask is the honor of the village meeting ground,/And the village meeting ground is the honor of the mask/ The crossroads of the village meeting ground is the honor of the mask/ Just as the mask is the honor of the crossroads, lines 53–56). The singer suddenly sees himself in terms of *Okwumwu* (mask). The idea of the host as *ojiyah orepejih* (i.e., the playground where the masked dancer makes his mark) brings the performance full circle to the ideal of reciprocity that all along has been an underlying quality celebrated by Ichegbeh. What he means is that neither himself nor his host could have achieved his significance without the other.

Thus, having shown to both the host and his fans the love, loyalty, and honor due them, Ichegbeh concludes his argument: he should not be detained further but be given a chance to take his leave to do duty to his dead relation as well. The performance is then brought to a close by the poet serving a strong notice that he will not be talking too much longer, he will be matching action with words. This statement turns his attention, once again, to proverbialization, and it strengthens the argument pursued throughout this chapter: that proverbs comprise the major stylistic devices used to lend liveliness, beauty, and the weight of tradition to the songs that serve as prologues and epilogues in Ichegbeh's performances of Adiyah praise songs.

Conclusion

Everyone who lives in an oral culture may be a potential performer, but few ever distinguish themselves as artists of the first order. The same is true also of the Igede society: while every Igede person can sing one song or another, not everyone can sing well. The decade of the eighties was a particularly creative moment in the life of Igede people. It was a period of monumental changes in the political, social, economic, and cultural lives of the people. These changes both inspired and motivated, and were reflected in, the oral artistic creativity of the community. Throughout the villages, the number of singing groups mushroomed. Many individuals found themselves at the crossroads of history and gave artistic expression to their hopes and aspirations, fears, doubts, and uncertainties, as well as their outrage and frustrations.

While these individuals were undoubtedly responding to the communal feelings of their people, their distinction, nay, their very survival, as artists rested on the stamp of individuality they could bring to bear on their compositions. Many of them have remained minor, not necessarily because they possess any inferior creative abilities, but because of such other factors as perseverance, audience support or the lack of it, self-determination, and even sheer inclination.

All over Igedeland in the period in which this study was conducted, I met many talented oral artists, a large number of whom never received anything like public recognition beyond the confines of their immediate communities. It is fair to say that these particular groups or individuals are not minor because of any limited creative abilities that they possess; rather because of other exigencies, such as lack of encouragement or motivation. All artists tend to view themselves as existing in a hostile sur-

rounding, an environment in conspiracy to stifle the creative spark; that is why those artists like Odeh Igbang and Micah Ichegbeh, who overcome these hurdles, are true heroes.

The careers of Ichegbeh and Odeh are both representative and singular: representative in the sense that they demonstrate the immeasurable gains that can result in professionalization of the oral arts; but singular because, so far, their success stories have not yet been repeated or duplicated on a large scale. In the case of Ichegbeh, he is first and foremost a social entertainer. Although he farms, Adiyah performance provides his principal source of income. In this respect, one can say that he has transformed what was originally a part-time art form (whose roots are not purely secular) into a quasi-professional, social art form. His career represents a major innovation in a society where, even after the introduction of Western education, there is little or no occupational specialization. This observation leads us to speculate on Igede views of talent or innate ability. When I asked Ichegbeh whether anyone with appropriate training can become an Adiyah poet or if such a person must come from a line of performers, he responded that anyone could do so provided that he or she had the necessary determination, the gift of a good voice, the wisdom, and the proper gait. His answer reveals a good deal about the egalitarian nature of Igede culture, in which people are regarded as having similar capabilities. If individuals excel in any particular endeavor, the Igede believe, their success is undoubtedly due more to hard work and perseverance than to natural skill. This ethic obviously contrasts with the conception of the artistic vocation as the preserve of certain classes—a conception that is common in less democratic African societies, such as the Yoruba, Hausa, and Wolof to name but a few.

The performances of the Igede children that I have sampled evidence the good prospects that exist in the future for Igede oral arts: as long as the opportunities continue to exit for the composition of the oral arts, those forecasts that announce the imminent demise of the oral arts as a result of the presumed antagonistic developments in modern communications media must remain unfounded inventions of alarmists, which must be ignored. Although Igbang's creative spark was ignited by a personal experience—a mental injury—in giving expression to this suffering he actually showed greater concern for the wider Igede community. As an artist, he explored the communal experience of Igede people, which he gained firsthand. Using an idiom of expression taken from the shared pool of Igede traditional wisdom, he used his songs to communicate to the people the ideals of transforming their society because he recognized that songs

could have a deep and profound impact in a rural community such as his own. And his messages were heightened by the new directions in which he deployed proverbs, images, and other established modes of communication to aid his use of praise and vilification forms of expression. Though deeply rooted in the ancient civilization of the people, Igbang's language was never hackneyed or bland but always fresh and stimulating. However, now that he has moved from the status of a composer of songs to the actual seat of power, it remains to be seen whether or not Igbang will implement his original dream of a transformed Igede society where ancient and new forces interact freely. Igbang's transformation from the status of singer to the elevated position of a chief will represent both a hope and a test for the Igede oral art.

Will Igbang continue to perform after his installation? And will he patronize other performers? Will his manner of ruling reveal a sensitivity to other's needs that he might have acquired during his career as a social critic? If he chooses to perform, and to patronize the existing oral artists—as well as rule with sensitivity—he will greatly boost the image of the oral arts in the community. Will Odeh Igbang's manner of ruling lead to a massive flourishing of the field or will it lead toward a scepticism toward the oral arts in general? Will Igbang take a decisive step to rejuvenate the oral performance culture of Igede, or will his elevated position actually cause the death of the oral arts in his community? It will be interesting to see the direction that Igede oral arts as a whole will take in the future, and I hope this study of the community's praise and vilification songs provides a good starting point for that journey.

NOTES

Introduction

1. Ominyi refers to a detachment of the 1908–09 Niger–Cross River Expedition as the earliest recorded European visit to Igede. He mentions other visits that took place before the 1928 war—that of a British surveying team led by Captain Heron in 1910, and that in 1913 by a British officer, Mr. Poiderin, to carry out the Tiv-Igabu-Yala boundary demarcation. On the basis of evidence from oral and archival sources, he claims that each of the visits was met with hostility by the Igede. O. J. Ominyi, "The Igede Rebellion of 1928–29." Unpublished manuscript, Ahmadu Bello University, Zaria, 1972.

2. Etuh, which means proverb, is tied with the life of Igbang, and it has been ever since it was initiated by him in 1967 and gradually moved beyond his home in Adum-Owo. On the other hand, *Adiyah* means dance queen and is reputed to have been the name of the first Igede women's dance association. Adiyah, too, is inseparable from the career of Ichegbeh, for even though it is associated with the beginnings of Igede expressive art, Ichegbeh is today its only key exponent.

3. Although dirges are performed throughout Igede, only a good death is by custom fit to be mourned on the elaborate scale that calls for dirge compositions. A good death is one arising from such normal illnesses as fever, heat exhaustion, headache, or from old age, while bad death emanates from what the people regard as such abnormal causes as suicide, an accident, epilepsy, a swollen stomach, witchcraft, and any other deaths so declared by the religious elders of the community. Amali (in *An Ancient Nigerian Drama*, 17) describes a similar practice among the Idoma, one of Igede's immediate neighbors. His explanation, that it may be society's attempt to minimize the spread of diseases and limit actions that it regards as harmful, may apply to the Igede situation.

4. That a society like the Igede (which practices gender politics that discriminate against women) should give dead women who are survived by children full burial honors similar to those given to men who die a good death tells us much about the significance the Igede attach to childbearing. Because it is usually the woman who is

blamed when a marriage is childless, a woman's ability to bear a child is automatically a measure of her distinction and her qualification for full funeral honors. She is laid on the *aqwurubeh* (a raised platform made of giant bamboo stalks) instead of being seated, as is a man's corpse. At the high point of the funerary ritual, a kinsman and sons and daughters of the deceased in single file approach the body while it is lying on the aqwurubeh. They weep as they go. The man walks in front carrying a yam on his shoulder; the women walk behind him. The eldest daughter carries a *ubejeh* (a Y-shaped piece of iron made locally by blacksmiths) or a ten kobo coin, if no ubejeh is available. When they reach the aqwurubeh they put the yam and the ubejeh down on the ground by the side of the aqwurubeh. These actions, along with the water that is sprayed on the chest of the deceased before burial, are of great symbolic significance. The deceased is to use the yam to prepare the meal that she will eat and use the ubejeh or coin to purchase the items that she may need on her journey to the land of the dead. The water symbolizes the peace wished for her in her final resting place. The Igede highly honor a woman who is survived by her children because her life is viewed as womanhood fulfilled; ultimately it is honor done to her fertility, which has ensured the continuity of the race.

5. The songs quoted are children's songs that I taped in the Uchenyim village of the Ibilla clan, about forty kilometers away from Igede's local government headquarters at Ibilla Barracks. More than thirty children between the ages of six and thirteen were involved. The occasion was the moonlight play when children in the culture mix freely and perform songs and dance. The performance context was therefore natural. All the songs were taped and later played back repeatedly to the children who answered questions posed by the researcher. More than twenty housewives, who represent every one of the thirteen clans of Igede, were also interviewed. My translations and transcriptions reflect the dialect of the performers, which is the Igede-Central dialect spoken throughout the Ibilla clan.

6. I have deliberately avoided the categorization of Igede children's play songs along the lines established by Ruth Finnegan. According to Finnegan, all African children's play songs fall neatly within such categories as nonsense songs, singing games, catch rhymes, and so on (*Oral Literature*, 303). This typology serves a convenient analytical purpose, and Abarry ("The Role of Playsongs"), for example, has adopted it successfully in his recent study of the Ghana Ga children's play songs. My own experience with Igede children's play songs, however, indicates that such neat divisions do not exist because, depending on the interest of the composers, genre boundaries are continually crossed and songs used in one activity are moved with ease to another. Strict categorization would be arbitrary. One category, nonsense songs, did not feature among the twenty-three songs that I was able to record.

7. I refer here to the widespread phenomenon in many parts of Africa where criticism is tolerated in song where it would not be tolerated elsewhere. For similar practices among the Igbo of Nigeria, the Nyororo of Uganda, and the Podzo of Mozambique's lower Zambesia Province, see Ebeogus's "The World of the Lullaby,"

110; Finnegan's *Oral Literature in Africa*, 300; and Vail and White's *Power and the Praise Poem*, 41, 198–227.

8. The story of the woman who rejects all suitors is found in many cultures. The children have truncated the plot and eliminated the details of the story.

9. This song is not part of the adult repertoire but exclusively a children's composition sung from an adult perspective.

10. To a great extent Igede children's practices resemble those Abarry has described as belonging to the Ga people of Ghana, especially in relation to the way they periodically retreat from adult company to perform songs of their own, while their singing activities almost always encompass and enhance the cultural values of the society as conceived and promoted by adults.

Chapter 1: The Dialectics of Satire

1. The remarks are also appropriate references to the host as he was living a flamboyant life at the time—spending money freely on alcohol, clothes, and women.

2. The Igede of the 1980s was a virtually peaceful semirural community, where such urban crimes as rape, armed robbery, and thuggery were unknown. For accounts of earlier periods, see Frampton's "Intelligence Report."

3. Igede is a society where the habit of second-hand smoking is very common. In the absence of electricity or any form of major power supply, life is very difficult at night all over Igedeland. The significance of Egena's story is deepened by an audience aware of these facts about Igede social life and also aware that cash is very scarce in the community. When one realizes that at the time this research was conducted in 1981 one Nigerian naira was the equivalent of two U.S. dollars, and that the average weekly income of an Igede farmer was less than ten naira at that time, one can then understand why the smoking of a naira bill was considered a major loss.

Chapter 2: Death and the Communal Consciousness

1. Of course, in addition to startling imagery, Igede dirges employ such devices of sound as repetition, vowel harmony or assonance, alliteration, pun, tonal variation, and so on, which are not of primary attention in this chapter.

2. Writing about the dirgers in Balto-Finic culture, Samuli Paulaharju remarks how each performer requires close relatives and friends to support her on both sides because some people lament so strongly that they are overwhelmed and collapse; they have to be revived with water (quoted in Ajuwon, *Funeral Dirges*, 4). And yet, comments Ajuwon, Balto-Finic lamentation poetry displays the composer's ability to organize his or her thoughts perfectly, and he identifies the techniques of assimilation, repetition, the occurrence of nicknames, and the metaphorical figures of speech for praising the deceased and expressing pathos (4) as the main characteristics that highlight the composer's skills. All these things are also present in Igede dirges, as are common motifs that are believed to typify not only Balto-Finic but also northern

Russian dirges, such as asking the deceased why he chose to die, why he has abandoned his loved ones, and to what new place he is going (Ajuwon 5).

3. Nketia's report on dirgers' behavior among the Akan of Ghana compares well with the behavior of Igede dirgers, especially when he remarks that premature death—the death of a useful or important member of a community in particular—calls for a good deal of wailing and singing of dirges (*Akan Funeral Dirges*, 6).

Chapter 3: Politics and Creativity

1. For details on some of Igbang's political messages conveyed through proverbs not related to praise, see my "Songs from the Edge of Power."

2. The notion of communal participation that I indicate here is similar to what Kirsten Alnaes has observed among the Herero singers of Botswana; (see her "Living with the Past"). In this richly illustrated essay on the Herero singers, Alnaes documents how the Herero compose songs about every facet of their experience, the most central of which has been in recent times their long drawn-out war with the German occupation forces and the suffering brought by that war. Alnaes identifies among the Herero the existence of professional singers of the caliber of Micah Ichegbeh. The author's description of how the lead singer among the Herero produces the art bears a striking resemblance to the practice that I witnessed in operation within Micah Ichegbeh's ensemble—especially in relation to the way in which the lead singer introduces a song, so that as the singing proceeds, "audience and singer create a dialogue in which themes and motifs interweave, influencing the direction in which the song develops. After a period of dialogue the lead singer will take over with a new solo performance, developing the song in a new direction . . . It is the interplay between lead singer and audience which determines the form the song takes. The performance of the song is thus a joint effort" (273).

3. In this song, as in the performance of other Adiyah praise songs generally, the musical accompaniment played a major part in producing the overall impact on the audience. The musical effect was heightened, most particularly, in that episode recounting the drama of the encounter between the Igede people and their enemies, the Ora (lines 111–41). This is the real contest of power, and the scene appropriately witnessed one of the poet's most inspired moments of creativity. He employed ideophone, hyperbole, parallelism, word play, and pure verbal virtuosity in his bid to vivify the imaginative heroism displayed by the Igede's ancestral fathers. The musical accompaniment attempted to match the fever-pitched tempo of the oral delivery. The lead drummer sought release in an ecstatic and wild lyrical flourish. It became a battle of words, keenly contested between the human voice and the drums. The audience responded hysterically. Naira rain fell on the drummer and poet, and applause thundered through the chilled night. This was the point at which a member of the audience rushed toward the lead drummer holding a bottle of the local gin, *ogogoroh*, which he emptied on the drummer's head as the drummer pounded mercilessly on his instruments. The gin is the symbolic libation offered to the gods of the drums who were being requested not to withdraw their gift from the human community.

Chapter 4: The Image Burden

1. In his *Interpretation of Dreams,* Freud reads phallic meanings in a similar usage when he explains one of his patient's dreams: "I added from my own knowledge derived from elsewhere that climbing down, like climbing up in other cases, described sexual intercourse in the vagina" (401). Note, however, that none of this is implied whatsoever by Ichegbeh in his song.

2. See Okara's *The Fisherman's Invocation* and pBitek's *Song of Lawino.*

3. In Okpewho's lucid and informative discussion of praise poetry from different parts of Africa in his *African Oral Literature,* he makes the claim that the majority of praise poetry from Africa deals with the praise of others by more or less professional praise singers, and many of the people thus praised have distinguished themselves in various endeavors, such as war, hunting, and farming (*African Oral Literature,* 144). If he is right, as I believe he is, Igede praises can be considered truly revolutionary in that they tend to be attentive to heroism that exists in most unlikely places, in aspects of what are usually considered mundane human activities.

Chapter 5: Proverb Usage in Igede Praise Songs

1. Proverbs, like many other elements of oral culture, are never fixed but are in a constantly shifting and changing mode; Wolfgang Mieder has, with typical wit, encouraged paremiologists to become increasingly aware of the use and function of traditional proverbs in modern technological and sophisticated societies (*The Proverb in the Modern Age,* 118). While much work remains to be done in that direction, here I am primarily concerned with clearing the first hurdle and exploring proverb usage in a typically semirural and folk context.

2. That many traditional artists have song formulas that serve mainly as prologues and epilogues in their performances has also been observed by Kwesi Yankah ("To Praise or Not to Praise," 389–90) in respect of the recitations in Dankyira court performance among the Akan of Ghana. It seems therefore useful to bring to light as many specific case studies of this widespread practice by African oral artists because such investigations will not only help us more clearly establish the nature of the creative temper of many men and women artists who work within the oral medium but also tell us much about the specific cultures in which the artists carry out their work.

BIBLIOGRAPHY

Abarry, Abu. "The Role of Play Songs in the Moral, Social and Emotional Development of African Children." *Research in African Literatures* 20, no. 2 (1989): 202–16.
Abi, M. B. "Administration of Justice in Igede." In *Igede Gedegede: Selected Essays on Igede Language, Culture, and Literature,* Ogaga Agocha et al., eds., 70–81. Makurdi: Onaivi Press, 1987.
Abrahams, Roger. "Introductory Remarks to a Rhetorical Theory of Folklore." *Journal of American Folklore* 81 (1968): 143–58.
Agovi, K. E. "The Political Relevance of Ghanaian Highlife Songs since 1957." *Research in African Literatures* 20, no. 2 (1989): 194–201.
Agu, Ogonna. "Songs and War: The Mixed Messages of Biafran War Songs." *African Languages and Cultures* 4, no. 1 (1991): 5–19.
Ajima, Moses. "Western Education and Its Contribution to Igedeland." In *Igede Gedegede,* Ogaga Agocha et al., eds., 143–50.
Ajuwon, Bade. *Funeral Dirges of Yoruba Hunters.* New York: Nok Publishers, 1982.
Alnaes, Kirsten. "Living with the Past: The Songs of the Herero in Botswana." *Africa* 60, no. 3 (1989): 267–99.
Amali, S. O. O. *An Ancient Nigerian Drama.* Stuttgart: Franz Steiner, 1985.
———. *Onugbo Me Loko.* Ibadan: Institute of African Studies, University of Ibadan, 1972.
Armstrong, R. G. "The Idoma-speaking Peoples." In *Peoples of the Niger-Benue Confluence,* Daryl Forde, ed., 91–147. London: International African Institute, 1955.
Azuonye, Chukwuma. "Stability and Change in the Performances of Ohafia Igbo Singers of Tales." *Research in African Literatures* 14, no. 3 (1983): 332–80.
Babalola, Adeboye S. *The Content and Form of Yoruba Ijala.* London: Oxford University Press, 1966.
Balogun, Odun F. *Tradition and Modernity in the African Short Story: An Introduction to a Literature in Search of Critics.* New York: Greenwood Press, 1991.

Barber, Karin. *I Could Speak Until Tomorrow: Oriki, Women, and the Past in a Yoruba Town*. Washington, D.C.: Smithsonian Institution Press, 1991.

———. "Popular Cultures in Africa." *African Studies Review* 30, no. 3 (1987): 1–78, 105–11.

———. "Yoruba Oriki and Deconstructive Criticism." *Research in African Literatures* 15, no. 4 (1984): 497–518.

Barber, Karin, and P. F. de M. Farias, eds. *Discourse and Its Disguises: The Interpretation of African Oral Texts*. Birmingham, Eng.: CWAS Interdisciplinary African Studies Series 1, 1989.

Bauman, Richard. *Verbal Arts as Performance*. Rowley, Mass.: Newbury House, 1977.

Ben-Amos, Dan, ed. *American Folklore Society*. Austin: University of Texas Press, 1976.

———. *Folklore Genres*. Austin: University of Texas Press, 1976.

Bird, C. "Heroic Songs of the Mande Hunters." In *African Folklore*, R. M. Dorson, ed., 275–93. Bloomington: Indiana University Press, 1972.

Bowra, C. M. *Heroic Poetry*. New York: Cambridge University Press, 1952.

Boadi, I. A. "The Language of the Proverb in Akan." In *African Folklore*, Richard M. Dorson, ed., 183–91. Bloomington: Indiana University Press, 1972.

Cook, David. *African Literature: A Critical View*. Harlow: Longman, 1977.

Collins, E. J. "Ghanaian Highlife." *African Arts* 10 (1976): 62–68, 100.

Cronin, J. "Even under the Reign of Terror!: Insurgent South African Poetry." *Research in African Literatures* 19, no. 1 (1988): 12–22.

Dundes, Alan. *The Study of Folklore*. Englewood Cliffs, N.J.: Prentice-Hall, 1965.

Ebeogu, Afam. "The World of the Lullaby: The Igbo Experience." *Research in African Literatures* 22, no. 2 (1991): 99–117.

Egudu R. N. *The Study of Poetry*. Ibadan: University Press Limited, 1985.

Finnegan, Ruth. *Oral Literature in Africa*. London: Oxford University Press, 1970.

———. *Oral Poetry: Its Nature, Social Context, and Significance*. Cambridge: Cambridge University Press, 1977.

Ford, Daryl, ed. *The Peoples of the Niger-Benue Confluence*. London, 1955.

Frampton, A., "Intelligence Report on the Egedde District of Idoma Division." Unpublished manuscript, 1935.

Freud, Sigmund. *The Interpretation of Dreams*. London: Hogarth Press, 1957.

Hamilton, R. G. "Cape Verdean Poetry and the P.A.I.G.C." In *Artist and Shared Audience: African Literature as a Shared Experience*, O. Priebe and T. A. Hale, eds., 103–25. Washington D.C.: Three Continents Press, 1979.

Idikwu, E. "Burial in Igede." In *Igede Gedegede: Selected Essays on Igede Language, Culture, and Literature*, Ogaga Agocha et al., eds., 85–91. Makurdi: Onaivi, 1987.

Innes, Gordon. *Sunjata: Three Mandinka Versions*. London: School of Oriental and African Studies, 1974.

———. "Formulae in the Mandinka Epic: The Problem of Translation." In *The Oral Performance in Africa*, Isidore Okpewho, ed., 101–10. Ibadan: Spectrum Books, 1990.

Jordan, A. C. *Towards an African Literature: The Emergence of Literary Form in Xhosa.* Berkeley: University of California Press, 1973.

Kasfir, S. L. "Remembering Ojiji: Portrait of an Idoma Artist." *African Arts* 22, no. 4 (1989): 44–87.

Kermode, Frank. *The Sense of an Ending: Studies in the Theory of Fiction.* New York: Oxford University Press, 1967.

Krappe, Alexander, II. *The Science of Folklore.* London: Methuen, 1934; rpt., New York, 1964.

Kunene, Dan P. *Heroic Poetry of the Basotho.* Oxford: Clarendon Press, 1970.

———. "Journey as Metaphor in African Literature." In *African Literature: The Present State*, 189–215. Washington: Three Continents Press, 1985.

———. "Metaphor and Symbolism in the Heroic Poetry of Southern Africa." In *African Folklore*, R. Dorson, ed., 295–318. Bloomington: Indiana University Press, 1972.

Mack, Beverly B. "Songs from Silence: Hausa Women's Poetry." In *Ngambika: Studies of Women in African Literature*, Carole Boyce Davies and Anne Adams Graves, eds., 181–90. Trenton, N.J.: Africa World Press, 1986.

Mafeje, Archie. "The Role of the Bard in a Contemporary African Community." *Journal of African Languages* 6 (1967): 193–223.

Mieder, Wolfgang. "Popular Views of the Proverb." *Proverbium* 2 (1985): 108–43.

———. "The Proverb in the Modern Age: Old Wisdom in New Clothing." In *Tradition and Innovation in Folk Literature*, 118–56. Hanover: University Press of New England, 1987.

Mohammed Jama, Zainab. "Fighting to be Heard: Somali Women's Poetry." *African Languages and Cultures* 4, no. 1 (1991): 43–53.

Mortimer, Mildred. *Journeys through the French African Novel.* Portsmouth, N.H.: Heinemann, 1990.

Mphande, Lupenga. "Ideophone and African Verse." *Research in African Literatures* 23, no. 1 (1992): 117–29.

Mzamane, Mbulelo. "Popular Culture and Revolution: The Example of FRELIMO Poetry in Mozambique, 1962–1979." Paper presented at the Conference on Popular Culture and the Media, Ahmadu Bello University, Zaria, 1984.

———. "The Uses of Oral Forms in Black South African Literature." In *Literature and Society in South Africa*, L. White and T. Couzens, eds., 147–60. Harlow, Eng.: Longman, 1984.

Nettl, Bruno. *Music in Primitive Cultures.* Cambridge, Mass.: Harvard University Press, 1965.

Nicholls, R. "Igede Funeral Masquerades." *African Arts* 17, no. 3 (1984): 70–76.

———. "Music and Dance Guilds in Igedes." In *More Than Drumming: Essays on African and Afro-American Music and Musicians*, Irene V. Jackson, ed., 91–117. Westport, Conn.: Greenwood Press, 1985.

———. "Ensemble Music of the Igede." *Black Perspective in Music* 16, no. 2 (Fall 1988): 191–212.

———. "Music and Dance Association of the Igede of Nigeria: The Relevance of Indigenous Communication Learning Systems to Rural Development Projects." Ph.D. diss., Howard University, 1992.

Nketia, Kwabena. *Funeral Dirges of the Akan People*. Achimota, 1955.

Nwoga, Donatus I. "The Igbo Poet and Satire." In *Oral Poetry in Nigeria*, U. N. Abalogu, G. Ashiwaju, and R. Amadi-Tshiwala, eds. Lagos: Nigeria Magazine, 1981.

Obiechina, E. N. *Culture, Tradition, and Society in the West African Novel*. Cambridge: Cambridge University Press, 1975.

Ogede, Ode S. "Counters to Male Domination: Images of Pain in Igede Women's Songs." *Research in African Literatures* 25, no. 3 (1994): 105–20.

———. "Igede Oral Literature: Preliminary Issues of Identification." In *Igede Gedegede: Selected Essays on Igede Language, Culture, and Literature*, Ogaga Agocha et al., eds., 128–32.

———. "Imagery in the Praise Poetry of the Igede *Adiyah* Poet Micah Ichegbeh." *Research in African Literatures* 22, no. 3 (1991): 149–70.

———. "Oral Performance as Instruction: Aesthetic Strategies in Children's Play Songs from a Nigerian Community." *Children's Literature Association Quarterly* 19, no. 3 (1994): 113–17.

———. "The Poetry of Micah Ichegbeh and Odeh Igbang." *Nigeria Magazine* 55, nos. 1–2 (1989): 44–48.

———. "Proverb Usage in the Praise Songs of the Igede: *Adiyah* Poet Micah Ichegbeh." *Proverbium* 10 (1993): 237–56.

———. Review of *African Literature Today: Oral and Written Literature*, Eldred Jones et al., eds., *Africa* 61, no. 2 (1991): 284–86.

———. Review of *Power and the Praise Poem: Southern African Voices in History*, Landeg White and Leroy Vail. *Matatu* 11 (1994): 207–208.

———. Review of *African Oral Literature: Backgrounds, Character, and Continuity*, Isidore Okpewho. *Research in African Literatures* 26, no. 1 (1996): 205–207.

———. Review of *The Oral Performance in Africa*, Isidore Okpewho, ed. *Research in African Literatures* 22, no.1 (1991): 120–23.

———. "The Role of Micah Ichegbeh's *Adiyah* Songs in the Political Education of His Local Audiences." *African Languages and Cultures* 6, no. 1 (1993): 49–68.

———. "Some Igede Light-hearted Erotic Songs: The Uses of Obscenity in Moral Education." *Lore and Language* 11, no. 2 (1992–93): 143–54.

———. "Power and the Creative Flame: The Invention of the *Etuh* (Proverb Songs) by the Igede poet Odeh Igbang." *International Folklore Review*, forthcoming.

———. "Songs from the Edge of Power: Interpreting Some Political Polemic of the Igede *Etuh* (Proverbs) Poet Odeh Igbang." *African Affairs* 93 (April 1994): 219–31.

Ogunba, Oyin. "Traditional African Poetry." *Journal of the Nigerian English Studies Association* 8, no. 2 (1976).

Ojoade, Olowo. "Proverbial Evidences of African Legal Customs." *International Folklore Review* 6 (1988): 26–38.

Okara, Gabriel. *The Fisherman's Invocation*. Benin: Ethiope Publishing, 1978.
Okpata, Damian. "Adynation Symbols in Igbo Proverbial Usage." *Lore and Language* 6, no. 1 (1987): 51–57.
Okpewho, Isidore. *African Oral Literature: Backgrounds, Character, and Continuity*. Bloomington: Indiana University Press, 1992.
———. *The Epic in Africa*. New York: Columbia University Press, 1979.
———. *Myth in Africa*. Cambridge: Cambridge University Press, 1983.
———. "Rethinking Myth." *African Literature Today* 11 (1980): 5–23.
Okpewho, ed. *The Heritage of African Poetry*. London: Longman, 1985.
———. *The Oral Performance in Africa*. Ibadan: Spectrum, 1990.
Ominyi, O. J. "The Igede Rebellion of 1928–29." Unpublished manuscript, Ahmadu Bello University, Zaria, 1972.
Pointer, F. H. "In Praise of Kambili Sananfila." *African Literature Today* 16 (1989): 39–60.
Pongweni, Alec. *Songs that Won the Liberation War*. Harare, Zimbabwe: College Press, 1982.
pBitek, Okot. *Song of Lawino and Song of Ocol*. London: Heinemann, 1984.
Ranung, Bjorn. *Music of Dawn and Day: Music and Dance Association of the Igede of Nigeria*. Love Records LXLP 513/514. Helsinki, 1972. Sound recording.
Schipper, Mineke. "Mother Africa on a Pedestal: The Male Heritage in African Literature and Criticism." In *Women in African Literature Today* 15, Eldred Durosimi Jones, Eustace Palmer, and Marjorie Jones, eds., 35–54. London: James Currey, 1987.
Sekoni, Ropo. *Folk Poetics. A Sociosemiotic Study of Yoruba Trickster Tales*. Westport, Conn.: Greenwood Press, 1994.
Seydou, Christaine. "A Few Reflections on Narrative Structures of Epic Texts: A Case Example of Bambara and Fulani Epics." Brunhilde Biebuyck, trans. *Research in African Literatures* 14 (1983): 312–31.
Soyinka, Wole. *A Dance of the Forests*. Oxford: Oxford University Press, 1963.
Steadman, Ian. "Alternative Theatre: Fifty Years of Performance in Johannesburg." In *Literature and Society in South Africa*, L. White and T. Couzens, eds., 138–46. Harlow, Eng.: Longman, 1984.
———. "Stages in the Revolution: Black South African Theatre since 1976." *Research in African Literatures* 19, no. 1 (1988): 24–33.
Tedlock, Dennis. "Towards an Oral Poetics." *New Literary History* 8 (1979): 507–19.
Wellek, Rene, and Austin Warren. *Theory of Literature*. Third edition. New York: Harcourt, 1977.
White, Landeg, "Poetic License." In *Discourse and Its Disguises: The Interpretation of African Oral Texts*, Karin Barber and P. F. de Moraes Farias, eds., 41–45.
White, Landeg, and Leroy Vail. *Power and the Praise Poem: Southern African Voices in History*. Charlottesville: University Press of Virginia, 1991.
———. "The Art of Being Ruled: Ndebele Praise-poetry, 1835–1971." In *Literature and Society in South Africa*, edited by Landeg White and T. Couzens, 41–59. Harlow: Longman, 1984.

Yankah, Kwesi. "Creativity and Traditional Rhetoric: Nkrumah's Personal Poet and His Son." In *Literature and National Consciousness,* Ebele Eko, Julius Ogu, and Azubuike Iloeje, eds. *Calabar Studies in African Literature* 4 (1989): 78–88.

———. "To Praise or Not to Praise the King: The Akan *Apae* in the Context of Referential Poetry." *Research in African Literatures* 14, no. 3 (1983): 381–400.

———. Proverbs: The Aesthetics of Traditional Communication. *Research in African Literatures* 20. no. 3 (1989): 325–46.

Index

Abarry, Abu, 17, 158n. 6
Abi, M. B., 5
accountability, importance of, xv
action, ideophones' embodiment of, 129–33. *See also* dance
Adiyah tradition: approach of, 18–19, 101; dance's role in, 103; goals of, 79–80, 82–84; imagery used in, 104–8; music's role in, 103; origin of, 5; performances of, 25–26, 29, 38, 49; political songs in, 80–81, 83–99, 101; possibilities in, 113; support for, 144. *See also* Ichegbeh, Micah
adultery, as taboo, 28–29
Africa: commonalities in, 50–51, 66; diversity in, xi; social criticism in, 75; song form in, 139–40. *See also* Botswana; Gambia; Ghana; Nigeria; South Africa; Zimbabwe; *names of specific groups*
Ahi Kpahi j' Igede (Let's Preserve Igede), 104–6, 113
Ainu, war of, 5
Ajima, Moses E., 136–37
Ajuwon, Bade, 6, 159–60n. 2
Akan: ancestors of, 62–63; dirges of, 160n. 3; praise poetry of, 75; proverbs of, 139; singers of, 6; song formulas of, 161n. 2
Akpara ny' Anyang (Women's Prostitution), 29–32, 35
Akuffo, Okyeame Boafo, 75
alcohol: addiction to, 38–39; as symbol, 160n. 3
Alekwu troupe, 6
allegory, in songs about suitors, 13
allusions: to folktales, 142, 150; to Ikpekpe and thunder, 119–20; role of, 107
Alnaes, Kirsten, 160n. 2
Amali, S. O. O., 122–23, 157n. 3
Am' ar' Egena-Ony-Ode ka (I Am Not Egena, Child of Ode), 38–39
ancestors: addresses to, 62–64; conjured in dirges, xv; irresponsibility of, 61; role of, 60, 62, 76
animal world, as metaphor, 123, 126, 133, 142–43, 149–51
Anyang A likpa (Women Age-Mates), 32–34
Apae tradition (Ghana), 75
A Pwam Ka (Don't Divorce Me), 40–42
aqwurubeh, function of, 157–58n. 4
Armstrong, Robert G., 2, 122–23

art: diversity in, xi; and egalitarianism, 155; political function of, 48. *See also* performance; songs
audience: active participation of, 49, 71, 73–74, 78, 83, 144–45; approach to, 80, 83–85; challenge to, 151–52; encouragement of, 74, 76; familiar images for, 65; gaining confidence of, 7–8, 98, 124; goodwill among, 140–43; ideophones' effect on, 130–32; jubilation of, 80; and performance endings, 148–53; and political understanding, 82–84, 106, 134, 137; silence of, 123; warnings to, 77–78, 83–84, 143, 151
Awolowo, Obafemi, 81–82
Awolowo Did Dare to Touch Shagari (*Awolowo kp' Ubwo kaka gw' Ishagari*), 80–82
Awolowo kp' Ubwo kaka gw' Ishagari (Awolowo Did Dare to Touch Shagari), 80–82
Ayilo, definition of, 9
A y' ujih j' urube ka (Do Not Bear Malice Toward the Thatch), 108–13
Azuonye, Chukwuma, 20

Babalola, Adeboye S., xi, 6
Balewa, Tafawa, 74, 76
Balto-Finic culture, dirges in, 159–60n. 2
Barber, Karin, xi, 47, 140
beauty, concept of, 37–38, 60–61
Ben-Amos, Dan, 23
Biafran war, 96, 140
bicycle, as metaphor, 26–28
Bird, Charles, 20, 100
birds, imagery of, 78, 119, 151
Boadi, I. A., 75, 139
Botswana, communal participation in, 160n. 2
brothers: dirge for, 53–62; folklore story about, 126–36

cash: meaning of, 37; smoking of, 39
childbearing, attitudes toward, 34, 101, 157–58n. 4
children: attitudes toward, 10–11; as audience, 74; death of, 42, 51–52, 64–66; performance by, 9–18, 155; role of, xiv, 8–18; songs by, 11–17. *See also* girls; infants; sons
colonialism, 2–4
communal consciousness, xii. *See also* community
community: addressing entire, 49; characteristics of, 2–3; children's role in, 8–9, 14–15; empowerment of, 69–71; games in support of, 17; harmony as goal for, 32, 77, 79, 143; importance of, xiv, 11, 76–79, 143; versus individualism, xii, 13–14, 61, 77–78; participation of, 160n. 2; responsibility of, 74; social control in, 24–25; solidarity of, 12–13, 140; symbolic system in, 37–38; warnings to, 39. *See also* audience; morals; tradition
composition: categories of, 9; components in, 123–24, 139, 148–49, 161n. 2; creativity in, 85; improvisation versus memorization in, 20–21; methods in, 29, 37, 71, 120; motives in, xii; satire in, 37; as social criticism, 74–75; variations in, 47
contraception, attitudes toward, 34
Cook, David, 82
cooking pot, as metaphor, 32–34
costumes, types of, 103
creation story, historical epic as, 99
crime, absence of, 159n. 2
criticism, tolerated in song, 11–13, 74–75

dance: learning, 19; in play songs, 9–10, 15, 17–18; in political songs, 74, 83; role of, 103; in vilification songs, 25
death: attitudes toward, 7, 51, 53, 62, 67,

153; causes of, 65, 157n. 3; customs associated with, 5–7; good versus bad, 5–6, 98; premature, 160n. 3; symbolism of, 95, 100. *See also* dirges
defamation. *See* vilification poetry
Dimka, Col. S. D., 127–28, 133, 135–36
dirgers: emotion of, 64–65; linked to family predicament, 63–64; men as, 64–66; role of, 50, 67; techniques of, 50–60, 51–53; women as, 51–60, 66
dirges: ancestors addressed in, 62–64; components of, 53–60, 63–64; context of, 5–6; form and function of, xiv-xv, 50–51, 67; versus lament or elegy, 6; motifs in, 63–64, 159–60n. 2; motivation for, 59–60; period for, 6–7; strategies in, 60–63; techniques in, 51–53, 64–66
Do Not Bear Malice Toward the Thatch (*A y' ujih j' urube ka*), 108–13
Don't Divorce Me (*A Pwam Ka*), 40–42
dreams, as source of song, 20
Dundes, Alan, xi-xii

Ebeogu, Afam, 9, 47
education: resistance to Western, 136–37; role of, 68, 73, 79
Egede. *See* Igede
Egoh Ny' Igede (The History of Igede), 2–3, 83–99
Egudu, R. N., 51, 103–4
Ehwong, symbolism of, 94, 100
Ejeh ny' Ewa Ol' Oboche (The Song of the Proud Spur-Fowl), 13
Ejeh Ny' Imahi (Song of Frustration), 42–47
Ejeh Ny Okpahi (Goodbye Song), 145–53
Eje Ny' Owurabah (Welcome Song), 141–43
elders, role of, 7
elegy (*eru*): versus dirge, 6; in political songs, 69

ethnicity: lack of concern for, 106–7; politics of, 74–76
Etuh tradition: approach of, 20–21; dance's role in, 103; invention of, 122, 124–25; music's role in, 103; name of, 138; origin of, 5; performances of, 25–26, 35, 49, 68, 123–24; political songs in, 68–71; rehearsals in, 20–21. *See also* Igbang, Odeh
Europeans, contacts with, 2–3. *See also* Great Britain
Evil Woman (*Onyang Onyobi*), 35–38

family status, 63–64
Farias, P. F. de Moraes, 140
farming, allusions to, 107
father, meaning of, 52
Finnegan, Ruth, 13, 20, 158n. 6
folklore: allusions to, 65–66, 121, 142, 150; on Odugboh and Okoh, 126–36; style of, 122–23
food, symbolism of, 97, 100
Frampton, A., 2, 4, 25
freedom, significance of, 83
Freud, Sigmund, 161n. 1
funeral essay. *See* dirges

Ga: games of, 17; play songs of, 158n. 6
Gambia, songs about sexuality in, 27–28
games, song as accompaniment to, 16–17
gender: and childbearing, 101; differentiation of, 35; and dirge composition, 66; and marital harmony, 35–38; and politics, 46–49; and songs' variations, 47–48. *See also* men; women
Ghana: ancestors, 62–63; dirges in, 160n. 3; games in, 17; play songs of, 158n. 6; political songs in, 75; proverbs in, 139; singers in, 6; song formulas in, 161n. 2
gin, as symbol, 160n. 3

girls, warnings to, 13, 32–34
goat, as metaphor, 149
God, importance of, 79
God Willed, We Igede Won Our Freedom (*Oheh m' Aligede L' Ilohi*), 82–83
Goodbye Song (*Ejeh Ny Okpahi*), 145–53
gossip (ojah), role of, 123–24
grasscutter, as metaphor, 141–42
Great Britain, occupation by, 2–3, 46, 136–37

hen, as metaphor, 149
Herero singers (Botswana), 160n. 2
hero, imagery of, 108–13
Heron, Capt. (soldier), 157n. 1
home, meaning of, 112–13
host: goodwill toward, 140–43; and performance endings, 149–51; praise for, 119, 121, 143–44; respect for, 153
human beings: animals as metaphor for, 123, 126, 133, 142–43, 149–51; commonalities of, 50–53, 66, 67; harmony as goal of, 79–80; needs of, ix; prized qualities of, 128–29, 140, 142–43
humility, importance of, 143
hunting, imagery of, 65–66, 74, 76

I Am a Hated One (*M Haaka*), 10
I Am Going to Speak Out! (*M ja ka y'ela*), 83–84
I Am Not Egena, Child of Ode (*Am' ar' Egena-Ony-Ode ka*), 38–39
Ibilla, dispute of, 5, 46
Ibo, and politics, 82
Ibomah tradition, 48
Ichegbeh, Micah: approach of, 18–20, 78–80, 83–85, 101, 138; background of, 19, 28, 155; compositions by, 80–101, 104–22, 138–51; honesty of, 98; and Igede legend, 2–3; imagery used by, 104–22; improvisation by, 20; material for, 5; performances by, 26–27, 34, 144, 152; political activism of, 68, 81–82; popularity of, 101; proverbs used by, 120–21, 138–51; and religious practices, 143–44; significance of, 155; song formula of, 139, 148–49; word play by, 119. *See also* Adiyah tradition
ideophones: connotation of, 100; as derisive, 11; as descriptive, 18; effect of, 121, 129–36
Idikwu, Eriba, 5, 7
Idoma: burial customs of, 6, 157n. 3; Igede victory over, 83; location of, 1
Igabu, location of, 1
Igbang, Odeh: approach of, 20–21, 74, 78, 122, 124–31, 134, 138, 155–56; background of, 137; as chief, 137, 156; compositions by, 68–78, 122–36; costume of, 103; courage of, 74–75; folklore used by, 122–27; history used by, 127–28; ideophones used by, 129–36; imagery used by, 136–37; language of, 76; material for, 5, 20; performances by, 35, 123–25, 127; political activism of, 68; proverbs used by, 21, 76–78, 128–29; significance of, 155. *See also* Etuh tradition
Igbo: lullabies by, 9, 158–59n. 7; and political song, 96
Igede: beliefs of, 7–8, 50–53, 60–61, 66, 76, 120, 144, 155; characteristics of, xi–xii, 8–9, 25, 34, 37, 46, 98, 119, 123, 140, 159n. 2; divisions within, 4–5, 46, 80; egalitarianism of, 155; history in song of, 85–97; homeland of, 1, 2; interactions among, ix–x; political history of, 2–5, 46, 82, 134–37, 150, 154; proverbs' importance for, 138–39; social and cultural context of, 5–7; taboos of, 28–29; unification of, 144; welfare of, 77–79, 84–85. *See also* community; Igede language; performance; songs

Igede language: description of, 7; importance of, 107–8, 113, 144; manipulation of, 13, 125; and nationalism, 104–8; as poetic, 82; in political songs, 160n. 3; proverbs' role in, 138–39; transcription of, 22. *See also* poetry

Ihih songs: definition of, 48; performances of, 25–26

Ikpekpe, allusion to, 119–20

imagery: analysis of, xvi; of birds, 78, 119, 151; children's use of, 11–13; in dirges, 53, 60–66; enhanced by proverbs, 120–21; of greatness versus goodness, 113; Ichegbeh's use of, 104–22; Igbang's use of, 136–37; for marriage, 35; in political songs, 74, 76–78, 107–13, 136–37; role of, 103–4, 113; for sexual knowledge, 29, 32–34; sources of, 122. *See also* allusions; ideophones; metaphor; proverbs

Improve Your Fatherland, Then (*Nwu L' Opi Ny' Adang Me*), 71–74, 76

incest, as taboo, 28–29

independence, impact of, 4–5

individualism: attitudes toward, 140; combined with tradition, 19; versus community, xii, 13–14, 61, 77–78; as source of danger, 12–13

infants: caring for, 9; death of, 7

instruments (musical), 19, 21, 103, 160n. 3

Ito, war of, 5

Izzi: dispute with, 150; location of, 1

Jordan, A. C., 75

Kermode, Frank, 148
kites (birds), as metaphor for singer, 119
koh koh koh, definition of, 11
Kunene, Dan, xi, 99, 112

lament. *See* elegy (*eru*)
Leopard, imagery of, 65–66, 121

Let's Preserve Igede (*Ahi Kpahi j' Igede*), 104–6, 113
life, as market, 62
love poetry, in political songs, 69
lullabies: function of, 9; performance context of, 47; transformed into play song, 9–11, 17

Mafeje, Archie, 75
magician, allusion to, 119–20
mamba, use of, 61–62
Mande poetry, 20, 100
market: cycle of, 64; life as, 62
marriage: carefulness in, 78; context of, 48–49; responsibilities in, 42–47; songs about, 35–38, 40–42
meat, consumption of, 27, 29
men: death of elderly, 7; as dirgers, 64–66; and marital harmony, 35–38; and preference for sons, 49; vilification songs addressed to, 38–39; women's challenge to, 42–47
metaphor: animal world as, 123, 126, 133, 142–43, 149–51; bicycle as, 26–28; birds as, 78, 119, 149, 151; cooking pot as, 32–34; for neglect of language, 107–8; for prostitution, 37–38; for sexual intercourse, 34; soldier as, 152; thatch roof as, 108–13; washman as, 107–8; yam as, 60–61, 77–78, 150–51
M Haaka (I Am a Hated One), 10
Mieder, Wolfgang, 161n. 1
M ja ka y'ela (I Am Going to Speak Out!), 83–84
Mohammed, Gen. Murtala, 127–28, 133–36
money. *See* cash
Money, Capt. (soldier), 2
moonlight play, by children, 9–11, 16–17
morals: emphasis on, 32, 50, 61, 98–99; and politics, 79; satire as instruction in, 25; songs about, 14–15, 39; strengthening of, 34–35. *See also* sexuality

mother: in children's song, 10–11; meaning of, 52; performance by, 11; as refuge, 149
mourners, professional, 6
Mphande, Lupenga, 129
music: instruments for, 19, 21, 103, 160n. 3; role of, 102–3. *See also* sound effects; rhythm
My Bicycle Has No Bells (*Ojeh nyam j' Atang Ka*), 26–28
Mzamane, Mbulelo, 75

Nao Ayele Awi (Who Gets Hurt) game, 17
nationalism, song about, 104–6
National Party of Nigeria (NPN), 81–82
nature, as ground for social concerns, 13–14
Nicholls, Robert, 5–6, 51
Niger-Cross River Expedition, 157n. 1
Nigeria: elections in, 74, 81–82; harmony as goal of, 79–80; peoples in, 1; performance competition in, 19–20; politics in, 68, 71, 74–76, 81–82, 127, 134–37; songs about sexuality in, 27–28. *See also names of specific groups*
Nigerian People's Party (NPP), 81–82
Nketia, Kwabena, xi, 6, 62–63
Nkrumah, Kwame, 75
NPN (National Party of Nigeria), 81–82
NPP (Nigerian People's Party), 81–82
Nwoga, Donatus, 24–25
Nwu L' Opi Ny' Adang Me (Improve Your Fatherland, Then), 71–74, 76
Nyororo, lullabies of, 158–59n. 7

obedience, songs about, 14
Obeh Ohoho (Thank You), 113–21
Obiechina, E. N., 120
Ode, Christiana Edugbeke, 25, 40–42, 48
Ogbile, evoked in historical epic, 98
Ogunba, Oyin, 113

Ogwugwu, image of, 78
Ogwugwu, O'loju: approach of, 48; background of, 42; composition by, 42–47; performance by, 25, 46–47
Oheh m' Aligede L' Ilohi (God Willed, We Igede Won Our Freedom), 82–83
Oibe, Okwute, 84
ojah (gossip), role of, 123–24
Ojeh nyam j' Atang Ka (My Bicycle Has No Bells), 26–28
Oju, dispute of, 5, 46
Okara, Gabriel, 108
Okpabi, Ogo, 81–83
Okpewho, Isidore: on classification, 23; on historical epic, 99; on oral literature, ix; on praise poetry, 161n. 3; on sexuality in songs, 27–28; on words and music in epic, 102
O-kwurokochoh, definition of, 18
Omakwu, Joe Akatu, 81–83
Ominyi, O. J., 3–4, 157n. 1
Omwu Ny' Ejeh Nyam (Origin of My Song), 68–71, 122–37
Onawoh, Ogbilokoh, 3–4
Ondah, Ebeleh: composition by, 7, 53–59; performance by, 59–64
Onugbo and Oko (*Onugbo Me Oko*), 122–23
Onugbo Me Oko (Onugbo and Oko), 122–23
Onyang Onyobi (Evil Woman), 35–38
Ora: history of, 2–3; in political song, 91–95, 98–100
oral literature: children's role in, 8–18; classification of, 22–23; critical spirit in, ix; endings in, 148–49; form in, xi–xii; future of, 155–56; impact of, 49; legend in, 3; music's role in, 102–3; political context of, 2–5; proverbs' role in, 138–39; role reversal in, 99; social and cultural context of, 5–7; studies of, x–xii; transcription of, 22, 47–49. *See also* folklore; songs

Origin of My Song (*Omwu Ny' Ejeh Nyam*), 68–71, 122–37
Oriki, and songs' variations, 47
orphan, song about, 15
Owuloh, Moses Igo, 64–65

parody: in children's song, 10–11; in women's song, 46–47
patron. *See* host
Paulaharju, Samuli, 159–60n. 2
pBitek, Okot, 108
performance: by children, 9–18; competition in, 19–20; context of, xii, 47; definition of, xii; effects of, 25; endings of, 148–53; expectations in, 7–8; instruments used in, 19, 21, 103, 160n. 3; obstacles in, 152–53; as political act, 46; rehearsals for, 20–21; riddle sessions in, 144; role of, xiii–xiv, 7; simultaneous, 6; transformation of songs in, 9–11, 13. *See also* audience; dance; rhythm; sound effects
play songs: categorization of, 158n. 6; dance in, 9–10, 15, 17–18; function of, 18; lullaby transformed into, 9–11, 17
Podzo, lullabies by, 158–59n. 7
poetry: characteristics of, 8; by children, 9–18; as dirge strategy, 60; form of, 51; role of, 82. *See also* dirges; praise poetry; songs; vilification poetry
Poiderin (soldier), 157n. 1
Pointer, Fritz, 99
political songs: dance in, 74, 83; goals of, 71–74, 79–80, 82–83; on Igede history, 84–99; issues in, 68–71; language of, 76; meaning of, 140; optimism of, 67, 71, 78; proverbs in, 76–78; role of, 74–75; techniques of, 69–71, 74, 98–99; topics of, 80–82; warning in, 83–84
politics (Igede): analogies to, 32; art used in, 48; and education, 68; empowerment through, 67, 69–74, 79, 82–83; leadership in, 74, 77–79; and morals, 79; and performance, 46–47; praises used in, xv; responsibility in, 76; safeguarding gains in, 83–84. *See also* Nigeria, politics in; political songs
polygamy, implications of, 48–49
pots, as symbol, 32–34, 92
praise poetry: classification of, 22–23; context of, ix-x, xiii-xiv; in dirges, 52–53, 60–63, 66; effects of, x, 25, 122; focus of, 161n. 3; goals of, 28–29, 50; greatness versus goodness extolled in, 113; imagery in, 107–8, 113, 119–20; in political songs, 69, 71, 76, 84, 98–99; reverse epithets in, 71; transcription of, 22; vilification's role in, 24, 28, 42, 46; on women's duties, 40–42. *See also* songs
pregnancy, attitude toward, 151
prostitution: metaphor for, 37–38; song about, 29–32, 35; as taboo, 28–29
proverbialization, in songs, 144–45
proverbs: analysis of, xvi; combined with songs, 139–40; and composition, 20–21; drawn from animal world, 149–51; enigmatic type of, 128–29; goodwill solicited through, 140–43; imagery enhanced by, 120–21; misuse of, 139; and performance endings, 149–53; in political songs, 76–78; role of, 120, 138–40, 142–43; as shifting, 161n. 1; songs combined with, 139–40, 144–45

Rabbit, significance of, 121
race, imagery of, 136
Ranung, Bjorn, 6, 48, 139
reincarnation, metaphor for, 60–61
reproach. *See* vilification poetry
resistance war (1928), 3–4

rhythm: in play songs, 10, 14–15; in political songs, 68, 160n. 3; role of, 103
River Niger, and Igede homeland, 2–3, 91, 98
River Oyongo, as boundary, 150
Russian culture, dirges in, 159–60n. 2

satire, function of, 24–25, 29, 37. *See also* vilification poetry
scented soap, meaning of, 37
seasons, evoked in historical epic, 98
selflessness, praise for, 61
sexual intercourse, metaphor for, 34
sexuality: attitudes toward, 25, 151; songs about, 26–28, 32–34; taboos in, 28–29. *See also* prostitution
Seydou, Christaine, 102
Shagari, Alhaji Shehu, 81–82
singers: background of, 6–8, 155; birds as metaphor for, 119, 151; costumes of, 103; cultural knowledge of, 7–8; goals of, 9, 28–29, 48; material for, 5; number of, 154; obstacles for, 152–53; and performance endings, 149–53; political activism of, 68; possibilities for, 113; public recognition for, 154–55; role of lead, 160n. 2; as soldier, 152. *See also* composition; dirgers; Ichegbeh, Micah; Igbang, Odeh; Ogwugwu, O'loju; Ondah, Ebeleh
slave, importance of, 64
smoking, song about, 38–39, 159n. 3
society: commonalities in, 50–51; gender politics in, 101; idealistic perspective on, 29, 32; symbolic system in, 37–38; tensions in, 28. *See also* community
soldier, as metaphor, 152
Song of Frustration (*Ejeh Ny' Imahi*), 42–47
The Song of the Proud Spur-Fowl (*Ejeh ny' Ewa Ol' Oboche*), 13

songs: classification of, 9, 22–23; context of, xii, 5–7; effects of, ix–x, 49, 156; formulas for, 148–49, 161n. 2; function of, 13–15; legend in, 2–3; payment for, 113; play and instruction fused in, 11–12; and popularity, 7–8; proverbs combined with, 139–40, 144–45; topics of, 9, 144; transmission of, 8–18, 101; variations in, 47; words and music related in, 102–3. *See also* dirges; lullabies; performance; play songs; political songs
sons: dirge for, 64–66; preference for, 49
sound effects: in dirges, 52–53, 61–62, 64; instruments used for, 19, 21, 103, 160n. 3; in lullabies, 9, 17; in play songs, 9–10, 13–15; in political songs, 68, 71, 160n. 3; types of, 159n. 1
South Africa, heroic tales in, 99
Soyinka, Wole, 84–85

tarred roads, symbolism of, 76
taxation, resistance to, 3
Thank You (*Obeh Ohoho*), 113–21
thatch roof, as metaphor, 108–13
theft, song about, 15
thunder, allusion to, 119–20
Tiger, significance of, 121
time, evoked in historical epic, 98
Tiv, location of, 1
tradition: celebration of, 108–13; embedded in proverbs, 142–43; individualism combined with, 19; interpretation of, 122; and performance endings, 149–53; proverbs' role in, 120; uses of, xiii, 64–65, 77
translation and transcription, issues of, xiii–xiv, 22, 47–49
tsetse fly, poet as, 121

Ugaru bird, as metaphor, 151
Ukelle, location of, 1
Ukpa, dispute of, 5

Unity Party of Nigeria (UPN), 81–82
Uwoku, war of, 5

Vail, Leroy, xi, 75
vilification poetry: on alcoholic addiction, 38–39; by children, 11–13; context of, ix-x, xiii-xiv; in dirges, 61–64; effects of, x, 25; goals of, 28–29, 32, 37, 50; on marriage, 35–38; in political songs, 69, 74, 76, 78, 85, 98–99; praise's role in, 24, 28, 42, 46; on prostitution, 29–32, 35; on sexual knowledge, 32–34; on sexual promiscuity, 26–28; uses of, xiv, 24–25; on women's duties, 40–42. *See also* songs
violence, as context, 2–3

war: Biafran, 96, 140; as context, 2–3; of resistance, 3–4; songs about, 92–100, 160n. 2
Warren, Austen, 51
washman, as metaphor, 107–8
Welcome Song (*Eje Ny' Owurabah*), 141–43
Wellek, Rene, 51
Westernization, impact of, 61, 136–37
White, Landeg, xi, 75
Who Gets Hurt (*Nao Ayele Awi*) game, 17

widow, concept of, 77
women: attitudes toward, 29, 35, 77, 151, 157–58n. 4; challenge by, 42–47; childbearing status of, 49; compositions by, 39–42; death of, 7, 100–101; as dirgers, 51–60, 66; divisions among, 49; duties of, 34–35, 40–42, 46, 60; and marital harmony, 35–38; in proverbs, 150–51; role of, 100–101; sexual knowledge of, 32–34. *See also* girls; mother
Women Age-Mates (*Anyang alikpa*), 32–34
Women's Prostitution (*Akpara ny' Anyang*), 29–32, 35
wurum, connotation of, 100

Yachi, location of, 1
Yala, location of, 1
yam: importance of, 37; as metaphor, 60–61, 77–78, 150–51
Yankah, Kwesi, 23, 75, 161n. 2
Yoruba: customs of, 6; and politics, 81–82; and songs' variations, 47
Yugoslavia, songs about sexuality in, 27–28

Zimbabwe, war in, 140